HOOSIER BEER
TAPPING INTO INDIANA BREWING HISTORY

HOOSIER BEER

TAPPING INTO INDIANA BREWING HISTORY

Bob Ostrander & Derrick Morris

Charleston London

THE
Hi$tory
PRE$S

Published by The History Press
Charleston, SC 29403
www.historypress.net

Images are from the Derrick Morris collection unless otherwise noted.

First published 2011

Manufactured in the United States

ISBN 978.1.60949.359.2

Library of Congress CIP data applied for.

Notice: The information in this book is true and complete to the best of our knowledge. It is offered without guarantee on the part of the authors or The History Press. The authors and The History Press disclaim all liability in connection with the use of this book.

Beer, while being one of humanity's oldest beverages, can, when used to excess, be harmful to your body. Overuse can lead to weight gain, cirrhosis, alcoholism, halitotsis, DUI arrests and many other problems. This book does not advocate overindulgence.

Contents

CONTENTS

Acknowledgements

We wish to thank lots of people for their work, advice, inspiration and support. Our wives, Terry and Karen, of course; collectors John Coughanowr and Steve Paddack; proofreaders Josh Dials, Taber Landwerlen, Mark Stober and Jeff Eaton; historian Ron Grimes of the Madison–Jefferson County Public Library; Harold C. Feightner, executive director of the Indiana Brewers' Association from 1934 until 1967, for keeping detailed notes of this period; the Indiana State Library for making Feightner's notes available; John Holl for connecting us with The History Press; and Rita Kohn for believing.

We have set up a website, **www.HoosierBeerStory.com**, where you will find more information that wouldn't fit into these pages—more pictures, newspaper clippings, period advertisements and anecdotes. Feedback from our readers is also invited; if you have family stories to add, please let us know.

We wrote this book mainly because we are fascinated by the industry. OK, maybe also because we like beer. We hope you bought this book to find out more about your mania. If not, maybe reading it will start you down that path.

About This Book

On these pages, you'll find the complete history of the breweries of Indiana. About 370 commercial breweries have operated between 1816 and the present day. We'll explore stories about all of them, including the following:

- A farm brewery was part of the Underground Railroad during the Civil War and a speakeasy and bordello during Prohibition (Hoham/Klinghammer in Plymouth).
- A large brewery's life was ended due to a labor strike (F.W. Cook's in Evansville).
- One brewery was part of a utopian colony (New Harmony), and one was part of an Archabbey (Saint Meinrad).
- One brewery recovered from $3,000 debt in 1881 (Joseph Miller in Covington). Another brewery's owner, when faced with a $5,000 debt in 1889, shot himself (Main Street Brewery in New Albany).
- Several were in the back rooms of inns and hotels—early examples of brewpubs.
- One brewery bought the local newspaper in order to change its editorial stance during a temperance campaign (Indiana Brewing Association in Marion).
- Some breweries were related to famous people, including Hew Ainslie, Tony Hulman, Richard Lieber, Cole Porter, Knute Rockne, Howard Hawks, Governor Robert Orr and Kurt Vonnegut.

- A brewery and distillery company started a city's fire department (Great Crescent in Aurora).
- Many breweries were taken over and managed by the widows of the owners, and some were started and operated by women.
- One brewery paid its sales manager $108,000 per year during Prohibition (Kiley in Marion).
- One brewery piped water from its spring to neighbors during the Civil War—and even built a bathhouse (Spring Brewery in Lafayette).
- One came to an ignominious end when the president was arrested for income tax evasion after the ex-commissioner of the IRS got a $363,000 tax bill reduced to a $35,000 refund (Indianapolis Brewing Co.).
- Many brewery buildings have gone on to other uses, including shopping malls, college classrooms, apartments and office buildings.
- The first brewery in Fort Wayne, at the American Fur Trading Company post, was started by Francis Comparet and Alexis Coquillard, the founder of South Bend.
- Brewery owners were jailed for selling bootleg beer during Prohibition. One was given probation because people would be put out of work (Huntington Brewery). One owner was jailed for bribing federal Prohibition agents (Southern Indiana Brewing Company in New Albany).
- Breweries owned or sponsored minor-league and Negro League baseball teams. One sponsored the Notre Dame football team (Kamm's in Mishawaka).
- One brewery was built specifically to entice settlers in the 1850s to buy land in a new community (Cephas Hawks in Waterford).
- One brewery closed three days before winning a gold medal at the Great American Beer Festival (Evansville Brewing Co.).
- Many were started by immigrants to the United States from Belgium, England, France, Germany, Scotland and Switzerland.
- One "Brew on Premises" was set up where anyone over twenty-one could brew his or her own beer.
- Dozens of brewery owners served as mayors, bank presidents or congressmen.
- A surprising number of breweries burned down—some multiple times. One man (Charles T. Doxey of Anderson) had a brewery, a barrel stave factory, an opera house, a handle factory, a music hall and a plate glass works destroyed by fire while he was a state senator, a U.S. representative and running for governor.

- One brewery opened a famous restaurant in Chicago that is still operating (Berghoff in Fort Wayne).
- One brewery was owned by a pipe organ builder (Louis van Dinter in Mishawaka).
- Three modern-era breweries were opened by doctors.
- Inventions from Indiana led to the modern CO_2 regulator, beer line cleaning equipment and corn-adjunct beers.
- The largest of the old-line breweries made over one million barrels (bbls) of beer annually (a barrel is sixty-one gallons; Sterling, Drewrys and Falstaff).
- The largest of the modern-era breweries has a capacity of about fifteen thousand bbls (Three Floyds).

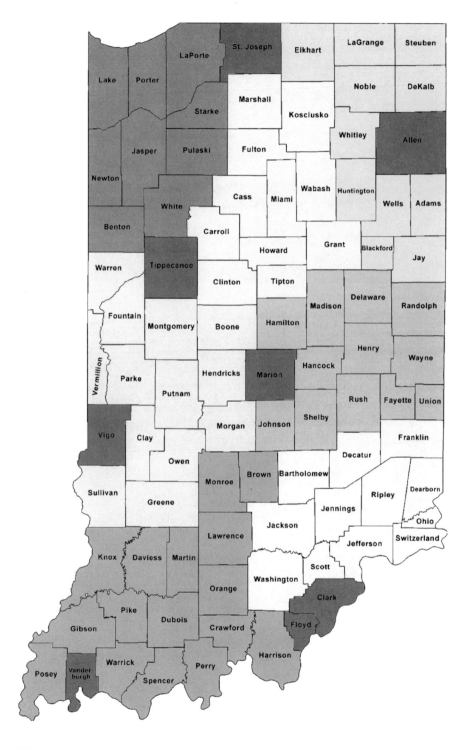

Map of Indiana showing the regions covered in this book.

Common Beer, Ale and Lager

COMMON BEER

Until 1857, all beers were fermented by wild yeasts. This, of course, included all beers made in Indiana. In southern Indiana, a specific style of beer made this way was called Common or Kentucky Common. The recipe used about 30 percent corn and 70 percent barley malt. Some roasted malt or artificial coloring was often added to the mix to darken it.

Fermentation of Common was done by a sour mash process. The brewery added (inoculated) a bit of beer from the last batch to introduce the yeast. This process is still used with sourdough bread, whiskey and some Belgian beers. The brewer's term for this is "krausening."

Starting a brewery in those days must have been a risky undertaking, with the first batches being merely experiments to obtain a drinkable beer from the wild yeasts. There is no doubt all these beers had a certain sourness that we mostly find unacceptable today, except in beers of Belgian and Berlin styles.

After the Civil War, improved transportation brought imported yeast strains from Europe, so brewers could make ale and lager. A major difference between these was the type of yeast used.

ALE

Ale uses a variety of yeast that clumps together so some CO_2 is trapped, and the yeast floats to the top of the liquid. These originally came from northern Europe and are associated with Britain, France, Belgium and Northern Germany. The resulting beer has a somewhat fruity taste.

Ales are ready to drink almost immediately after fermentation. This makes the whole process cheaper, releasing maturation tanks for more beer. Today, ales are the favorite products of small breweries and brewpubs, since tanks are expensive and take up precious space. Porter, stout, mild, blonde, Irish, Scottish, Belgian, Kölsch, saison, barley wine and wheat beers are all styles of ale.

LAGER

Lagers were first popularized in the 1830s in Munich and Vienna and quickly migrated to Czechoslovakia (Bohemia), Southern France and Italy. Using yeast that settles to the bottom of the tank, lagers are better with a long maturation in comparatively cold conditions, requiring ice or cold-storage caves, not to mention tanks or casks to keep the beer for up to six months before it can be sold. Indeed, *lager* is the German word for a storehouse or cellar. The final product is clean, crisp and more refreshing than most ales on a hot summer day.

Pilsner, Octoberfest, Bock and American mass-market beers are the major styles of lagers. It is said that the F.W. Cook City Brewery in Evansville made the first lager beer in Indiana in 1858.[1]

Six-row barley grown in the United States differs from two-row European barley, as it is higher in proteins that give haze and aromas to the beer during the lagering process. To help control this, brewers started using adjuncts, including rice, wheat and especially corn. Pre-Prohibition pilsners often contained up to 20 percent corn in the recipe.

Influences

Family Brewing

Aberdeen records show that there were 152 professional brewers in 1509—all women. Edinburgh had over 300. London had about 290 breweries—110 run by men and 180 by women. Almost all of these were one-person enterprises, many on estates or at coaching inns. The British system was brought to the colonies with home and estate brewing. Washington and Jefferson both had estate breweries.

As we expanded westward, beer came with us. Brew kettles were hung over open fires, and fermentation took place outside in the cool of the dogtrot, where wild yeast could find the sweet wort easier. Scores of breweries found in the following pages were home or farm enterprises. They are the ones that sold their beer for extra income. Hundreds of family breweries that provided for the household or neighbors have never been documented and aren't included, but there is no doubt that nineteenth-century Indiana had more breweries than it will ever have again.

Immigration into Indiana

The first pioneers in Indiana were of French origin. They settled along the Ohio River and in Fort Wayne, Lafayette and Vincennes, where

forts were built prior to the French and Indian Wars. Vincennes itself had nearly one thousand European inhabitants before the Northwest Territory was set up in 1787.

In the first decade of the 1800s, people of Quaker, Baptist and Methodist faiths came from the Carolinas to Cincinnati and southeastern Indiana to get away from the spread of slavery. Here, in 1816, Ezra Boswell, a Quaker who had moved to Richmond from North Carolina, started a commercial brewery.

After the War of 1812, the Ohio River became the main migratory path westward, with the communities of Lawrenceburg, Aurora, Madison, New Albany, Tell City and Evansville being developed. The Rappite colony at New Harmony near Evansville also started a brewery in 1816. The fort at Vincennes held the first state capitol building and the first bank of the state. Money was easy to come by, and J. and William L. Coleman started the third Indiana commercial brewery there in 1818.

In the 1850s, a Swiss colonization society moved from Cincinnati to Tell City and started a planned capitalist community that would have four breweries before the Civil War began.

German immigrants were also coming to Indiana before the Civil War. By 1860, there were over 500,000 people in both the southern and central Indiana regions and another 280,000 in northern Indiana. By the 1880 census, those numbers had all risen by half.

Indiana did not attract as many overseas nationals in the mid-nineteenth century as other midwestern states did, but two-thirds of those who came to Indiana were from Germany, with French, English and Irish behind them in numbers.

In the early 1900s, before World War I, Polish and Hungarian immigration to northern Indiana soared, and a general movement from Austria, Italy, Romania and Russia took place; however, Prohibition was just around the corner, and few entered the brewing business.[2]

In all, we have found fifty-five Indiana brewery owners who were German immigrants (seven from Württemberg itself); eight from France (including six from the Alsace-Lorraine region, which has been both French and German); seven from Prussia; three each from England and Scotland; and one each from Belgium, Ireland, Lichtenstein, Russia, Switzerland and the Netherlands. Canada even supplied us with one major brewery if you include Drewrys' purchase of the Muessel Brewing Co. Note that the vast majority of these were before Prohibition.

1855: INDIANA GOES DRY—FOR SIX MONTHS

Ezra Bozwell's brewery in Richmond started in 1816, and two years later, James Burgess, a Methodist preacher, circulated a pledge throughout the town for the people to abstain from drinking. This movement, as with all of them until the Civil War, was directed more against spirits (whiskey) than beer, wine or cider.

Indiana's first real temperance society was organized by Isaac McCoy in 1822 in Fort Wayne. It did not last long. In 1826, the New Harmony Society in southwest Indiana, under its new leader, Robert Owen, closed down the town's distillery and brewery and declared the community dry.

A brewery in Fountain City was effectively run out of the city by a local temperance society action in 1830. This action also closed the four saloons in town.

The first "township option" effectively came into place in 1828, when license applications could be refused if more than 50 percent of the freehold residents (adult males who owned property) objected. This led to a true township option by vote in 1842.

All the local option laws were found to be unconstitutional by the Indiana Supreme Court in 1853, but statewide prohibition was passed in 1855. Yes, Indiana was officially dry. This lasted for only six months before the Indiana Supreme Court ruled on the side of the wets and found the law unconstitutional.

Twenty years later, the Republicans tried again, putting in the harshest laws they could. The "Baxter Law" of 1873 required a petition signed by more than half of the voting-eligible inhabitants of the county in order to obtain a liquor license. Additionally, a $3,000 bond was required to get a license—this when the average income was less than $500—and taverns needed to close at 9:00 p.m. This proposal turned out to be too draconian for the voters, and the Republicans lost both legislative houses in the election the next year. The law was completely revamped in 1875.

TECHNICAL ADVANCES

Pasteur's discovery of yeast in 1857 added an important tool to the brewer's kit: beer could now be made consistently from batch to batch. Then, in 1871, Carl von Linde invented refrigeration, and the consistency of beer was practically perfected. By following a single recipe, an identical product could be made batch after batch, month after month, year after year.

Breweries could grow when they could transport their beer to a wider audience. The refrigerated railroad car allowed beer, and even wort, to be sent outside the local area. In the late nineteenth century, ice was used to keep the cargo cold, and that was enough to cause a revolution in the meatpacking industry and in brewing.

The last important advancement that made the huge breweries of today possible, even inevitable, was mass advertising. Nationwide television broadcasting helped brands like Blatz, Budweiser, Falstaff, Miller and Schlitz dominate the national market, and much of this advertising was and is oriented toward the male sports fan.

BOTTLERS

From 1875 until 1890, Federal regulations prohibited breweries from bottling their own beer at the brewery. It had to be done in a separate building and by a separate company. Many breweries owned the bottling plants through sister corporations, but some contracted to outside companies.

In Indianapolis, for instance, Lieber beers were bottled by Jacob Metzger & Co., located across the street from the brewery. Metzger & Co. also bottled Budweiser, Bass and Guinness Extra Stout. Jacob Metzger was a German immigrant and father-in-law of Hermann Lieber. This company closed in 1896, when a fire ended production at the Lieber brewery. Casper Maus used an independent company, C. Habich & Co., which also bottled Champagne Velvet from the Terre Haute Brewing Co. Beers were often brought into the area in bulk to be bottled or distributed in kegs locally. Pabst set up a bottling line in Indianapolis in 1893, run by William Stumpf.[3]

CONSOLIDATION, PART 1

The 1890s saw a financial panic in the United States that put many companies into debt, and many previously successful breweries found themselves on the brink of bankruptcy. At the same time, brewing syndicates from England (including Watneys) moved into America to invest in the industry here. They were instrumental in merging companies into large firms in New York, New Jersey, Chicago, Baltimore, Detroit, Boston, Philadelphia, San Francisco, Cincinnati and, in 1887, Indianapolis. This trend led to the formation of

the Evansville Brewing Association and, in defense against takeover, the Indianapolis Brewing Co. Thus, brewing became a for-profit business rather than a for-beer business.

1918: Indiana Goes Dry

Frank Hanly was elected governor in 1904 on an anti-alcohol and anti-gambling platform. He called a special session of the legislature in 1908 that voted county option laws onto the books—passed strictly by party line. If 20 percent of the voters petitioned, a vote would be held. In that year, seventeen counties went dry. In two years, seventy counties were dry. Dozens of breweries, such as Paul Reising in New Albany, the Marion Brewing Association, the Huntington Brewery, the Wabash Brewing Co. and Rettig and Alber in Wabash, gave up because their customers were taken away.

In 1911, the Democrats came back into power and loosened the laws a bit with the help of the newly formed Indiana Brewers' Association. The main impact of their efforts was to change the county option laws to township options. This necessitated revoting across the state and staved off the coming storm for a while.

Signed by Governor James Goodrich, statewide Prohibition passed the House seventy to twenty-eight and the Senate by thirty-eight to eleven, effective on April 2, 1918. Indiana, of course, ratified the National Prohibition Amendment in 1919, and the entire country went dry in 1920.

At this time, all the breweries and distilleries went out of business, although home-brewing stuck around. Some commercial breweries produced "near beer" that had more than the allowable 0.5 percent alcohol. The Paul Reising Brewing Co. in New Albany was closed by Prohibition agents when its cereal beverage, Hop-O, was found to contain several percent alcohol. Owner Michael Shrick went to jail for attempting to bribe a federal agent.

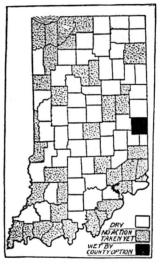

TEMPERANCE MAP OF THE STATE OF INDIANA

Temperance map of the state of Indiana showing dry counties in 1907. Only Wayne County saw a vote that failed. From *A Magazine of Religious Freedom, General Conference of Seventh-Day Adventists.*

The T.M. Norton & Sons brewery in Anderson was raided in 1923, and two truck drivers were arrested for trying to take twenty-nine barrels of possibly 5 percent beer to Cincinnati to be sold. The brewery itself was seized by federal agents, and owner William Norton was subsequently arrested and sentenced to prison.

Many breweries sold soda pop, near beer and even mineral water to get by during Prohibition. Many made malt syrup, which was popular for cooking and for producing home-brewed beer.

Indiana had the toughest laws supporting Prohibition in the nation. The Wright "Bone-Dry" Law of 1925 called for a prison penalty for possession of any liquor, and even the smell of alcohol was evidence of guilt. Local prosecutors were given a twenty-five-dollar bonus for each conviction, and there were 250 arrests in the first week the law went into effect. Some well-known backsliders weren't prosecuted though; Governor Edward Jackson's wife was treated by a doctor with alcohol—an act that was illegal.

Finally, in 1933, with the national repeal in sight, Governor Paul McNutt oversaw the repeal of the Bone-Dry Law, and he released 1,027 people from Indiana prisons. That same year, a state referendum showed support for repeal (554,129 to 311,464), and Hoosiers helped ratify the Twenty-first Amendment by a convention vote of 246 to 83.

Consolidation, Part 2

The demise of dozens of Indiana breweries after World War II is directly linked to the mergers and takeovers by what would have been considered "trusts" in the early part of the century. The S&P Corporation, Associated Brewing Co., Atlantic Brewing Co. and G. Heileman succeeded one another, buying as many breweries as possible and closing them. They thought that larger national breweries were more efficient, and because most mass-produced lagers tasted quite similar, local drinkers wouldn't notice or wouldn't mind the difference.

They lost the local followings, and names like Champagne Velvet, Centlivre, Sterling, Drewrys and Falstaff fell out of favor, while nationwide advertising— particularly on televised sports programs—made Budweiser and Miller Lite the beers of choice for the vast majority.

In 1875, there were eighty-eight breweries in Indiana. In 1975, there were two: Heileman's Sterling facility in Evansville and Falstaff in Fort Wayne.

In 1880, there were 2,830 breweries in the United States. At the start of national Prohibition in 1920, there were 1,400. Only 160 reopened after Prohibition. By 1951, there were only 230—90 in consortiums and 140 independents. In 1983, 51 companies and a total of 80 breweries were in operation, with the top 6 conglomerates making 92 percent of the beer (Anheuser-Busch, Miller, G. Heileman, Stroh, Coors and Pabst).[4]

THE RISE OF THE MICROBREWERY

Microbreweries started on the West Coast when California's New Albion Brewery opened in 1977. In 1982, Yakima Brewing in Oregon became the first brewpub—a brewery specifically making beer for its own restaurant.

Local products had become fashionable, and local beers were recognized by customers as fresher and available in more varieties, giving these smaller companies a competitive edge. Craft breweries (aka microbreweries) are one aspect of this ongoing trend.

Indiana was a bit behind the trend but has caught up fast. The new Indianapolis Brewing Co., a production brewery making draft and bottled beer, started in 1989. John Hill, an innovative immigrant from Yorkshire, started our first brewpub in 1990. At that time, Indiana law didn't allow breweries to sell food or their beer to the public. Hill got around this by having two companies: a brewery and an adjacent restaurant. Beer had to be kegged and hand-trucked outside and then brought back into the restaurant side.

Six years later, Indiana had fifteen breweries—twelve brewpubs and three production breweries that sold their beer to liquor stores and restaurants.

Even more recently, the family brewery is making a comeback. One-person or family breweries have emerged in Aurora, Brazil, Columbus, Kokomo, La Porte, Valparaiso, Richmond, Salem, Sellersburg, South Bend and Wilbur.

Today, there are over fifteen hundred craft breweries countrywide that make 91 percent of our different beers but only 4 percent of the total beer sold.[5] The last chapter of this book details the fifty-three breweries that have opened in Indiana since 1989.

Table 1. Number of Indiana Breweries through the Years

1830	3	1935	17
1840	8	1940	15
1850	19	1950	11
1860	56	1960	4
1870	76	1970	4
1880	77	1980	2
1890	49	1990	4
1900	44	2000	23
1910	41	2010	37
1918	19		

Collecting Beer Memorabilia
(Breweriana)

While researching this book, we've seen many personal collections of beer bottles and cans. People enjoy decorating their home bars and recreation rooms with mementos of beers they have enjoyed or that they tried on trips. Displays of bottles or brewpub growlers seem to be part of every beer nut's décor.

Serious collectors sometimes accumulate along a specialty, such as beers from one city, region or state; advertising; printed articles; matchbooks; openers; or packaging (quarts, stubbies, steel cans, cone tops; etc.). Some people try to get every variant of specific breweries.

There are three Indiana chapters of the Brewery Collectibles Club of America (BCCA): the Hoosier chapter in the Michiana area, the Three Rivers chapter in Fort Wayne and the widely dispersed IBC chapter covering a large area of the state. Trade shows are held each year, where people can find items for their collections or sell interesting items they've found. You can find more information at www.BCCA.com.

DETERMINING THE AGE OF BEER BOTTLES AND CANS

Pre-Prohibition

Early beer bottles were built for a cork, rubber or porcelain stopper held in place by a metal cage. Twisted wire was used on most bottles. Swing-type

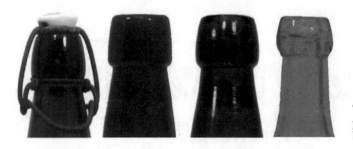

Types of early
pre–crown top
bottle lips.

retainers (bails) were patented in 1855, but workable versions weren't seen until the 1870s. Caps replaced these closures even before Prohibition.

Embossed bottles were quite thick and featured a brewery or bottling plant name and other information, including the city. Deposits were taken on all these bottles. Paper labels were usually applied over the embossing, and these labels didn't necessarily match the embossing; bottles were often recycled and refilled without regard to the company of origin.

Very early lips were tapered flatly toward the top. The "blob top" round lip with a taper was used from 1850 until Prohibition. A pure round lip (doughnut) was used from 1885 until 1905. Other styles featuring very narrow square lips were used with proprietary stoppers during this period and are quite rare.

Green, olive, black and aqua colors generally appear on older bottles, with amber and brown bottles appearing about 1870. Truly clear glass wasn't available until the 1890s.

Mold marks (vertical seams) are common, and many bottles were actually hand blown. Bubbles and crazing throughout the body of the bottle was also common. Hand-blown bottles often have a scar on the bottom where the pontil rod was attached. This would date the bottle to before the 1870s.

If the lip of the bottle does not have mold marks, it has either been ground down or fire polished, or it has a lip that was welded on from a pre-made piece rather than molded during the blowing process. This practice often left an irregular ring under the lip and was first done in the 1880s. It came into vogue in the 1890s, although molded-in lips (applied finishes) continued to be used.

Separate bottling companies were mandated before 1890. Sometimes the brewery name was embossed on the bottle, and sometimes independent bottling companies used their own names. Around the turn of the century, capacities started to be molded into the bottle; in 1914, this practice

became mandatory. Throughout this entire era, sizes from twelve ounce to thirty-two ounce were common.

Crown caps were patented in 1892, and the design has changed very little since. Bottles built for these caps have a distinctive bead identical to modern bottles and usually date to after 1898 because the financial panic of 1893 delayed retooling and implementation of the new technique.

Prohibition

During Prohibition, "L-Permits" were required on near beer labels, as were notices along the lines of "not more than one half of 1 percent alcohol." Squat bottles with a distinct shoulder and long neck were popular for malt tonics and malt syrups.

Post-Prohibition

A typical malt syrup bottle sold during Prohibition.

After Prohibition, virtually all beer bottles used crown caps, and embossed bottles disappeared completely. At this time, many federal laws changed the way bottles and labels were presented. Brewers were issued "U-Permits" and from 1933 until 1935 had to list the permit number on the label. Many labels with permit numbers were used into 1936 while breweries exhausted their stocks of labels.

The phrase "Internal Revenue Tax Paid" or "Tax Paid at the Rate Prescribed by Internal Revenue Law" was required from 1933 until World War II. From 1942 through March 1950, a shortened "IRTP" could be used.

Applied (painted-on) labels first appeared in 1934 but weren't used in Indiana until 1940.

Beer Cans

The first canned beer in America was famously sold by Krueger's of Virginia in 1935 and by Pabst later that same year. Krueger's had sold its near beer in cans since 1933. These were heavy steel, flattopped cans that required an opener (or "church key"). Flattopped cans were made through 1970. Drewrys and Centlivre were the first Indiana breweries to can beer.

Cone-top cans were also introduced in 1935. Many smaller breweries liked these because they could be filled on existing bottling lines, complete with crown caps.

The Crowntainer (Kamm's) was first produced in 1939. It was a seemingly seamless cone-top can that had no rim at the top shoulder. It was made of steel and clad in aluminum. The last cone-top filled with beer in Indiana was made by the Terre Haute Brewing Co. just before it closed in 1959.

Production of canned beer for civilians ended in April 1942 and didn't resume until 1947. Olive drab cans were still produced for military use.

Pull-tab cans, invented by Emil Faze of Dayton, Ohio, were first marketed by Iron City Beer in 1963 and soon picked up by Schlitz. In just two years, 75 percent of all cans had pull-tab tops. Non-detachable pop-tops were also invented by Emil Faze and were first used by Falls City in 1975. This style is now used for virtually all carbonated beverages.

Bottles

Stubbies, or "steinies," bottles were introduced in 1935 in response to canned beer and became popular after World War II through the 1970s as non-returnable bottles. Two-step stubbies with a longer neck were manufactured until the early 1950s.

"Picnic bottles" of half-gallon size date from Prohibition until 1957.

By the way, if you see a bottle that is embossed with the phrase "Federal Law Forbids Sale or Re-Use of this Bottle," you have a liquor bottle. Breweries could and were encouraged to reuse bottles.

Plain (maybe two-color) labels were prevalent during World War II to save the tiny amount of metal in gilt ink. Labels during this time often encouraged the purchase of war bonds.

You can usually identify the era of later labels by remembering that zip codes came about in 1963, twist tops were invented in 1966, UPC codes started in 1973, state deposit and redemption values ("5¢ Michigan") started in the 1970s and government warning labels were mandated in the fall of 1989.

Northwest Indiana

CROWN POINT

KROST & HORST
UNTIL ABOUT 1873

John Krost and Joseph Horst had a small brewery in Crown Point that closed in bankruptcy before 1873. It produced about 550 bbls per year at its peak. The bankruptcy proceedings lasted until 1877 and ended up in front of the Indiana Supreme Court.[6]

JULIUS KORN, 1860–1875
KORN & BERG, 1875–1878
BERG BROS. & CO., 1878–1895
CROWN BREWING CO., 1895–1914

This brewery was located on Pratt and Goldsboro Streets until 1910 and then moved to Hammond. It was started before the Civil War by Julius Korn. John Berg was brought in as a partner in 1875, and Korn left three years later.

August Koehle worked at the Korn & Berg Brewery in 1876 and became foreman of the plant. He left in 1880 to open a saloon in Crown Point.

The L. Sonnenschein Co. of Chicago bought the operation in 1895, reincorporating under the Crown Brewing Company name, and started

building a new four-story building, which opened in 1898. It grew quickly, going from about five hundred bbl capacity in 1879 to twenty thousand bbl near the end, making it one of the largest breweries in Indiana at that time.[7]

The main brand was KronenBräu. The company moved to Hammond in 1910, "partly due to an environmental problem caused by draining the hops into Beaver Dam Ditch."[8]

HAMMOND

HAMMOND BREWING CO.
ABOUT 1890–1918

In 1886, Charles H. Mayer started a bottling business in Hammond. Four years later, he went in with George M. Eder, an immigrant from Germany, to form the Hammond Brewing Company. Mayer's son, Joseph P. Mayer, was the bookkeeper. Eder was the secretary, treasurer and director.

Brands included Muhlhauser Export and Bohemian Lager. By 1917, the business was essentially bankrupt, and it disappeared at the onset of Prohibition.

HOBART

WALKER BURT BREWING CO.
ABOUT 1907

According to the *Lake County Times* of Friday, December 6, 1907, "The Walker Burt Brewing Company [is] erecting [its] ice house and several sheds on Second Street next to the Michigan Central railroad tracks."[9]

LA PORTE

A brewery existed in La Porte before 1831 north of the courthouse in an area called "Ten Mile Strip"—the ten miles of Indiana across the northern border that was split off from Michigan when Indiana was admitted to the Union in 1816. La Porte County was formed in 1832, and La Porte's streets weren't laid out until 1833.

Nicholas Bader Brewery, 1859–Before 1879
J.B. Puissant, Before 1879–1884
Puissant & Dick, 1884–1887
J.W. Russert, Crystal Spring Brewery, 1887–1896
Guenther Bros. Brewing Co./Crystal Spring Brewery, 1896–1911
Guenther and Zerweck, 1911–1918

Nicholas Bader started the brewery on Lake and Tyler Streets before the Civil War. John B. Puissant bought the brewery before 1879; he is recorded as selling 880 bbls in that year.[10]

From 1870 until 1875, Clemens Dick and his brother, Frank, owned a brewery in Mishawaka that was to become Kamm & Schellinger. Frank started a brewery in La Porte and came in with Puissant in the mid-1880s for a bit before they sold both breweries to John W. Russert in 1887.

Russert was a thirty-eight-year-old immigrant from Germany who had just come to America. At this time, the brewery capacity was ten thousand bbls, and they produced five thousand bbls.[11]

Russert sold the plant, and it became the Guenther Bros. Brewing Co., aka Crystal Spring Brewery, in June 1896. The brothers were Fritz K. and John J. Guenther. Fritz had brewed in Sacramento and John in Massilon, Ohio, before they both moved to La Porte to take over this business.[12]

In 1905, they opened a saloon and sample room at 609 West Main Street. By 1907, there were eight employees at the brewery.

Herman Zerweck, a brewer from Württemberg, Germany, bought Fritz's share, and the enterprise was renamed Guenther & Zerweck in September 1911. Peak production was seven thousand bbls.

Brand names included Excelsior, Home Brew and Indiana Gold. Closed at the onset of Prohibition, the building was torn down in 1932 and replaced with a highway department garage.

August Zahm
1859–1874

Zahm's brewery was on the west side of Clear Lake, "north of the furnace." It burned and was closed in 1874.[13]

Urban Gaeckle
1866

Urban Gaeckle had a brewery and beer garden in 1866.[14]

GALLAS BADER
ABOUT 1868

This brewery was located on Tipton between Front and Limit Streets. The 1868 *Chandler & Co.'s Business Directory for Indiana* lists Gallas Bader as owning a brewery near Clear Lake. This is in addition to the Nicholas Bader brewery that became the Crystal Spring Brewery.

MATHIAS KREIDLER
1869–1874

Mathias Kreidler, an immigrant from Württemberg, Germany, came to La Porte in 1854. He worked as a shoemaker and operated a saloon on Madison Street, between Washington and Main, until opening a brewery on the north side of Clear Lake. When it closed, he opened a clothing store.[15]

FRANK DICK, 1875–1884
DICK & DICK, 1884–1887

Frank Dick was a partner with his brother, Clemens, in the Dick Bros. Brewery in Mishawaka. He sold his interest to Adolph Kamm and started a brewery in La Porte. His son, Frank Jr., was brought in, and the establishment was renamed Dick & Dick in 1884.

Frank Sr. also had an interest in the Crystal Spring Brewery (above) with John Puissant. Operations of Dick & Dick were merged with the Puissant & Dick Brewery when the Crystal Spring Brewery was formed by John Russert in 1887. Frank Dick Jr. then moved to Ohio to work at another brewery.

Hop Growing

West of La Porte, near Westville, Shepherd Crumpacker grew hops starting about 1874. He had ten acres devoted to the crop and an oast house for drying and curing the hops. The children of the area picked the crops in the fall, and families made from twenty-five to forty dollars each season. He stopped growing the hops after a storm destroyed the oast house. By 1887, Crumpacker was a lawyer in La Porte and had run for mayor in 1884.[16]

La Porte Bottlers

There were at least three bottlers of beer in La Porte in the 1870s.

Michael Noll was the Schlitz distributor starting in 1872, and his son, G. Noll, started a bottling plant for Schlitz beer in 1887. He built a larger plant in 1892 at Washington and Clay Streets. He supplied taverns and stores and would take telephone orders for home delivery.

E. Lindstrom bottled Blatz beer.[17] C.W. Kipphut bottled Crystal Spring beers at a plant located at 509 Main Street.[18] Charles Loetz and H.E. Schultz also seem to have bottled beer in La Porte.

MICHIGAN CITY

CHRISTIAN F. KIMBALL
1840S–1850S

This brewery was located on Seventh Street, on the north side of Michigan Street. According to Carter H. Manny Jr., his great-great-grandfather, Christian F. Kimball, an immigrant from Saxony (then a separate country from Germany) had a small brewery that probably started in the 1840s. He is listed as a brewer in the 1850 census. His older sons, Ernest, Christopher and possibly Charles, operated the brewery in the late 1850s.

Jasper Teaser, another German immigrant, was in the 1850 census as a brewer in Michigan City. He may have worked for Kimball or had his own small brewery.

PHILIP ZORN, 1871–1891
P.H. ZORN BREWING CO., 1871–1918
ZORN BREWING CO. INC., 1933–1935
DUNES BREWING CO., 1935–1938

Philip Zorn Sr. was a brewer in Germany until his death in 1849. Philip Zorn Jr., an immigrant from Würzburg, Bavaria, at the age of eighteen, worked at the Busch & Brandt Brewery in Blue Island, Illinois, from 1855 until 1871. That year, he moved from the management of that brewery to Michigan City and established his own brewery at Jernegan's Hill. Philip also was a city councilman and a founder of the Citizens Bank of Michigan City.[19]

Fred Umlauf's company in Michigan City bottled Zorn's beer.

The brewery grew quickly, surpassing three thousand bbls annual production before 1880.[20] It passed to Philip's son Robert. Philip's second son, Charles, was the treasurer. After building a new brewhouse in 1903, they reached between ten and fifteen thousand bbls annually before the onset of Prohibition. The plant was then used to make Zoro brand soda pop.

The company morphed into the Dunes Brewery after Prohibition. The change of name may have been influenced by a court action against the Zorn Brewing Company in September 1935 on the charge of selling to unlicensed companies.

Zorn and Dunes made Grain State, Golden Grain, Michigan City Cream and Pilsenzorn brands with the motto: "It's Good For You.".

There was a spring-fed well in the building that supplied brewery water. They had a Chicago branch at 2560 South Halsted Street. The office building and some of the brewery were made into now-abandoned offices.

The brewery building is still standing at Michigan Boulevard (now U.S. 35) at Eighth Street. Tours of Robert Zorn's house are available at 225 East Ninth Street.

MISHAWAKA

JOHN WAGNER, 1839–1840s, 1853–1868
C. DICK & BRO., 1870–1875
DICK & KAMM, 1875–1887
KAMM & SCHELLINGER BREWING COMPANY, 1887–1918
ARROW BEVERAGE MFG. CO., 1918–1933
KAMM & SCHELLINGER COMPANY, INC., 1933–1951

Located at 700 Lincolnway West, the building is still standing as the 100 Center mall and is listed on the National Register of Historic Places.

John Wagner founded what some say was a distillery and others say was a brewery in 1839. After a few years, the site was converted into a furniture factory, and Wagner moved to Illinois. He returned to Mishawaka and started another brewery, which he ran from 1853 until 1868, when he sold the enterprise and retired.[21]

We're not sure what hands our subject brewery went through in the next two years, but it was bought by brothers Frank and Clemens Dick in 1870.

An immigrant from Württemberg, Germany, Adolph Kamm bought Frank Dick's interests in the company in 1875. Kamm had been a brewer in

Delphos and Toledo, Ohio, and in Fort Wayne at the Bloomingdale Brewery. By 1879, they were producing thirty-six hundred bbls annually.[22]

Frank Dick left the company that year and moved to La Porte to open another brewery with his son, Frank Jr. Clemens Dick had an interest in what would become the Crystal Spring Brewery in La Porte beginning in 1884.

Kamm bought Clemens Dick's interest in the business in 1887, brought in his brother-in-law, Nicholas Schellinger, and renamed the company Kamm & Schellinger. K&S was incorporated on March 1, 1887, with a capital of $65,000. William Bender Jr. was also a part owner of the company and the secretary. Rudolph Kamm was the brewmaster and foreman.[23]

Schellinger was born in Meuhlheim, near Württemberg, had been working at a hotel in Bremen, Indiana, and was married to Kamm's sister, Amelia. Nicolas's sister, Josephine, later became Adolph's second wife.[24]

The brewery complex had its own maltings, cooperage and charcoal production (for filtering). A 723-foot-deep well was drilled in 1906, but usable water was not found, and it continued to obtain water from the adjacent St. Joseph River. By 1907, it was producing thirty-three thousand bbls of beer annually.

Adolph and Nicolas were quite active businessmen, owning stock in many companies, including the St. Joseph Milling Co. and the Mishawaka Public Utility Co.

The brewmaster around the turn of the century was a German immigrant named Frederick Trippel. Adolph Kamm's son, Clarence J., was born in 1894, and he eventually became the brewmaster. His daughter, Laura, became secretary of the company.

K&S's brands before Prohibition included Red Band, Premona, Private Stock Export and Standard. The motto was: "Challenge the World."

During Prohibition, they renamed the company Arrow Beverage Mfg. Co. and did well during the dry years with a wide line of soft drinks in five- and ten-cent bottles. The signature product was Emral, a "Julepy Mint Drink." They expanded by 1920 to root beer, ginger ale, cherry, strawberry, raspberry, grape, chocolate and Julade (a carbonated orange drink). They also sold distilled water, root beer syrup, Emral syrup and sparkling cider.

Arrow, K&S Special and K&S Special Bock Brew were near beers made during Prohibition with less than half of 1 percent alcohol by weight.

Arrow sponsored a professional football team, the South Bend Arrows, starting in 1919.

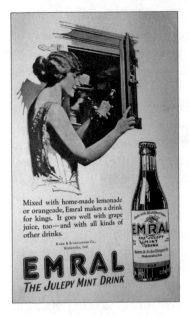

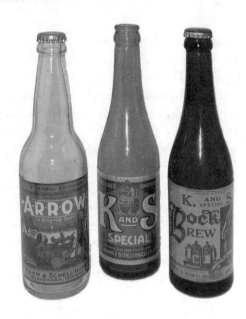

An ad for Emral and three near beers: Arrow, K&S Special and Special Bock Brew.

Arrow's officers were Adolph Kamm Sr., president; Rudolph A. Kamm, vice-president; Laura J. Kamm, secretary; and Albin J. Kamm, treasurer. In 1927, the Schellinger family left the company.

Kamm's is reputed to have been the first brewery in Indiana to resume production after Prohibition.

The company prospered throughout the 1940s. By 1950, it had a 300 bbl brewing size with an annual capacity of 280,000 bbls. Clarence. J. Kamm was by then the owner, along with his brother, Rudolph.

Post-Prohibition brands included Arrow, Black Label, Black Label Special, Kamm's Lager, Kamm's Pilsener, Prize, Skilbru, Bock, Export, Export Dark, Pilsener, Pilsener Light, Gay 90 and Copper.

During World War II, the labels changed from colorful gold foil to a plain one-color motif.

Kamm's closed in 1951 after a fire in 1950. The entire property was placed on the National Register of Historic Places in 1979. Text of the marker reads, "Kamm and Schellinger Brewery is significant in the industrial heritage of Mishawaka and Indiana. First structures built 1853; expansions in late nineteenth and early twentieth centuries. Incorporated in 1883; beer production ended in 1951."

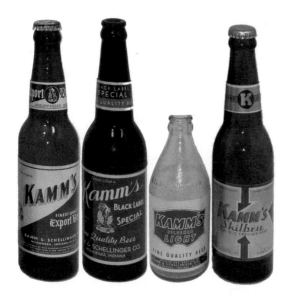

A selection of Kamm's post-Prohibition bottles: Export, Black Label Special, World War II Pilsner Light and Skilbru.

JOHN WAGGONER, P. POPPENDYCK
ABOUT 1868

The 1868 *Mishawaka Business Directory* lists two brewers: "P. Poppendyck and John Waggoner"—both on Vistula Boulevard east of Mishawaka. Given the inaccuracies of these directories, it is possible that Poppendyck worked for Waggoner or vice versa.

LOUIS VAN DINTER
1895–1904

Located on Fourth and Spring Streets, this small brewery never made more than five hundred bbls in any one year. It probably was a small side project unrelated to the family business.

Louis Hubert van Dinter was born in 1851 in Weert, the Netherlands. He died in 1932. His grandfather, Pieter Adam van Dinter, had been renowned in the Netherlands for his organs. His father, Mathieu Hermanus van Dinter, had immigrated to Detroit in 1869, bringing the family with him and immediately starting an organ manufacturer. Louis Hubert moved the family and company to Mishawaka in the 1880s.

The business, Louis van Dinter & Sons, continued making organs into the twentieth century, installing more than thirty organs in at least Elkhart, Fort Wayne, Huntington, La Porte, Logansport, New Haven, Peru, Plymouth, Chicago, Detroit and Louisville.

NORTH JUDSON

NORTH JUDSON BREWING CO., BEFORE 1890–1905
NORTHERN INDIANA BREWING CO., 1905–1908

The trade journal *Ice and Refrigeration* says that the North Judson Brewing Co. bought a fifteen-ton Linde refrigerating machine in 1897, not an inexpensive purchase.

Evidently, 1897 was a year of expansion for the company, as it filed incorporation papers on November 4. It was in Wayne Township, Section 17. Still, it never made more than five hundred bbls per year.

The Northern Indiana Brewing Company was incorporated in 1905 with $30,000 in capital stock. It lasted just three years. One of its brands was Pink Label.

LION BREWING CO.
1904–AFTER 1910

Lion Brewing Company was incorporated in 1904 with $65,000 capital stock. Other than being involved in a 1904 lawsuit about property rights along with the Northern Indiana Brewing Co., there isn't much information available about Lion.[25]

VALPARAISO

SAMUEL IRVIN
1857–1865

Samuel Irvin was a brewer in Chicago from 1854 until 1857, when he "returned to Valparaiso, where he erected the first brewery in the county, and afterward engaged in carpentering. Mr. Irvin was County Assessor three years and Assessor of Boone Township fifteen years."[26]

KORN & JUNKER
ABOUT 1862–1882

This brewery was located on South Campbell Street just south of what are now the Grand Trunk Railroad tracks.

John Junker, an immigrant from Germany, moved to Valparaiso in 1881 and bought half interest in the Korn & Junker brewery.[27]

We do not know if Mr. Korn was or was not related to Julius Korn of the brewery in Crown Point.

"A brewery was started about twenty years ago, now owned by Korn & Junker and producing over two thousand barrels per annum. Another was carried on for some time on the present site of the gasworks but came to an end about 1865."[28]

GEORGE HILLER
1874–1884

In 1879, Hiller sold 468 bbls of beer.[29] This rose to a capacity of about 1,000 bbls annually.[30]

South Bend

CHRISTOPHER MUESSEL, 1852–1874
MUESSEL BROS., 1874–1891
M. & W. MUESSEL, 1891–1893
MUESSEL BREWING CO., 1893–1922, 1933–1936

Originally located at St. Joseph Street and Vistula (where the College Football Hall of Fame now stands), in 1868, the brewery was moved to a 136-acre lot at 1408 Elwood Avenue, near Portage Avenue. The building still stands today (as Drewry's Brewery) and is listed on the National Register of Historic Places.

Johann Christoph (Christopher) Muessel and his family immigrated to the United States in 1852 from Arzberg, Germany, where his father, George Adam Muessel, brewed beer. Arzberg is, not coincidentally, South Bend's sister city.

Their first beers were branded Arzberg Export and Bavarian. They also made distilled vinegar.

Ice at the time was becoming mechanized, and they had a machine that could produce forty-five tons daily. In 1879, they sold 2,129 bbls of beer.[31] By 1893, the capacity was 10,000 bbls.

They incorporated in 1894 with Godfrey L. Poehlman, a son-in-law of Christopher, who owned a hardware store in the city.

Christopher's sons, Edward, William Lorenz and Johann Ludwig Muessel, were active in the company. Ludwig's sons, Adolph and Walter, entered the business in 1893 and 1895, respectively.

South Bend

Gabrielle Robinson said in her book, *German Settlers of South Bend*:

> *The Muessels were a prime example of how the Arzbergers preserved and transplanted their class status. In Arzberg, they were a patrician family who, in the seventeenth century, owned three major buildings in town, two on the market square and another on the* berg, *or hill, overlooking the town. The latter was the large Muessel brewery, and the owners were called the "Berg Muessels."*

In 1865, Christopher Muessel filed a patent for an apparatus that would fill a keg with beer and eliminate the foaming that left kegs partially filled with air. This patent (#331,251) was granted in 1885. He also patented a bottle decanting and cleaning device.

The family built the Grand View Hotel on the original brewery site in 1892.[32]

When Christopher died in 1894, his son Edward became president. Another son, William, became secretary. Grandson Walter G. became the treasurer and manager, and grandson Adolph J. was the superintendent.[33]

Around the turn of the century, Muessel beer was bottled for distribution by the Alex Zipperer Company located at 418 West Madison Street. Zipperer moved to South Bend from Wisconsin in 1888, and when he died in 1899, his son, Otto J., took over the business.[34]

Brands included Nine Star Lager, Bavarian, Burberry Ale, Arzberg Export, Muessel's Export Beer, Silver Edge Beer and Silver Edge Export.

In 1905, the brewery built a housing addition, Muessel's Grove, nearby.

In 1913, it started a professional football team for advertising purposes and hired Knute Rockne, then a college senior at Notre Dame, to organize and coach the team. He and an assistant were paid $500 each for the season. In its first year, the team was undefeated, with a tie against the South Bend Century Club. For the 1914 season, Muessel added the 1913 Indiana champion "Huebners" and renamed the team Silver Edge, a brand Muessel made. Rockne coached both teams and was an assistant coach at Notre Dame.

Henry Muessel was the general manager when he, his fifteen-year-old son William and his chauffeur were shot and killed during a robbery at the brewery office on December 30, 1915. Company president Walter Muessel's son, Robert, was eighteen at that time and in the office when the robbery occurred, but the two masked robbers tied and gagged him instead of shooting him.

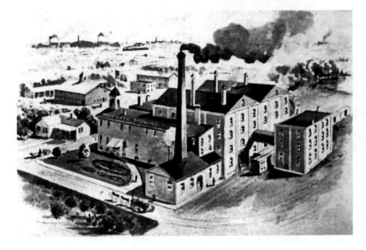

A stylized drawing of the Muessel Brewery building on Elwood Avenue. From *South Bend and the Men Who have Made It* (Anderson & Cooley, Tribune Printing Co., 1901).

After a brief flirtation with soft drinks, Muessel closed in 1922 to wait out Prohibition. It was reopened in 1933 after building a new boiler and bottling house. Unfortunately, Kamm's Brewery and the South Bend Brewing Association opened earlier because they had produced nonalcoholic drinks during Prohibition. Muessel's couldn't catch up to the competition and declared bankruptcy on May 25, 1936. The business and facilities were sold to Drewrys of Canada on October 1, 1936.

SOUTH BEND BREWING CO.
1895–1897

This was a small brewery located at 1622 South Michigan Avenue in a residential neighborhood with a less than five hundred bbl capacity.

SOUTH BEND BREWING ASSOCIATION, 1903–1918
SOUTH BEND BEVERAGE & ICE CO., 1918–1933
SOUTH BEND BREWING ASSOCIATION, 1933–1949

Located at 1636 Lincolnway West, the building is still standing and is listed in the National Register of Historic Places.

The South Bend Brewing Association (SBBA) was formed in 1900 by a consortium of local tavern owners with a total $100,000 investment. They were interested in obtaining beer cheaper than what the Kamm & Schellinger and Muessel breweries provided. Gustav A. Stueckle, an immigrant from Württemberg, Germany, was president. They built a four-story brewhouse on twenty-two acres by 1903 and opened for business.

In April 1904, Gerhard (Jerry) Voelkers, an immigrant from Germany, was named general manager.

A brick bottling house and an $18,000 icehouse were added in 1910. By this time, they had twenty employees. Maximum capacity was seventy-five thousand bbls.[35]

The SBBA was known as the Hoosier Brewery from its Hoosier Beer flagship brand.

During Prohibition, the company was renamed the South Bend Beverage & Ice Company and made soda and Hoosier Brew near beer. The owners also started the Polar Ice & Fuel Company.

In 1922, George Glueckert was the brewer. He had been the head brewer at the Walter-Raupfer Brewery in Columbia City during the 1910s.

An advertisement in the souvenir booklet from the Indiana State Benevolent and Protective Order of Eagles' ninth convention in 1910 said:

> *The company's product is frequently referred to as "South Bend" beer, but its draught or keg beer is sold under the brand of Hoosier Cream and their bottled beer under the brand of Tiger Export. These brands have a flavor that is distinctive and is produced by the use of the choicest barley malt and selected hops skillfully blended.*
>
> *The Association has a superbly equipped bottling department, and its Tiger Export is put up with as much care and in as attractive a style as if it were the costliest champagne. Its highly nutritious and tonic properties particularly commend it to invalids, while it is no less the ideal beverage for the table, and as such, it is immensely popular with the family, hotel and restaurant trade.*

After Prohibition, the SBBA went back to the Hoosier Beer brand and made a pilsner and a bock. Golden Glow and Tiger Export brands added to the lineup. The unofficial motto became: "Good Old Hoosier Beer." George H. Voediach was the post-Prohibition president, Ernest Krueger was vice-president and Gustave Stueckle, one of the original founders, continued as secretary and treasurer.

The SBBA closed its doors in 1949, as Drewrys became the beer of choice in the area. The building still stands vacant, waiting to be reused. As of this writing, a group of investors is working to start a new brewery in the original building.

During cleanup of the old brewery, Stephen Foster, of the new investment group, found a recipe dated December 8, 1911. It called for 11,346 gallons of water, 9,000 pounds of "choice" malt, 6,720 pounds of rice, 6,500 pounds of grits and 40 pounds of salt.

DREWRYS LTD. U.S.A. INC., 1836–1966
ASSOCIATED BREWING CO. (DETROIT, MI), 1966–1972
G. HEILEMAN, 1972–1972

Located at 1408 Elwood Avenue, the building still stands and is in the National Register of Historic Places.

Drewrys was originally Drewry's Lake of the Woods Brewery in Winnipeg, Manitoba. Edward Lancaster Drewry, manager of the Hermchemer & Batkin Brewery (formed 1874), bought that company in 1877, renaming it for himself.

At the end of U.S. Prohibition, he contract-brewed Drewrys at the Sterling facility in Evansville for U.S. distribution. This being successful, he bought the bankrupt Muessel Brewing Co. in 1936 and closed the Canadian operations in 1940.

Muessel's Nine Star and Silver Edge brands were made for a time. Drewrys Old Stock Ale was the flagship for many years. In the 1930s, the brewery also marketed a white soda and a root beer named Drewrys Mountie.

Alfred Epstein, Carleton Smith and Elias Epps were on the boards of both Pfeiffer Brewing Co. (in Detroit) and Drewrys. They were convicted of fraud in 1943 for selling brewing materials and supplies at excessive prices to these two companies. All three were fined and given jail sentences.

Just after World War II, Drewrys issued a series of twelve horoscope cans. Another series from Drewrys featured sports scenes. The brewery's slogans included "Less Filling, More Satisfying" and "The Beer with the Fuggles Hops."

In 1951, Drewrys bought the Atlas Brewing Company of Chicago to provide extra capacity. Atlas had bought the Peter Schoenhofen Brewing Co. in the 1940s, that company dating back to 1861. It closed the Atlas plant in 1962 and bought Piels Brewery of New York.

In the 1950s, brands included Bock, Old Stock Ale, Drewrys Lager, Drewrys Malt Liquor ("A Man's Drink"), Drewrys Extra Dry, Friars Ale, 20 Grand Cream Ale, Old Dutch, Great Lakes, Redtop, Gold Coast and Dorf Bohemian Lager. Drewrys Draft was a popular bottled and canned product in the 1960s.

Drewrys was bought by the Associated Brewing Co. of Michigan in 1963. This company was merged into G. Heileman on August 1, 1972, just three months before its doors closed. There were 350 employees at Drewrys at that time. Peak production was a massive 1,300,000 bbls.

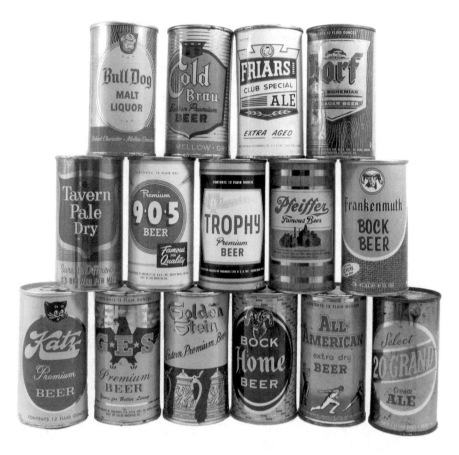

Contract beers made by Drewrys under the Associated/Heileman ownership.

Under the Associated/Heileman ownership, brands made in the South Bend plant included many names of defunct breweries in the parent portfolio. These included All American, Atlas Prager, Bull Dog (for Grace Bros. of California), Champagne Velvet, Cold Brau, Cooks, Dorf, Drewrys Extra Dry, E&B, Eastern, Edelweiss, F&G Supreme, Friars Club, G.E.S., Gold Coast, Golden Stein, Great Lakes, Heritage, Home, K&J, Leisy's, Pfeiffer, Prager, Prost, Redtop, Regal, Salzburg, Schmidt's, SGA, Skol, Trophy, Twenty Grand and Volks Brau. 9-0-5 was made specifically for a St. Louis liquor store chain. Katz was contract brewed for a drugstore chain.

Drewrys brands, as well as many of the others from the Heileman portfolio, continued to be made at the Sterling brewery in Evansville, which G. Heileman had also acquired in the 1972 merger with Associated Brewing.

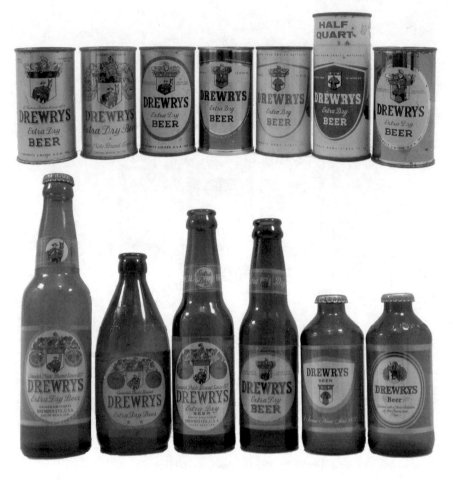

Drewrys Extra Dry Beer was the flagship. The art department continually updated the labels.

The Drewrys brand was sold to the Evansville Brewing Co. (EBC) in 1988, when it bought the Sterling plant. The last Drewrys beer brewed in Indiana was in 1997, when the EBC shut its doors. The brand rights went to the Pittsburgh Brewing Co., and its bankruptcy in 2005 spelled the end of the Drewrys name.

Northeast Indiana

Auburn

BENDER & CO.
ABOUT 1868

The 1868 *Chander & Co.'s Business Directory for Indiana* lists a Bender & Co. brewery in Auburn. Earlier than that, in 1865, a defunct brewery building on north Main Street was converted into a weaving factory.

Columbia City

WILLIAM WALTER, 1869–1872
SCHAPER & WALTER, 1872–1875
H. SCHAPER, 1875–1879
WALTER & RAUPFER, 1879–1893
WALTER-RAUPFER BREWING CO., 1893–1916

The Eagle Brewery, located on the bank of the Blue River on Whitley Street at East Ellsworth Street, was first started by William Walter and partners Attinger and H. Schaper (their first names and the exact relationships are unknown).

Schaper sold in 1879 to Benjamin Raupfer and Fredrick Walter. The latter came from Mansfield, Ohio, and was not related to William Walter. In that year, they sold 1,086 bbls of beer.[36]

Benjamin Raupfer, an immigrant from Baden, Germany, married Mary Meyers (with an "s") in 1869. Twenty years later, Mary's brother, Anton Meyer (without the "s"), bought into the business when Raupfer sold his interest. The Walter & Raupfer name was kept, and in 1893, it was modified to Walter-Raupfer, without adding the Meyer name to the official title.

Frederick Walter went on to build a three-story building downtown that held his hardware store, the Free City Library and a lodge. He was on the town board and was director of the Whitley County Building and Loan Association; the Huntington, Columbia City and Northern Electric Railway; and the Harper Buggy Factory.[37]

Beer was bottled in brown and green quart bottles and in twelve-ounce electric blue bottles. Brands included Select and Extra Export. Maximum production reached nine thousand bbls annually. Throughout the history of the various companies, the name Eagle Brewery was always the common name.

George Glueckert was the head brewer for some years during the 1910s. He went on to become the brewer at Kamm & Schellinger in Mishawaka in the 1920s.

In 1913, the operators abandoned a plan to open a satellite brewery in Gary, Indiana.[38] With the temperance movement growing and local-option laws turning townships and counties around Fort Wayne dry, it must have seemed like a good move to transfer the operation to the Chicago area, where temperance wasn't as much of a problem. Possibly, they realized that national Prohibition was inevitable and the end was coming anyway. (See the Huntington and Wabash Brewing companies for examples of other breweries with a similar dilemma.)

Upon closing, the plant was converted into an icehouse, cold storage and a coal yard.

COLUMBIA CITY

STRAUSSER BREWERY
BEFORE 1882–ABOUT 1887

William Henry Morsches, a native of the Rhine area of Germany, immigrated to Columbia City to be the brewmaster of the Eagle Brewery in 1871. He stayed on as the brewmaster of the Walter & Raupfer Brewery. In 1882, he purchased the Strausser Brewing Company, located just east of the old jail, and ran it for four or five years.[39] He started a bakery after that.

DECATUR

John Dozenbach ran a small brewery in Decatur for a year in 1874. Henry Meyer ran another in 1883.

WILLIAM ROLVER
1874–1879

William Theodore Rolver closed his brewery in Fort Wayne in 1874 and moved to Decatur to open a brewery. His wife, Anna, took it over, probably by inheritance, the next year and ran it until 1879. In that last year, she made 280 bbls of beer.

ELKHART

In October 1905, Frank Wickwire organized the Elkhart Brewing and Ice Company ($150,000 capital stock) with the objective of building a brewery in Elkhart. We have found no evidence of this project coming to fruition.

GOSHEN

CEPHAS HAWKS
1850S

The town of Waterford Mills, on the south edge of Goshen, was first settled in 1833 as Waterford, Indiana. By 1850, the family of Cephas Hawks operated a sawmill, woolen mill, store, tannery, ashery and brewery.

Waterford Mills died out by the 1860s, doomed when the railroad went to Goshen in 1852 but was not built southward. By the time the Cincinnati Wabash & Michigan Railroad built through the area in 1876, Goshen was by far the larger town.

Filmmaker Howard Hawks was Cephas's grandson.

HUNTINGTON

HUNTINGTON BREWERY
1860S

There was a Huntington Brewery in Goblesville (about six miles north of Huntington). Roy Goble started the settlement in 1855, and his sons owned the brewery and many other stores and small factories.

BOOS & PHALER, 1866–1870
JACOB BOOS, 1870–1890
CARL LANG, HUNTINGTON BREWERY, 1890–1901
HOCH & KNIPP, HUNTINGTON BREWING CO, 1901–1908, 1911–1918

This brewery was located at 147–157 East Tipton Street at Front Street. Though it was started by Jacob Boos and George Phaler, Boos became the sole proprietor four years later. In 1879, he made 889 bbls of beer.[40] By 1887, he made from 2,000 to 5,000 bbls annually, depending on whose report you reference.

Boos sold the brewery in 1890 to Carl Lang. The building burned on October 18, 1900. Lang sold the brewery to Hoch and Knipp for $45,000 but had to sue them to get the money after they paid him only $5,714.20.

Brands were Golden Drops, High Card and Silver Cream. The brewery also produced a malt tonic medicinal beverage.

Henry W. Hoch moved from Marquett, Michigan, where he had a bottling plant for making soft drinks and bottling the beer for the local brewery. He was the president and treasurer of the new company. His partner was William P. Knipp. They incorporated in 1901 with $100,000 capital stock.[41]

After closing the brewery for a time in 1908, when the county went dry, they re-formed in Fort Wayne for a period. Lager was shipped to Fort Wayne for distribution, thus getting around the dry laws in Huntington. They did reopen the Huntington brewing facility in 1911, but that ran afoul of the local constabulatory.

Maximum capacity was 18,000 bbls.

During Prohibition, the plant was converted to the making of caffeine, tannin, soaps, chemicals and nonalcoholic malt tonic. It did not open again as a brewery.

According to the *Indianapolis Star* of June 13, 1911:

> *Hoch and William P. Knipp, proprietors of the Huntington Brewery, today were sentenced to thirty days in jail each for illegal sale of liquor, though Judge S.E. Cook suspended the sentence on their showing that they employed a number of men about their plant who would be thrown out of employment if they were deprived of their liberty.*

HERBERG BROS.
1874–1884

Brothers John and Adam Herberg, immigrants from Hesse, Germany ran this small establishment for ten years, making from 106 bbls to 1500 bbls of beer annually.

Adam shows up again in 1914 as a manufacturer of orange, strawberry and lemon soda.[42]

KENDALLVILLE

JOSEPH BECKER
1850s

Joseph Becker, a German immigrant, had a brewery on the west side of Bixler Lake (possibly at 920 Minor Street). Workers cut ice from the lake for refrigeration.

SCHWARTZKOPF & AICHELE, 1867–BEFORE 1874
SCHWARTZKOPF, AICHELE, BEEK, SEIFERT, & HEINIKE, BEFORE 1874–1877
SEIFERT & WICHMANN, 1877–1879
A.C.F. WICHMANN, 1879–1881
HENRY C. PAUL, 1881–1885

Louis Schwartzkopf and George Aichele sold their brewery to Francis J. Beek, William Seifert and someone named Heinike.

In 1877, Seifert and Albert Christian Friedrich Wichmann, an immigrant from Lyuchen, Brandenburg, bought out the other two owners, with Wichmann and Seifert each ending up with half of the business. Upon the death of Seifert, Wichmann became the sole owner. Production never exceeded the 1,068 bbls brewed in 1879, just before Wichmann sold the business to Henry C. Paul. Wichmann stayed on as the brewery manager.[43]

Paul had been a partner in a cement and stone company in Fort Wayne. In 1885, he became president of the newly reorganized Old National Bank. This may explain the brewery closure.[44] Later, he was a principal in a natural gas company and a streetcar company. All of these businesses were in Fort Wayne. He was still president of the bank as late as 1907.[45] He was also on the executive committee of the Red Cross War Fund Drive in 1917.[46]

JOHN GEORGE KRATZER
1874–ABOUT 1877

This small brewery probably never made more than 150 bbls of beer in any one year.

LIGONIER

LIGONIER BREWING CO., 1875–1882
ANDREW WALDER, 1882–1893
DRACHTER & CO., 1893–1897
CHARLES FRANKE, 1897–1899

The Ligonier Brewing Co. was started in 1875 by someone whose name time has forgotten. Andrew Walder ran the brewery from 1882 to 1893, producing about one thousand bbls annually.

Walder sold the operation to Drachter & Co., which seemingly did not do well, as production dropped to five hundred bbls.[47]

Drachter & Co. sold it in 1897 to Charles Franke. He closed the business in 1899.

NEW HAVEN

STRASBOURG BREWING CO.
1882–1904

Owned by Mack and Gabet, this brewery was located on "Summit St. west of the bridge."[48] Production never exceeded five hundred bbls per year.

WABASH

F.A. RETTIG, 1853–1866
RETTIG & ALBER, 1866–1896
WABASH BREWING CO., 1896–1915

Near what are now Cass and Alber Streets, the Wabash Brewing Company traces its roots to a backyard and two brothers-in-law. Franz Anton Rettig,

an immigrant from Hesse-Cassel, Germany, where he was a brewer, formed a partnership with Wintz Stanley in 1853. Part of this business was a brewery located in what was said to have been a shed behind the Rettig home.[49]

Phillip Alber, an immigrant from Furstenhum, Lichtenstein, had a small home brewery in Wabash that he closed to join his brother-in-law, Rettig, in 1866.[50]

Together, they built a bigger facility on two and a half newly purchased acres, and the firm flourished. From an output of 1,126 in 1879, it reached 20,000 bbls annually.[51]

Rettig died in 1896, and Alber continued to run the brewery as the Wabash Brewing Company. Born in 1818, Alber was still active in the brewery in 1901 and died in 1906.

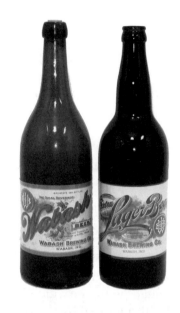

Wabash Brewing Co. bottles: Wabash Beer and Extra Lager Beer.

His son, Jacob Alber, continued the brewery after Phillip's death. Another son, Karl, also worked at the brewery.

Brands were Wabash Beer and Extra Lager Beer.

On December 21, 1909, the *Fort Wayne News* printed the following:

> GETS AROUND THE LAW
>
> THE WABASH BREWERY SELLS THROUGH FORT WANE MAN
>
> People Wanting Home Beer Send Orders Here and Delivery is Then Made.
>
> The recent decision of the supreme court, construing the Beardsley law as preventing Indiana breweries from retailing beer, hit the Wabash Brewery rather hard, but through a clever scheme, in which Albert Weber, of this city, acts as agent, the concern expects to still retain its large Wabash trade and not suffer at all as a consequence of this decision. Under the new plan Wabash parties are to give their orders to Mr. Weber, who is the proprietor of the Weber hotel here, and he, in turn, will deliver the goods in Wabash free of charge.
>
> The plan has been broached to the Wabash customers of the company in the following advertisement inserted in the newspapers there: Wabash Beer For Sale. Since the decision of the supreme court, holding that a brewery cannot sell to a customer, I am buying and will continue to buy beer of the manufacture of the Wabash Brewing company in bottles and cooperage.

I am prepared to sell such beer at my licensed place of business at Fort Wayne to you if you should see fit to favor me with your orders which will have my attention. All goods will be delivered to you in Wabash free of charge, for delivery. I have employed Sam Snyder to solicit and collect for me in Wabash. Thanking you in advance for any favors, I beg to remain, Yours respectfully, ALBERT WEBER, Fort Wayne

There doesn't seem to be any connection between Franz Rettig of Wabash and George Rettig of Rettig & Cole in Peru or to the Franz Rettig who started the brewery in Louisville that eventually became Oertel's.

As part of the temperance movement, Indiana put into effect the Beardsley Law in 1907. This said that customers could buy alcohol only from licensed dealers. One could not buy beer directly from the brewery. Albert Weber's plan to circumvent this law didn't get anywhere because Weber was blocked by the prosecutor in Wabash.

Still, the brewery did soldier on. In 1915, the Indiana State Board of Health approved Nectar Foam, produced by the Wabash Brewing Co., as a legal temperance beer, having less than 0.5 percent alcohol. The company, though, closed that same year, and the building became the Wabash Packing Company.

WATERLOO

A defunct frame brewery building, north of the creek in Waterloo, was moved across the street and converted into a house in 1882.

VERA CRUZ

SAMUEL GEHRING
1874–1875

The *Register of United States Breweries, 1876–1976,* lists a brewery in Vera Cruz (Wells County, southeast of Bluffton) owned by Samuel Gehring. It closed about 1875. Production was only one hundred bbls annually.

Fort Wayne

COMPARET & COQUILLARD
BY 1834

Way back before 1818, Francis Comparet, his son-in-law, Alexis Coquillard, and Benjamin B. Kercheval were the agents for the Fort Wayne station of John Jacob Astor's American Fur Company.

Alexis Coquillard, born in Detroit in 1795, is considered one of the founders of the city of South Bend. That area was first settled by two competing fur traders, Pierre Navarre in 1820 and Coquillard in 1824, when he moved his family from Fort Wayne.

Comparet stayed at the Fort Wayne location, called Little St. Joseph's Station. The South Bend branch became known as Big St. Joseph's Station, both located along rivers named for St. Joseph.[52] They continued to operate as a partnership.

The very first issue of the *Fort Wayne Sentinel*, dated June 14, 1834, mentioned Comparet & Coquillard, "brewers of good strong beer."[53]

CARL PHENNING, 1853–?
GEORGE MEIER, ?–1862
SUMMIT CITY BREWERY, 1866–1880

Until 1874, this brewery was located on the east side of Harrison Street, between Berry and Wayne Streets. From 1874, it was at 232–244 West Main Street.

Carl Phenning erected the Phenning Brewery in 1853 on the east side of town. George Meier ran the business after Phenning died.

In 1860, the business was leased to John George Horning, who bought it outright in 1862, renamed it and expanded onto the two adjacent lots. He moved to a new building a block north in 1874. Production there reached twenty-five hundred bbl per year.

Fred Kley was the proprietor by 1875. He also owned a cooperage that made "Casks, Kegs, Tanks, Cisterns, $c."[54] Possibly because of these other business interests, production had dropped to forty-one bbls in 1879, the year he closed the brewery.

HERMAN HARTMAN
1853–1875

Another commercial brewery in Fort Wayne, located at 128 East Washington Street, was founded in 1853 by Herman C. Hartman, a thirty-one-year-old fireman in the Alert Engine Co. He lived next door at 134 East Washington. He kept his job at the fire department

The *City Directory for Indiana* (1859) lists Adolph and August Hartman as brewers at the Herman Hartman brewery. Herman died in 1896.

STAR BREWERY, 1853–ABOUT 1871
WASHINGTON ST. BREWERY, ABOUT 1871–1882

Located on the northwest corner of Wayne and Monroe Streets, this brewery was moved between 1871 and 1874 to the southwest corner of Washington and Wabash Avenues.

A Mr. Stultzman started the Star Brewery in 1853. It passed to a Mr. Guntner, who leased the plant to Jacob Kegg until it was sold to Martin Schmidt in 1868. The following year, it was sold again to Linker, Hay & Co. (Valentine Linker, Amandus Hay and Anthony Dreyer). August Schmidt, Frederick Geisel, Charles Bilser, Peter Speilmann, Henry Fraig and Emanuel Giesen were brewers.

The Star plant proved to be inadequate for the volume, so a move of location and name was made sometime before 1874.

The *Fort Wayne City Directory* of 1876 lists "Linker, Hey & Co. [John V. Linker, August A. Hey and Anton T. Dreyer], Proprs Washington Street Brewery." In 1879, they sold 1,616 bbls of beer.[55]

Fort Wayne

STONE BREWERY AND MALT HOUSE
1855–ABOUT 1875

This brewery was located on the southwest corner of Water (now Superior) and Harrison Streets.

Herman H. Niermann, an immigrant from Munster, Germany, moved to Fort Wayne in 1840. He constructed the market house and town hall for Fort Wayne in 1853 at a cost of $2,800.[56]

Two years later, he erected the Stone Brewery. Upon Herman's death in 1873, the business was inherited by his brother, Martin, who had been a brewer at Stone since at least 1859 and was a member of the Mechanics Engine and Hose Company since 1856.

Herman's daughter, Frances Amelia, married Charles F. Centlivre, the son of Charles L. Centlivre, in 1886.

BLOOMINGDALE BREWERY
FRANCIS J. BECK, 1856–BEFORE 1868
BECK & STOTZ, BEFORE 1868–1869
U. STOTZ & CO., 1869–1870
CERTIA AND RANKERT, 1870–1873
EDER, CERTIA & CO., 1873–CA. 1877
LUTZ & COMPANY, CA. 1877–1880

This brewery was located on Wells Street (Lima Plank Road) at Huffman Street (at the feeder canal). Bloomingdale is the name of the Fort Wayne neighborhood just north of downtown.

In 1856, Francis J. Beck, born in Großeislingen, Württemberg, Germany, in 1829, built a brewery on Fort Wayne's north side. He brought in Ulrich S. Stotz before 1868. Beck left the firm in 1869 and died in 1878.

Adolphus Kamm was a brewer here but left in 1870 to buy into the C. Dick Brewery in Mishawaka—later to become Kamm & Schellinger.[57] Stotz sold the company to Peter Certia and Charles Rankert in 1870 and became a wine merchant and restaurateur.

Fred Fiegel, Frederick Hunsche, John Strausz, Killian Zeller and M.F. Halm were the brewers between 1870 and 1877. Charles Stuckmau was the brewery foreman.

About 1877, the company was sold to Lutz & Company, which operated it until 1880. During all these changes of ownership, the property on which the brewery sat remained with Beck's heirs.

Maximum sales were almost five thousand bbls, but this slipped to thirty-three hundred bbls the year before it closed.[58]

ALBACHTEN & ROLVER
1858–1874

Hubert A. Albachten and Theodore R. Rolver started this brewery, located on the west side of Monroe between Berry and Wayne Streets. By 1874, Rolver was the sole owner.[59] He closed the brewery here and moved to Decatur, Indiana, to start a new brewery.

WAYNE ST. BREWERY
1874–1876

Henry Hubach & Leonhard Friedrich could not make this brewery work. It had a fairly large capacity of 1,630 bbls. Joseph Seltz was the brewer.

EAGLE BREWERY
1874–1882

John M. Reidmiller was the owner of this small brewery, located on the southeast corner of Taylor and Reidmiller Streets on Fort Wayne's residential southwest side. The immediately adjacent Reidmiller and Eagle Streets were named after our subject before 1900, when the area was platted for houses.

Reidmiller closed the brewery in 1878 and leased the buildings to the Buckeye Lager Beer Co. of Toledo, which used them for storage. By 1903, he was an agent for Centilivre Brewing Co.

FRENCH BREWERY, 1862–1895
C.L. CENTLIVRE BREWING CO., 1895–1918
CENTLIVRE ICE AND COLD PRODUCTION STORAGE CO., 1918–1933
C.L. CENTLIVRE BREWING CO., 1933–1961
OLD CROWN BREWING CORP., 1961–1973

Located on Spy Run Avenue near State Boulevard (then between the feeder canal and the St. Joseph River on the east branch of Lima Plank Road), the Centlivre brewery was founded in 1862 as the French Brewery by immigrants from the Alsace region of France, Charles Centlivre and his brother, Frank. Charles came to America in 1847 and previously had breweries in Louisville and in McGregor, Iowa.

Fort Wayne

According to the *Fort Wayne Daily Gazette* of August 10, 1881:

> *Mr. Centlivre, proprietor of the French brewery, while he has a good business and is generally prosperous, feels that Fort Wayne people, especially all the business men, should be more liberal in their patronage, and especially more generous in their comments of a home industry which brings so much money to the town.*
>
> *Mr. Centlivre pays, on an average, twelve hundred dollars per month to the government in the shape of taxes, and employs a large number of men, who must necessarily spend their money here. Mr. Centlivre makes a quality of beer equal to any of the brands imported from outside cities, and it would be a credit to the city for the people to call for it in preference to any other, in order to give encouragement to a worthy home enterprise. Mr. Centlivre has been in business here for many years and has proven himself to be a good and very enterprising citizen.*
>
> *We are not urging the consumption of beer, but so long as people will drink it they should use the article, which is made at home.*

A malting house was built in 1868 and a bottling building in 1876. By 1879, they were making almost four thousand bbls annually.[60] The main brewery succumbed to fire in 1882 and was rebuilt by the summer of 1884. A larger fire hit in 1889, but everything damaged was quickly rebuilt.

Brewers listed in the 1895 *City Directory* included Michael Funck, William Gobb, John Kramer, Frank Peltier, Christian Schadel, Frederick Wagner and Killian Zeller.

The Centlivres operated a horse-drawn railroad line, which was sold to the city in 1894. They also built a public park near the brewery that had horse racing and boat rides.

A statue of Charles Centlivre was made (with his foot on a barrel) and placed on the roof of the main building when it was reconstructed after the 1882 fire. Wind blew it off the roof in 1964, and it is now at Hall's Gas House Restaurant on Superior Street in downtown Fort Wayne.

Pre-Prohibition brands included Export, Bohemian, Kaiser, Kulmbacher, Münchner, Münchner Special Export, Nickel Plate, Pale, Old Reliable and Classic.

Kaiser Beck Co., of Bremen, Germany, sued Centlivre in 1897 to halt the use of the name "Kaiser" as a brand of Centlivre beer. The matter was settled out of court with no payments, but Centlivre did drop the Kaiser name.[61]

At one o'clock in the morning on May 30, 1905, a gang of probably seven masked men broke into the Centlivre offices, tied up the night watchman and blew open the safe. The explosion was heard nearby but ignored. By three o'clock, George Keller, the night watchman, had escaped his bindings and made his way to a nearby home, where the police were called. The perpetrators were never found.[62]

Charles Centlivre died in 1911.

Just before Prohibition, the brewery made three thousand bbls annually. The company was renamed to Centlivre Ice and Cold Production Storage Company during Prohibition. Like many breweries, it made a near beer. It was named "That's It," and Centlivre made it for only two years. The brewery also made Centlivre Tonic and Birch Beer, both before and during Prohibition.

Post-Prohibition brands included Bock, Old Reliable, Classic, Nickel Plate, Little Nick, 1862, Old German, Extra Pale, Special and Holiday Special. The brewery introduced the Old Crown brand in 1939, which included beer, ale, and Bock. In 1951, it took over the Hoff-Bräu brands. The Alps Brau name started in 1957.

A major $1.5 million expansion was made in 1950, bringing capacity up to 250,000 bbls.

Centlivre merged with Chris-Craft in 1961 and was renamed Old Crown. Capacity at that time was 125,000 bbls. It had a motto: "Lazy Aged." Marjorie Aubrey was general manager. The new company was soon sold to its employees. Old Crown's brands included Nickel Plate, Old Crown and Van Merritt ("The World's Most Honored Beer").

In the early 1960s, Renner Brewing of Youngstown, Ohio, was in difficulties because its garage was damaged and its delivery trucks were out of operation. The company laid off all the distribution and sales staff and counted on a wholesale distributor instead. In 1962, it shut down entirely and sold the brands Old Oxford, Old German, Golden Amber and Kings Brew to Old Crown. For eleven years, that beer was shipped back across Ohio.

Old Crown closed its doors on December 1st, 1973. All the brands were sold to Peter Hand Brewery of Chicago. Nothing remains of any Centlivre/Old Crown buildings now.

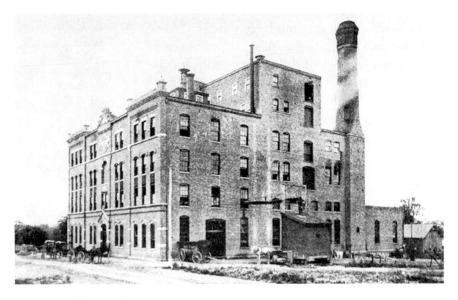

The Berghoff Brewing plant.

BERGHOFF BROS., EAST END BOTTLING WORKS, 1882–1885
HERMANN BERGHOFF BREWING CO., 1885–1889
BERGHOFF BREWING CO., 1889–1910
BERGHOFF BREWING ASSOCIATION, 1910–1918
BERGHOFF PRODUCTS MFG. CO., 1918–1933
BERGHOFF BREWING CORP., 1933–1954

This brewery was located at 1025 Grant Street at Washington Boulevard. Herman Joseph Berghoff emigrated from Dortmund, Germany, in 1870 when he was only seventeen. His younger brother, Henry, joined him two years later, and by 1874, they had settled in Fort Wayne.

By 1882, they had bought the East End Bottling Works (not then a brewery) with brothers Hubert (who came in 1880) and Gustavis (Gustav), who joined the company when he arrived in 1883. It's thought that they also had a saloon at 274 Calhoun Street.

Henry was appointed treasurer of Fort Wayne in 1884 and became somewhat less active in the business.[63]

They incorporated in 1885 (some sources say 1887) with $100,000 capital and set about building a brewery structure to supplement the bottling plant. A fire on August 22, 1887, caused $50,000 damage, but the Berghoffs immediately ordered replacement equipment and rebuilt.

On June 1, 1888, they produced their first beer, a Dortmunder-style lager that used imported German hops (as did virtually all breweries at that time). They made twelve thousand bbls that first year. By 1890, output was ninety thousand bbls.

In 1891, they added a 50- by 170-foot addition to house a "beer vault" and a second ice machine. In total, they spent $100,000 on this expansion. Another ice machine in 1901 and a bottling house in 1902 were other major additions.

Chicago played a big part in the Berghoff story. Berghoff beer was sold at the World Columbian Exposition in Chicago in 1893. Well, not actually at the fair, but at a stand outside the fairgrounds gate. Herman wanted to move into the Chicago market but couldn't get a wholesale license. He got a restaurant license instead and opened the Berghoff Restaurant at State and Adams Streets in the Loop to gain a foothold in Chicago. It became an institution and was open until 2006. (It reopened in 2009.)

William Breuer, who apprenticed in his native Westphalen, Germany, was the president from the time of incorporation until he resigned in 1894 to start a "brewery, either in Fort Wayne or elsewhere in a few months." No documentation remains to show whether this effort came to fruition.[64]

Henry J.'s son, Henry C. Berghoff, was elected city controller of Fort Wayne in 1896 and mayor in 1902. Later, he founded the German-American National Bank on Maumee Avenue.

Bergo Orange-Tang, "a snappy bubbling drink" made by Berghoff during Prohibition.

Pre-Prohibition brands included Dortmunder, Dortmunder Doppel, Extra Pale, Holiday Beer and Bock.

In the early 1900s, a new beer from the plant was a Munich lager with a stronger flavor than a Dortmunder. We might be amused now that they named it Salvator because that is the name of a very famous Dobbelbock beer from Germany, but the Berghoff Salvator was called "a select beer for the table and for family use." Starting in 1908, a special Holiday Brew was made each winter.

In 1910, Hubert retired, and Gustav became president. At that time, the company was rechristened the Berghoff Brewing Association.

In 1913, Martin C. Norton of the T.M. Norton Brewery in Anderson became the manager of Berghoff. He was made secretary of the company when Stephen B. Fleming became the manager in 1915. Brewers around this time included Doehla Christian, Charles Held, Fred Hutt, Fred Kiel, Pete Marcher, Alois Maurer, Fred Roth and William Seisling.

At the start of World War I, the company slogan changed from "A Real German Brew" to "A Real Honest Brew." In 1917, the plant's capacity was over 180,000 bbls. It was the largest shipper on the Nickel Plate Railroad.

Prohibition, of course, changed everything. First, the company was renamed the Berghoff Products Mfg. Co. The beer was replaced by Bergo soft drink and Berghoff Malt Tonic. Its most notable "dry" drink was a root beer that is still being made today by Sprecher Brewing of Wisconsin. It also produced Grape-Tang, Lemon-Tang, Orange-Tang, birch beer, Bergo Cola and ginger ale. Its near beers were named Berghoff Light Brew, Berghoff Dark Brew and Double X.

The restaurant in Chicago thrived during Prohibition and did not sell alcohol as so many others did. It was issued Chicago Liquor License #1 when Prohibition ended.

Berghoff flattop cans of the 1950s: 1887 Pale Extra Dry Beer, Berghoff Light Beer, Ale, Dark Beer and Malt Liquor.

The company was bought by a Chicago company after Prohibition, removing it from family control for the first time. Gustavis's sons continued the family business, opening the Hoff-Brau Brewing Company just a block away.

Post-Prohibition brands included Dortmunder, Pale Dortmunder, Dark Dortmunder, Bock, International Club, Malt Liquor and Stout Malt Liquor. The brewery sometimes used the motto: "The beer that made itself famous."

By 1954, the company was brewing Berghoff Beer and Ale, Berghoff 1887 Beer and Bock, Malt Liquor and Hoff-Brau Beer and Ale

(which had returned to the Berghoff portfolio when Hoff-Brau shut down in 1951).

The brewery was sold to Falstaff on April 12, 1954. At this time, the facility had a capacity of over 500,000 bbls per year.

The sale was for the brewing plant and buildings only, with the Berghoff family company keeping the name and recipes. Almost immediately, they contracted the Joseph Huber Brewing Co. in Monroe, Wisconsin, to make beer under the Berghoff name.

The Berghoff name was sold by the family to Walter Brewing in Pueblo, Colorado, and it subsequently went to Huber. Huber went "regional" with Berghoff Original, Dark, Red and Oktoberfest in 1994. The Berghoff name still is being used on a wide line, including Hefe-Weizen, Pale Ale, Genuine Dark, Famous Bock, Classic Pilsner and Premium.

BERGHOFF BROTHERS BREWERY, INC., 1934–1934
HOFF-BRAU BREWING COMPANY, 1934–1951

Immediately after Prohibition, Gustav Berghoff's sons started this new brewery just a block away from the Berghoff brewery that the family had recently sold. This site, Glasgow Avenue at Dwenger Street, had been the location of the Rub-No-More soap company that Gustav had owned since 1887. He sold that business to Procter & Gamble in 1925 but kept the building, which had became vacant during the Great Depression.

The company was originally named Berghoff Brothers Brewery, Inc., but that was changed almost immediately to the Hoff-Brau Brewing Co.

A 1934 booklet advised parents that "growing children need a small glass [of beer] with every meal." Its motto was: "The beer without a headache." In 1940, Hoff-Brau was the exclusive beer provider to the Indiana State Fair. John A. Berghoff was the president of the corporation and had served as the president of the National Brewers' Association.

The main brands were Hoff-Brau Stout, Golden Ale, Bock, Beer (lager), Muenchener, Pilsener and King Kole Pilsner. In 1936, the brewery added a Gold Star brand. Hoff-Brau brands in the 1940s also included Dry Pilsener Beer and Brewers' Best. The brewery produced beer in cans starting in 1953.

In the end, the brewery just got old; the equipment and plant needed updating. The Hoff-Brau brand after World War II, despite interesting sports-oriented advertising, seemed stodgy. The national brands were taking a large share of the market. Rather than spend money on a complete

refurbishment, the family retired and closed the doors. The Hoff-Brau name and recipe went to the Berghoff Brewing Co., which made Hoff-Brau Ale and Beer until 1954. After Falstaff bought Berghoff, Hoff-Brau ended up being brewed by Walter Brewing of Pueblo, Colorado.

FALSTAFF BREWING CO., 1954–1975
S&P, 1975–1990

Johann Adam Lemp reputedly made the first lager beer in the western hemisphere behind his St. Louis grocery in 1838. That's debatable, but his beer was popular and his company prospered. He renamed the beer Falstaff in the 1840s and was very successful until closing for Prohibition in 1918.

In 1920, Joseph Griesedieck stepped in and bought the Falstaff trademark from the Lemp family for $25,000. In the next three years, the company bought breweries in Omaha and New Orleans. It went on a buying spree again in the 1950s with purchases of breweries in San Jose (1952), Berghoff in Fort Wayne (April 12, 1954), Galveston and El Paso (1955). These additions made Falstaff the fourth largest brewer in the United States, with a total capacity of over 3.5 million bbls.

Falstaff kept the staff from Berghoff but moved Frank King from St. Louis to be the head brewer. To be accurate, we must say that the brewery facility was leased from the Berghoff family from 1954 until the purchase was completed by Falstaff in 1964.

Ballantine, Haffenreffer and Narragansett were bought by Falstaff in the 1960s, and production moved to Fort Wayne.

Haffenreffer & Co. was formed in 1870 and moved from Boston in 1964 to Narragansett, Rhode Island. The sixteen buildings of the brewery in Boston were abandoned until 1983, when they became an industrial park. This became the home of the Boston Beer Company (Sam Adams) in 1985. The Falstaff acquisition of Narragansett in 1965 resulted in an antitrust suit that ended up before the U.S. Supreme Court.[65]

The Falstaff Corporation was bought by Paul Kalmanovitz's S&P brewing conglomerate (General Brewing) in 1975. At that time, it made 1.2 million bbls annually at the Fort Wayne plant. The conglomerate moved the corporate headquarters to Fort Wayne in 1977.

S&P moved Ballantine from Newark, New Jersey, and the Narragansett brands from Cranston, Rhode Island, to Fort Wayne in 1979 and 1982, respectively.

Sales of Falstaff slid dramatically starting in the 1970s. By 1976, the Fort Wayne brewery was operating at 60 percent capacity, putting out an

estimated 900,000 bbls. Falstaff moved production to Fort Wayne as it closed its home brewery in St. Louis, as well as its other purchased breweries (San Francisco, San Antonio, New Orleans, El Paso, San Jose, Galveston, Newark, Omaha and Cranston, Rhode Island). The Fort Wayne plant went back to full capacity by 1982, when it was the sole producer of most of the products in the Falstaff library. All of S&P's operations were in Fort Wayne by 1985.

Many have questioned Kalmanovitz's methods, and lawsuits from stockholders, competitors and the government were continuous.

In one strange move, the company announced plans to close the Fort Wayne brewery in 1985—just as the entire company had moved to Fort Wayne with 160 new jobs in administration and operations. The business was to be moved to the Pearl Brewery in San Antonio. The entire idea was scrapped after a distributor, Best Brands of New York, sued for $52 million for price gouging because freight costs would be higher from Texas than Indiana.

Specialty labels included M*A*S*H 4077, Polska Piwo and generic Beer: "Ask for it by name." The brewery also made Haffenreffer Malt Liquor and Feigenspan beers. It brewed Pulaski Piwo and Say Double K Beer for a marketing company in Bay City, Michigan. The top of the cans say, "Brewed and canned by Great Lakes Brewing Company, Fort Wayne IN." The S&P conglomerate often used "interesting" names on its regionally distributed brands. Walgreens sold Old Heidel Brau Lager in cans also labeled Great Lakes.

Paul Kalmanovitz died in 1987, which was the death warrant for S&P. Embroiled in lawsuits, it eliminated the advertising budget to maximize profits before closing on January 7, 1990.

In the 1990s, Labatt's tried to purchase the Fort Wayne brewery, but the deal never happened. The equipment in Fort Wayne went to China's Pabst facility in 1993. The property at 1025 Grant Avenue was sold by the city in 2001. S&P's holdings were bought by G. Heileman, and the Falstaff brand became part of the Pabst family.

By 2001, the sales of Falstaff had dropped to only twenty thousand bbls. By 2004, this was down to fifteen hundred bbls. Pabst stopped using the Falstaff name on April 15, 2005.[66]

North Central Indiana

ARGOS

ARGOS BREWERY
ABOUT 1873

According to the *Rochester Union Spy* of March 6, 1873, "The Argos Brewery is for sale. Eidson and Osborn are endeavoring to purchase it. They mean business." The *Spy* may have been talking about Jacob W. Eidson, a doctor in the county, the coroner and later a state representative. There are no records of the start, end or exact location of this brewery.

BREMEN

BREMEN BREWERY
1872

This brewery was located on the east side of East Street at Bike Street. It is noted on an old Bremen map as Bauer & Hindersheet, Proprietors.

HUGO WOLFF
1875–1884

Hugo Wolff's brewery sold 277 bbls of beer in 1879.[67]

HOOSIER BEER

BOURBON

EARNEST ECKELSTAFFER
1859

According to *The Story of Marshall County* by Norris Harris: "In 1859, Earnest Eckelstaffer had a distillery and brewery two miles east and a quarter mile south of Bourbon. This is the only one that ever existed in Bourbon Township."

DELPHI

DELPHI BREWERY
ABOUT 1868

George Shillinger was the proprietor of this brewery, located near the Deer Creek Bridge in Delphi.[68]

JONESBORO

ROBERT CORDER
ABOUT 1868

Robert Corder owned this brewery located in the small village of Jonesborough, which later simplified its name to Jonesboro.

LOGANSPORT

JACOB KLINE
1847–1870S

Originally located at the Northeast corner of Ninth Street and Erie Avenue, this brewery soon moved to the North bank of the Wabash River between Second and Third Streets. It moved again, in about 1865, to Fifteenth Street north of Erie Avenue.

Jacob Kline was born in 1817 and died in either 1887 or 1893. He had a public house in Logansport about 1855.[69]

CHARLES LUY
SCHAEFER & MARKERT
1855–AFTER 1859

This brewery was located on Columbia Street west of Sixth Street. Charles Luy was one of a succession of operators of a distillery and cooperage on the Eel River until he ended that profession in 1855 to build a brewery near his residence. He sold that brewery business to Gotleib Schaefer and Frederick Markert, "who soon found it was not a paying investment and it passed into innocuous desuetude."[70]

AUGUST FROST, 1866–?
JOHN HURBNER, ?–1874
JOHN MUTSCHLER, 1875–1889
LOGANSPORT BREWING CO., 1889–1894
COLUMBIA BREWING CO., 1894–1918
K.G. SCHMIDT BREWING, 1935–1951

August Frost founded his brewery in 1866 on the north side of High Street (412–416 High Street), west of Fifth, and sold it some years later to John Hurbner. John Mutscheler acquired the business in 1875 and, in 1879, sold a not-unsubstantial 1,044 bbls of beer.[71]

Eugene Prager and a complement of businessmen purchased the enterprise in 1889 and renamed it the Logansport Brewing Company, with Prager as president and manager. Capacity in the 1890s was reputed to be about twelve thousand bbls.

Logansport Brewing was sold in 1894 to Ferdinand Krebs, George Schmidt and three brothers: Frank, August and William Binz.[72] August left the company that same year to become a traveling salesman for another company.[73]

John G. Kelp was the first manager of the Columbia Brewing Company. John N.C. Woefel, an immigrant from Rehau, Germany, was the brewer until he moved to the Indiana Brewing Association of Marion in 1897.

By 1913, the facility had been greatly enlarged with an ice plant, and it employed forty-five people processing twenty-five thousand bushels of barley and 500,000 pounds of corn grits to produce twenty-five thousand bbls of beer.[74]

Logansport Brewing made Export Beer, and Columbia Brewing added a Logan Brew brand. Columbia closed at the onset of Prohibition and sold

the plant sometime during the next few years to the K.G. Schmidt Brewing Co. of Chicago.

The K.G. Schmidt Brewing Co. of Chicago was owned from the 1860s by Kaspar George Schmidt and his son, George K. Their facility was destroyed in the Chicago fire of 1871 but was quickly rebuilt. They sold the brewery to an English syndicate in 1889. At that time, it made forty-five thousand bbls of beer annually.

The family established a bank, the North Chicago Safety Deposit Vaults, in 1897. George was appointed city controller of Chicago in 1928, but after he lost the mayoral election to "Big Bill" Thompson, he moved to Logansport. During Prohibition, he refurbished the closed Columbia Brewery and, in 1935, reopened it as the K.G. Schmidt Brewery with his sons, G.K. Junior (secretary) and Ernst (vice-president). They made First Premium and Bock beers with the mottos "Indiana's Pride" and "Famous Old Logan."

George K. died in 1939. The enterprise went bankrupt in 1951. The ensuing court case involved Schlitz Brewing and wasn't settled until after 1978.[75]

MARION

TOM MOORE
1871–1873

Tom Moore bought a two-year old vinegar factory on the corner of Lincoln and Washington Streets from David Horton and brewed beer in an addition built on the west side. "It was not a howling success."[76]

The brewery building was used as a carpenter shop and for making brooms before it sat empty, used as a shelter by homeless people, for several years before arsonists burned it to the ground on April 31, 1894.

INDIANA BREWING ASSOC., MARION BREWING ASSOC., INDIANA BREWING CO.,
1897–1913
KILEY BREWING CO., 1934–1941
PETER FOX BREWING CO., 1941–1949

The Indiana Brewing Association (IBA) incorporated with a $100,000 original outlay that included a bottling line. Refrigeration was added in 1899 at a cost of $375,000.[77] This was reputed to be one of the largest and best-

equipped breweries in northern Indiana at the time; it covered nine and a half acres at 1550 Railroad Avenue (now 525 Lincoln Boulevard).

According to the *Marion Leader Tribune* of March 9, 1897:

> *The new house proper will be five stories high, furnished with all modern machinery. The brew kettle will have a capacity of 200 barrels daily, and will be steam jacketed.*
>
> *The mash tub will be 18 feet in diameter and 9 feet high; the hop jack will be 14 feet in diameter and 6 feet high.*
>
> *The beer storage building will contain five rooms 48x93 feet and 14 feet high, where a temperature of 34 degrees will be maintained the year around. The hop room will be 20x20 feet in size; the ice storage will be 20x40 and 8 feet high; the cooperage shop will be 132x20 feet; the boiler house in the rear will contain 4 boilers of the latest horizontal, tubular patterns, of 125 horse-power.*
>
> *The office building will be two stories high divided into general and private offices, with genial Jim Corbett in charge.*

James S. Corbett was president, Thomas Mahaffey was treasurer and John N.C. Woelfel was the brewer and general manager. Woelfel followed F.O. Gephart as secretary of the corporation. Woelfel moved to this post from the Schoenhoffer brewery in Chicago and the Columbia Brewing Co. of Logansport.

Other owners were Frederick G. Seitz, John Mulcahey, Martin Blight, W.C. Smith and John Kiley, ex-mayor of Marion. The business was valued at $350,000 in 1901, when it employed more than forty people.[78]

Corbett was married to John Kiley's daughter, Nora; Mahaffey was married to another daughter, Katherine. A third sister, Celia, became the grandmother of William Ruckelshaus, first head of the EPA. Ruckelshaus, along with Elliot Richardson, resigned during the Saturday Night Massacre at the end of the Nixon administration.[79]

According to the *Water-supply and Irrigation Papers of the United States Geological Survey* (1905):

> *On December 1, the [twenty-four] water wells of the Indiana Brewing Association, at Marion, began pumping oil. They are 160 feet deep and in gravel. They are flowing well, but the flow not being sufficient, pumping by means of air lift is resorted to. When the amount of oil in the water becomes too great the pumps are stopped, and after standing for some time, so that the*

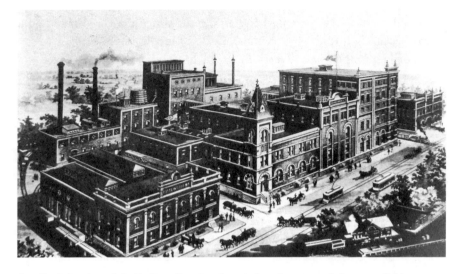

A stylized drawing of the Indiana Brewing Association plant around the turn of the century. From *100 Years of Brewing* (H.S. Rich & Co., 1903).

wells begin to flow, oil ceases to occur in the water. When pumping is resumed no oil is noticeable until the water level is lowered considerably through pumping. Mr. Hulley says further that the oil is with-out odor, showing that it has been purified by passing through sand and gravel and that it has evidently gotten into the ground from some distant source, as there are no oil wells near by.

In 1909, the IBA bought the major Marion newspaper, the *Dawn*. This was during a local temperance campaign, and the paper was previously on the side of the drys. Local support for the paper waned when the editorial stance changed to "wet," and the journal closed in April 1910.

The brewery also lost the fight against temperance and was closed shortly after local-option laws came into effect and Grant County went dry, five years before national Prohibition. This was the first major brewery in Indiana to be forced out of business for this reason. An estimated one hundred taverns in the county also disappeared at that time.[80]

IBA brands included Bavarian, Indiana Beer, Special Brew and Pride of the State Export. Peak annual output was forty thousand bbls. The brewer was William E. Jung, an immigrant from Germany.

At the onset of Prohibition, the company liquidated its assets and forfeited the entire finished product to the IRS, which dumped it into the Mississinewa River. The *Marion Leader Tribune* of July 4, 1913, reported:

The river foamed up as the beer was dumped and people came...with buckets and dipped the beer out of the river while others got on their hands and knees and drank from the river. Still others were swimming in it. It was a sight to see.

Thomas Mahaffey moved to Indianapolis in 1921 and organized the Consolidated Finance Co. The plant was used for meatpacking until Robert and Philip Kiley purchased the Indiana Brewing Association building on July 5, 1933. It needed to be furnished again as a brewery. Approximately $250,000 in stock was issued for this new corporation. A 250 bbl brew kettle was installed, and the business started production in early 1934.

Robert and Philip were sons of John Kiley's cousin, Patrick J. Kiley, and had been in the dairy business. They advertised heavily in Ohio, Wisconsin and Kansas City in the 1930s. Capacity topped out in 1936 at 260,000 bbls, employing more than one hundred people.[81] Hops were used from the "Pacific coast states, New York and Bohemian hops which are higher in price."[82]

Kiley brands included Patrick Henry, "The Beer with an Ale Base"; Old Dublin Style Stout, "Old Irish Flavor"; Limerick Ale, "The Finest Ale Brewed"; Original Old Time Half & Half, "½ Ale + ½ Stout=1 Good Beer"; Bock; Stout; and October Ale. The brewery strived to make all Kiley beers about 4 percent alcohol by weight (ABW); about 5 percent alcohol by volume (ABV).[83]

From 1937 through 1939, Kiley contracted the Gambrinus Brewery in Chicago to produce Patrick Henry beer for that market.

In 1941, the time and the money were right, and the company was sold to the Peter Fox Brewing Co. of Chicago. This was the fourth Fox plant, adding to ones in Grand Rapids, Michigan, and Tulsa, Oklahoma.

Robert Kiley's family continued to operate the Grant Distributing Co. in Marion, thus keeping their hands in the beer business.

Peter Fox continued the Patrick Henry brand for a time under brewmaster Emil W. Hertzil and added Patrick Henry Malt Liquor. Peter Fox brands were Fox Deluxe Ale, Fox Deluxe Beer ("The Beer with an Ale Base"), Silver Fox Beer, Silver Fox Deluxe Ale and Silver Fox Deluxe Beer. Distribution reached as far as Texas and Iowa, and the plant worked three shifts per day. Production ended in Marion in December 1949.

PERU

GEORGE RETTIG & SON, 1859–1867
RETTIG & COLE, 1867–1878
JAMES O. COLE, 1878–1905
PERU BREWERY, 1905–1908

George Rettig, an immigrant from Alsace, France, and his friend, James Omer Cole, left Peru and went to California in 1850 to do some gold prospecting. Rettig returned to Peru after four years while Cole continued on in California, opening a store.

Rettig took over his father's bakery business, which he quickly sold to open an ice company that morphed into a brewery.[84]

James Omer Cole. From *Cincinnati, the Queen City, 1788–1912*, Vol. 4 (S.J. Clarke Publishing Company, 1912).

Cole returned from California in 1867, having saved the considerable sum of $30,000. This was enough to buy into the Rettig brewery and start a family fruit farm in South Peru (annexed by Peru in 1914).

Rettig sold his interest to Cole in 1878 but continued to have interests in pork packing, real estate and lumber, as well as ice plants in Peru; Anderson; Cincinnati; Norfolk, Virginia; and Chattanooga.[85] Production was 4,729 bbls in 1879.[86]

On Saturday, July 18, 1885, a boiler explosion in the engine room killed a passerby, but it occurred at the dinner hour, so no workmen were in the building. Damages were estimated at $4,000.[87]

The Cole Brewery was unionized by 1891, but that union disbanded the same year. An effort to re-form the union was attempted in 1901.

By 1905, production was up to twelve thousand bbls annually. Cole beers—Golden Export, White Seal Export, Wiedersehen Special Brew and Bock—were bottled in corked, embossed bottles as well as one-quart stoppered bottles.

The Cole brewing operation ended with local-option prohibition. By that time the family owned the large Cole Brothers Circus, which merged with the Clyde Beatty Circus and toured until 1950. They also continued

Cole Bros. Natural Spring Water, using the same spring that supplied the brewery. That enterprise was sold to IdeaSphere Inc. in 2005.

Cole Porter, born in 1891, was given his mother's maiden name (she was J.O. Cole's daughter, Kate).

ANDREW BALDNER
1850S OR 1860S

This brewery was located on Canal at Wabash Street. Andrew Baldner was born in Hesse, Darmstadt, Germany, in 1819 and immigrated to the United States in the 1850s. He died in Peru in 1899.[88]

Andrew Baldner. *Submitted by Charles Bauer, St. Petersburg, Florida, Andrew Baldner's great-great-grandson. Picture taken by Lentz Bros., Peru.*

HINTON & CO.
ABOUT 1886

The 1886 *Miami Business Gazette* lists Frank Hinton and Hinton & Co. as "brewers and wholesale ice."

PLYMOUTH

A county temperance convention was held in Plymouth in 1853. That was about the time Indiana adopted local option and county agents to deal out spirituous liquors on physicians' prescriptions, ensuring that the desired fluid was for medicinal purposes only.

At that time, when spirituous liquors were so hard to get, lager beer began to make its appearance. Up to that time, none of the "foaming lager" had been shipped to Plymouth. So important was this innovation that the editor of the local paper deemed it necessary to explain the ingredients composing the newcomer:

"Lager beer is a malt liquor only made in Bavaria. It is similar to ale, which it clearly resembles in appearance. It is weaker than ale and retains foam for a short time. Its taste is sub-acid, and leaves in the mouth a peculiar flavor caused by a coating of pitch which the interior of the barrel receives before being filled."

What a change has taken place in this one article since the foregoing was written! Millions of money are invested in its manufacture, and in almost every city of importance in this and every other country, there is one or more breweries where lager beer is manufactured.[89]

JOHN HOHAM, 1857–1867
JOHN KLINGHAMMER, 1867–1884
JACOB WECKERLE, 1884–1888

An immigrant from Strasbourg, Alsace, France, John Hoham (or Hochheim in the old country) arrived in Marshall County in 1844 and purchased an eighty-acre farm. He moved, in 1857, to a three-acre homestead a mile southwest of Plymouth on the Yellow River, including a house built in 1847. This is located on present-day Indiana 17 at the southwest edge of the city limits. There he started the first brewery in Marshall County.[90]

In 1857, the Hoham Mansion had a cellar dug in the yard under nine feet of dirt. Down there were two rooms, each seventy by twenty feet with high, vaulted roofs and dirt floors. Brick vats in these rooms were made for storage of lager beer made in the brewery directly above. The family says these rooms were also used as part of the Underground Railroad. No written records of that survive, as harboring escaped slaves was illegal. During the Civil War, "Mr. Hoham put in a substitute and paid him $800."[91]

John Klinghammer was born in the Alsace region of France near Strasbourg. He had a management role in the Hoham family businesses, having married John Hoham's daughter, Magdalena. In 1867, he bought the business, but not the property, from his father-in-law.

Klinghammer's daughter, Mary, married Jacob Weckerle, a local saloonkeeper, and he joined the business in 1874. He leased the brewery and ran the operations for a few years but in the end closed it because of increased competition.[92]

The brewery produced 928 bbls of beer in 1879 and 1,585 bbls at its peak.[93] The brewery building burned down on January 2, 1900. The cellar had been used as a storehouse for eggs and mushrooms. John Hoham died in 1903. Klinghammer had become an agent for the Val Blatz Brewing Co. of Milwaukee.

The mansion was a popular speakeasy and bordello during Prohibition. A raid at midnight on a Saturday in July 1928 gathered in thirty-five customers of the "beer garden." The proprietress, Mathilda Homes, was sentenced to jail, and the house was boarded up for a year.[94] It is now an empty residence.

HENRY STEIN
1890–AT LEAST 1898

On August 18, 1898, the *Bourbon Mirror* reported:

> *Quite a bit of excitement was astir upon our streets yesterday morning, due to the runaway of the team belonging to Henry Stein, brewer at Plymouth. The team was backed against the door in the rear of Charles Glingle's place of business, where "hop tea" was being unloaded; while in this position the horses became frightened at the pouring out of some water from the above story, and immediately started down the alley, north, until they reached the road when they turned east and pursued this direction until Fribley's corner, when they again altered their course, dashing south through the main thoroughfare. At the corner they again turned east on Center street and ran a short distance, when Wm. Carter arrested their progress. By a quick turn the beer wagon was thrown over and barrels were set rolling. The wagon was slightly damaged and the tongue was broken.*

ROCHESTER

EIDLEMAN & HASLETT
1860S–1872?

John B. Eidleman and George W. Haslett dissolved their partnership in late 1869.[95] Eidleman may have continued brewing and is probably the same person involved in the *Rochester Union Spy* story of January 12, 1872, "John Adleman, the brewer, and one of his employees were arrested Saturday for stealing meat from Jake Rannels and chickens from James Elliott."

ROCHESTER BREWERY, 1873–1876
METZLER BREWERY, 1876–AT LEAST 1886

"Dr." John B. Metzler, a pharmacist of Wabash, bought the "old brewery," located on Monticello Road, just west of Main Street, refitted it and began brewing in November 1876.[96] This may have been the Eidleman brewery above.

This was not a large brewery, making only about two hundred bbls of beer a year. Ice was cut from Lake Manitou for use in the brewery and the storage room.[97]

Metzler also operated a saloon and billiard hall, as well as a small distillery, the latter probably to provide medicinal tonics.

WARSAW

RANDELS & LANGE
BEFORE 1864–1869

A man named Mauger started this brewery on North Lake Street near Center Lake (now near Osborn Street). He sold it to Alfred Randels (Randalls?) and Herman Lange in 1864.[98] Lange had been a grocer in the downtown area and had a bar in the rear of the grocery from 1860.[99]

William Augustine had an icehouse on North Lake Street from 1865 to 1869 as well as a brewery.[100] Given the proximity and the limited consumer base of a small, 1860s town of thirteen hundred souls, it seems likely that Augustine was involved in the Randels & Lange brewery.

According to the *Warsaw Daily Times* of October 19, 1901, "That old church edifice after the Warners left his county and settled in Iowa became the frame-work for the first brewery and the only one that Warsaw ever had."

Lafayette

NEWMAN & MILLER, NEWMAN'S BREWERY, WABASH BREWERY, 1842–1868
SPRING BREWERY, 1857–1868
NEWMAN & HERBERT'S SPRING BREWERY, 1868–1872
NEWMAN & BOHRER'S SPRING BREWERY, 1872–1888
GEORGE A. BOHRER BREWING CO., BOHRER BROS. BREWING CO., 1888–1918
BOHRER PRODUCTS CO., 1918–1923

John H. Newman, an immigrant from Mecklenburg, Prussia, and his brother-in-law, Abraham Miller, built a brewery in southern Lafayette on the Wabash and Erie Canal near Ellsworth Street in 1842. Miller died shortly after by drowning in the canal.

Newman moved the brewery in 1856 to property on Fourth Street, south of Alabama Street (then 82 South Fourth Street), which cost him $3,500. Water was brought in through a three-inch pipe from a spring "some distance away," giving the company its name.

The new brick brewery building was five stories high and 250 by 120 feet.[101] There is evidence that the old location was still used as a second brewery until 1868.

A large house was built just north of the Spring Brewery for the Newman family, and a tunnel was dug from the brewery to provide steam heat to the house and to use as a lagering cave.

The brewery started to pipe its water to neighbors in 1858. It also installed a fire hydrant on the street in front of the brewery and built a bathhouse next door, offering "hot and cold spring baths." Eventually, the spring dried up.

 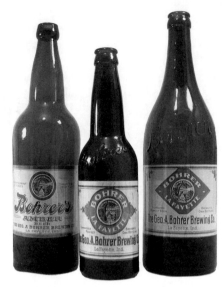

Above, left: George A. Bohrer. From *100 Years of Brewing* (H.S. Rich & Co., 1903).

Above, right: Bohrer's bottles: blob-top amber and embossed twelve- and twenty-four-ounce bottles. Note the three different logo styles.

Meinrad Hauser was a partner for a short period in 1867, before unsuccessfully trying to open his own brewery at Fourth Street and Teal Road.

Dietrich Herbert (previously of Wagner & Herbert) joined Newman in 1868.

George A. Bohrer, an immigrant from Bavaria and husband of John Newman's daughter, Catherine, moved to Lafayette from Cincinnati in 1872 and bought Dietrech Herbert's interest in the firm. It was renamed Newman & Bohrer. Production capacity was about five thousand bbls.[102]

In 1888, upon John Newman's death, the brewery became wholly owned by George A. Bohrer and was referred to as "Bohrer's brewery." Bohrer paid $12,000 for Newman's heirs' ownership. It was formally incorporated the next year with $100,000 capital stock.

Bohrer's son-in-law, Joseph Blistain, was the treasurer, and Joseph's son, William Blistain, was the bookkeeper.

Bohrer died in 1899, but the brewery stayed in the family. Sons George H. and Charles J. became president and vice-president, and his son-in-law, Joseph Blistain, remained treasurer. Brewers included Louis F. Panther, Ernst Huesman, Norbert Rouch and Gustav Schmid.[103]

Bohrer's made Indiana Pride, Bohrer's Amber Beer and Bohrer's Special Brew ("Brewed expressly for family use"). It had a capacity of about fourteen thousand bbls before it closed due to Prohibition.

The company continued until 1928 under Prohibition by making ice cream under the name Bohrer Products Co. and Boh Fay, "A Pure Healthful Beverage."

The full city block of the building complex was demolished in September 1939 and replaced by a Kroger drive-through supermarket.[104]

Howell's Bottling Works and the Star City Bottling Works were located just to the south of the brewery. These companies bought beer from the Spring Brewery and various Lafayette breweries, as well as Pabst, and also produced soda, ginger ale, seltzer and mineral water.

Wagner & Herbert Co.,1848–1862
Thieme & Wagner Brewing Co., 1862–1918
Lafayette Brewery, Inc., 1933–1953

Located at 151 North Fourth Street, Wagner & Herbert Co. was founded by John Wagner and Dietrich Herbert in 1848. Wagner was an immigrant from Weimar, Germany.

Herbert sold his interest to Frederick P. Thieme in either 1858 or 1862 (accounts vary, but most say 1862). He later joined John Newman in the Spring Brewery.

Wagner & Herbert produced about two thousand bbls of beer annually. By 1879, Thieme & Wagner had a production of about sixty-five hundred bbls.[105]

Lafayette Artificial Ice Co was a spin-off company in the 1890s. That company became the Lafayette Ice & Coal Co.

By the turn of the century, John Wagner was president; Thieme was vice-president; J. Henry Thieme was secretary and treasurer; Theodore Wagner was superintendent; Frederick P. Thieme was a brewer; and Frank H. Wagner was the manager of the Bottling Department.

As many breweries did at the time, its output was bottled by another firm. In this case it was Tengen & Thieme, located across the street. Wagner's in-laws represented the Tengen part of this company.

John Wagner was the driving force of this successful enterprise and had used some of his proceeds to buy interest in several Lafayette banks before he died in 1904. At that time, his son, John Wagner Jr., became president. Brewers around this time included Gustav Schmid, Matthew Schmid, Charles Wagner and Michael Yost. August Weniger was the cooper.

T&W brands included Bohemian, Extra Brew, T&W Special, Lockweiler Special Brew, Bock Export, Star City and Ye Tavern Brew. Peak production capacity was thirty-five thousand bbls.

Possibly because of impending Prohibition, in 1916 they started a subsidiary, the National Fruit Juice Company (NFJC), which made Apella brand ciders. During Prohibition, the NFJC made Yette and Ye Tavern near beers and Apple-Ade, a carbonated unfermented cider. It registered the trademark "An Apple a Day Keeps the Doctor Away."[106] Michigan's Food and Drug department tested Apella in 1918 and found it contained 0.94 percent alcohol, thus making it technically illegal.

The Val Blatz Co. took over the plant in 1927, and it was sold at the end of Prohibition to W.G. Hanger's start-up corporation for $200,000 to become the Lafayette Brewery, Inc. (LBI). The brewery facility was completely rebuilt utilizing forty men starting in April 1933. It sold its first batches of Ye Tavern beer just in time for the Christmas season that year.

William G. Gude was the president of the First Merchants National Bank in Lafayette and became the president of the new company as well. He held that position until just before his death in 1939. LBI's brands included Ye Tavern ("The Beer De Luxe"), Ye Tavern Bock, Tavern Beer, Tippecanoe and Kopper Kettle.

The original Ye Tavern was the same recipe used for Thieme & Wagner's Tavern Brew before Prohibition. It used hops from Oregon and Czechoslovakia. In fact, the labels for Ye Tavern Brew were originally almost identical to the pre-Prohibition T&W labels.[107]

The brewmaster was Louis F. Panther, who had worked for thirty-one years at Bohrer's Spring Brewery. Gustav Goob was a brewer here and went on to become the brewmaster at the Koppitz Brewery in Detroit.

At its height, the Lafayette Brewery, Inc., made about 100,000 bbls annually.

It's said that the Lafayette Brewery gave a free case of beer to every policeman and fireman in Lafayette every Christmas.[108]

The brewery closed in 1953, and the buildings sat empty until they were torn down in 1960 in favor of the Harrison Street Bridge.

CITY BREWERY
ABOUT 1851–ABOUT 1868

Christian Emdee had a brewery from at least 1851 until 1868, located about a half mile south of the county courthouse on Third Street between Ramsey and Alabama Streets. According to the Tippecanoe County Historical Association, on July 27, 1851, "at about 1 a.m. lightning struck Emdee's Brewery." It was listed in city directories from 1859 until 1868 (owned by J&H Emdee).

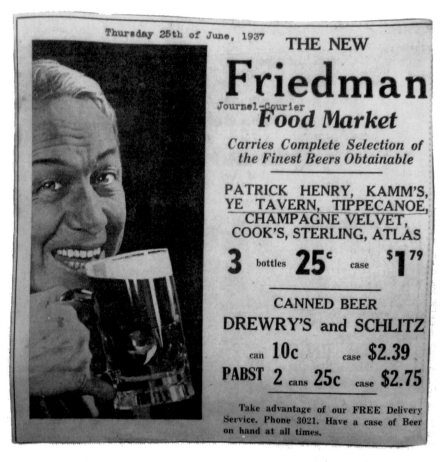

This ad in the *Lafayette Journal-Courier* of June 25, 1937, shows local beers as cheap as seven cents per bottle during the Depression.

HANNAGAN AND FITZGERALD
ABOUT 1900

Partners Stephen J. Hannagan and Patrick L. Fitzgerald had tried a short-lived brewing operation in about 1900, producing "Pride of the State" beer.[109] Fitzgerald had been, or continued to be, a saloonkeeper at 116 Main Street.

West Central Indiana

ATTICA

ANNA SMITH
1840S?–1875

Attica was a bustling town in the 1850s. The Wabash & Erie Canal was completed through town in 1847. The following three references may well be to the same brewery.

Chamberlain's *Indiana Gazetteer* of 1849 lists one brewery in Fountain County but has no more detail than that.

The *Indiana State Gazetteer and Business Directory* of 1859 indicates, at that time, a brewery in Attica.

Chandler Co.'s Business Directory for Indiana (1868) lists an Attica Brewery owned by Mrs. Anna Smith in Attica on Perry Street. She probably closed this small (seventy bbl capacity) brewery in 1875.[110]

BOWLING GREEN

JOSEPH LENHART
1860S

Bowling Green once had a bright future at the head of the then navigable Eel River. That era ended in 1861, when the last canalboat left town. At that

time, the population of Bowling Green was 466. *The History of Clay County*, written by William Travis in 1909 states:

> *The first brewery, it is said by early residents, was located and operated on the north side of the town of Bowling Green, on the site on which was afterward erected the first steam flouring-mill.*
>
> *At some time in the sixties, Joe Lenhart bought the tract of land on Birch Creek on which the Gibbons mill had been located and operated at a much earlier day, and started a brewery on the same ground, which he continued to run for several years after the war. This rural plant afforded the farmers of the Birch Creek agricultural community and its borders the opportunity to lay in a supply of lubricant for energizing the operations of the harvest field, of which some of them, at least, took advantage.*

Lenhart was listed as a cooper in an 1885 business directory.[111]

Fred Stucki
1874–1884

The warehouse of the Jesse Fuller, John M. Melton and Joseph Kennedy boat building enterprise was converted by Fred Stucki into a brewery. He was one of the town's first trustees when it was incorporated in 1871. He may have also distilled spirits.[112] His brewery produced about two hundred bbls per year.[113]

"At a later date, the Stucki brewery was established on the riverbank, on the west side just below the bridge. It was in operation during the Civil War and for a period of many years thereafter."[114]

Brazil

Brazil Brewing, Ice & Power Co. (BBI&P)
1901–1907

The names of the owners of this fairly large brewery located in a town of then five thousand people on the National Road have been lost to history. The plant was located on West Main Street at what were then the city limits.

Fred Houseworth was the manager of the BBI&P throughout its life. He left in 1907, about the same time Clay County voted itself dry. At that time, there were fifty-four saloons in Brazil and about one hundred in Clay County.

Thomas Jones of Indianapolis, Edward Beggs of the Terre Haute Brewing Company and W.H. Johnson of Terre Haute purchased the plant in 1907. It never brewed again.[115]

According to the *Yearbook of the United States Brewers' Association* of 1910:

> *At Seeleyville, a mining town eight miles away in Vigo County, there are nineteen saloons, much of whose trade comes from the people of Clay County. The residents of this county also go to Terre Haute, and many are taken off the trolley cars in a state of intoxication. It is doubtless for the reason that saloons are within such a short distance from Brazil that "blind tigers" and "boot-legging" do not exist to any extent in Brazil.*

COVINGTON

JOSEPH MILLER
1865–1885

Joseph Miller was a native of Württemberg, Germany, and came to the United States in 1854 at twenty-one years of age. He worked as a cooper until 1863 and then opened a saloon.

The brewery he built in 1865 burned, costing him everything and leaving him with a debt of $3,000. Starting over, he built a larger brewery that reached more than two thousand bbls capacity.[116]

CRAWFORDSVILLE

LORENZ BREWERY, 1853–AFTER 1870
R.H. HANNAN & CO., 1875–1877
JACOB MUTH, 1877–1879
VANCE, 1879–1882
MICHAEL KLAIBER, 1882–1884

This brewery was located in a triangle bounded by Lafayette Avenue, Market Street and Grant Avenue. Henry Lorenz was born in 1827 in Saxony, Germany. His family moved to America when he was five. In 1850, he moved to Crawfordsville, and in 1853, he bought an existing brewery (previous owner unknown). The property got an extensive remodeling in 1865, including a

beer cellar that extended under Market Street. The dedication was a major event in town, with a choir and a minister blessing the building.[117]

Lorenz was elected a member of the Crawfordsville City Council in 1867 and committed suicide in 1870, two years after his wife died. Bill McGillis ran the brewery after Lorenz's death. He could not keep up with the competition from Indianapolis and Cincinnati breweries and closed the plant soon after.

R.H. Hannan restarted the enterprise in the same location in 1875, and it passed to men named Muth and Vance in turn. It was not an extensive business, making 676 bbls of beer in 1879, probably its peak production.[118]

Michael Klaiber had been a brewer in La Porte before moving to Crawfordsville in 1882 to buy the subject brewery. A fire broke out in the brewery in early April 1882 and again on April 19, consuming the icehouse.

By 1885, Klaiber had stopped brewing and was an agent for Schmidt beer. He had built a large refrigerated warehouse near where the brewery stood. He moved from Crawfordsville to Cincinnati in 1892 and became a barber.[119]

On January 29, 1885, the *Crawfordsville Star* reported, "It is said a gentleman from abroad will lease the old brewery and resume beer-making here in the spring." Despite some optimistic plans, the building sat empty until 1887, when Anthony & Coon of St. Louis established a beer depot using the old brewery vault as storage. The building was finally razed in 1924.

GREENCASTLE

ROBERT L. HIGERT
1865–1871

A brewery in Greencastle owned by Robert L. Higert was destroyed by fire in 1871.[120] Higert went on to own a saloon in Greencastle in the mid-1880s through at least 1892. By the turn of the century, he was raising prize-winning chickens.

GREENCASTLE JUNCTION BREWERY
ABOUT 1868

Chandler Co.'s Business Directory for Indiana (1868) lists the Greencastle Junction Brewery, "F.P. Winchell, prop." Greencastle Junction was at the crossing of the Louisville, New Albany & Chicago and Terre Haute & Indianapolis Railroads in Putnam County, about a mile from Greencastle. There were also two saloons in Greencastle Junction.

HARMONY (WILLIAMSTOWN)

JOHN BAUER
1860S–1878

This was a tiny brewery that is reported to have produced fewer than one hundred bbls annually.[121] In his *History of Clay County*, William Travis wrote, "There was also a brewery on the National road, west of Williamstown, operated by John Bauer, who moved it to Harmony, about the year 1870, where it was planted and operated for several years on the south side of the town."

LEBANON

JACOB HALFMAN
1860S

The 1868 *Business Directory for Indiana* lists a Lebanon Brewery owned by Jacob Halfman near the railroad depot.

H.F. WIESEHAN AND BRO.
1874–1875

H.F. Weisenham, an immigrant from Germany, came to Lebanon in 1866 at the age of seventeen. By 1874, he and a brother had a brewery. It was quite small, with a capacity of only 160 bbls per year. Sources indicate that it closed the next year.[122]

Variously, the name is given as Weisehan, Wieseham, Wiesenham and Wiessenham.

Terre Haute

GEORGE HAGER
1835

Hager's brewery was located in a warehouse on Water and Sheets Streets, near the river known as Outlet 23. At that time, there was much traffic by flatboat, which transported goods produced at the brewery, a distillery, a foundry, brickworks, mills and many slaughterhouses.

A fire destroyed the premises soon after it was opened.[123]

WARREN AND DEMING, 1837–1868
BLEEMEL BREWERY, 1837–1848
MOGGER BREWERY, 1848–1868
KAUFMANN & MAYER, 1868–1869
ANTON MAYER, 1869–1889
TERRE HAUTE BREWING CO., 1889–1918, 1934–1958
TERRE HAUTE BREWING CORP., 1958–1959

Chauncey Warren and Demas Deming Sr. started the business that became the Terre Haute Brewing Company in 1837. Both were prominent citizens of the growing city. Deming was a successful merchant, a founder of the Terre Haute Branch Bank (in 1834) and later a judge. Warren was married to the daughter of a noted doctor.

The location Warren and Deming chose on what was then Bloomington Road was close to where the Wabash and Erie Canal would pass when

it reached Terre Haute in 1849. Unfortunately, the canal didn't help distribution and was gone by 1860.

The plant was leased by Ernest Bleemel until Matthias Mogger, a German immigrant, bought the business in 1848. Mogger died on July 13, 1868, while delivering beer to a depot.[124]

Andrew Kaufmann and Anton Mayer bought the facility in 1868 from Bleemel's heirs. Mayer bought out the Kaufmann family's share in 1869, upon Kaufmann's death. By 1879, he had a bottling plant and a total capacity of more than eleven thousand bbls.[125]

Anton Mayer was an immigrant from Württemberg, Germany, and was employed in a brewery there before he moved to the United States at age sixteen. He worked for eight years as a brewer in Cincinnati, becoming a brewmaster. He was also Matthias Mogger's brother-in-law.[126]

According to the book *Greater Terre Haute and Vigo County* by Charles Cochran Oakey:

> *When the brewery was first opened for business it was on a small scale, with a yearly capacity of two thousand five hundred barrels. During his ownership the plant was improved and enlarged until the capacity, in 1889, was raised to twenty-five thousand barrels a year. In that year Mr. Mayer sold that business, which is now the Terre Haute Brewing Company, and retired from active business. He owns considerable valuable improved city and farm property, the management of which takes all of the time he is now willing to devote to business. So successful has been the business career of Mr. Mayer that he is accounted one of the wealthy men of Terre Haute, as well as one of the city's leading and influential citizens.*

Anton Mayer sold his company in 1889 to Crawford Fairbanks and John H. Beggs of the Indiana Distilling Co. They reincorporated as the Terre Haute Brewing Company (THBC). At this time, with Mayer's expansions, the brewery occupied two blocks at Ninth and Poplar Streets.

By the turn of the century, THBC was the seventh-largest brewery in the United States. Stables were a block away, with fifty Clydesdales and Belgians delivering beer to the immediate area.[127]

Brands at this time included Tafel, Velvet, Bohemian and Radium.

John H. Beggs, an immigrant from Ireland, had owned and operated distilleries in New Richmond, Ohio, and at Metamora and Shelbyville in Indiana. He was involved in Fairbanks's Indiana Distilling Co. starting in 1884, when it was rebuilt after a fire. From 1890 through 1897, he was

involved in distilleries in Peoria, Illinois, known as the Whiskey Trust, which was broken up by the Sherman Anti-Trust Act.

His three sons, John Edward, Thomas and Harry, were all involved in the distillery. Harry went to Vincennes as president of the Vincennes Distilling Company, also owned by the Beggs family.[128]

John Edward Beggs was a partner with Herman Hulman in the Hulman & Beggs wholesale liquor distributors, was the major stockholder of the Pioneer Malting Company of Minneapolis and had, in 1907, bought into a concern that purchased the brewing plant of the Brazil Ice and Power Co.

In 1904, the Champagne Velvet brand was born. It would immediately become the flagship brand. The original recipe was drawn up by an assistant brewer, Walter Braun, and contained a fair amount of flaked corn as an adjunct to the barley malt.

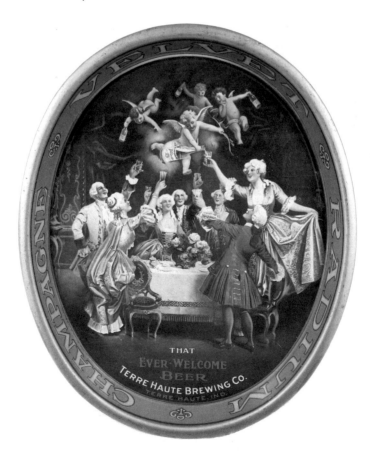

Champagne Velvet Radium serving tray.

THBC built a new office, storage house and bottling works in Indianapolis in 1904.[129] It also had an agent, Charles E. Patty, who bottled in Paris, Illinois, just over the state line, by 1908.[130]

An expansion completed in 1910 covered three city blocks and employed 250 men. The new address was 901–35 Poplar Street. At this time, Crawford Fairbanks sold some of his interest in the brewery and instituted a financial reorganization with Thomas Gibson and John Edward Beggs buying a substantial portion of the stock. Fairbanks went on to join Tom Taggert and W.W. McDeal, president of the Monon Railroad, in the formation of the French Lick Springs Hotel Company.

Not all was rosy in a city awash in pre-Prohibition beer. In the early part of the century, Terre Haute was called the "Paris of Indiana," or more often "Sin City" due to the wide-open nature of mayoral corruption. Sporting houses and saloons without closing hours were the most obvious public aspects of the local political machine being funded by distilling and brewing money. Candidates for local public office regularly gave business cards that could be traded at the brewery for a keg of beer.[131] Mayor Bidaman was impeached in 1906, and Mayor Roberts was convicted of election fraud in 1915, serving time in prison.

THBC was not a member of the Indiana State Brewers' Association (ISBA) and did not join any lobbying efforts to stave off prohibition in Indiana. The ISBA claimed that THBC was "owned by distillers" and "a detriment to brewers."

Severely reduced in size at the onset of Prohibition, the plant made root beer and cereal beverage near beers but laid off 70 percent of its workforce. It and the Peoples' Brewing Co. were the only breweries in Terre Haute to stay open. All the distilleries and two bottle-making firms closed, laying off more than two thousand people. The Root Glass Company stayed open only because it had the rights to the Coca-Cola bottle, having designed it in 1915.

The brewery used the Champagne Velvet name for root beer and a cereal beverage and also made Velveteen near beer during Prohibition.

A new president, Oscar Baur, reorganized THBC in 1934. Baur was a former Terre Hautean who returned to the city in 1933 to restart the brewery. It reopened in March 1934; the first deliveries were made on March 16, and 150 Vigo County restaurants and bars served it at midnight.[132]

The Baur family fortune had been made when Oscar's half brother, Jacob, patented a method of liquefying carbon dioxide for distribution in pressurized cylinders. These CO_2 tanks were the mainstay of the soda fountain industry. Baur's Liquid Carbonic Acid Manufacturing Co. was

based in Chicago, with a plant, run by Oscar, in Indianapolis. Jacob was also instrumental in the founding of the Monsanto Corporation.[133]

Oscar owned, among other things, Broad Ripple Park, which he had bought in 1927, and he was one of the founders of the First Financial Bank in Terre Haute. His half sister, Katherine, was Socialist presidential-hopeful Eugene Deb's wife.

Oscar Baur's son, Oscar Jr., was the vice-president. His son-in-law, Raymond Harris, was the general superintendent of the new company.

A local ad man, William Polje, started the motto "The Beer with the Million Dollar Flavor," and for publicity, the brewery insured the formula's secret for $1 million. THBC also used the motto "The Nation's Flavor-ite Drink."[134]

By 1935, distribution of Champagne Velvet had expanded to nineteen states and was eventually sold in all forty-eight. Production peaked at 202,000 bbls, and the brewery employed nine hundred people.

In 1935, stakeholders purchased controlling interest in the struggling ABC Brewery of St. Louis, with Oscar becoming president and Robert Baur secretary-treasurer. The company lost $73,000 in 1936 and was merged with THBC for the stated reason of raising a loan to modernize the ABC facility. By 1937, the ABC Brewery plant was shut down and only used for distribution of Champagne Velvet in the St. Louis area. Baur sold it in 1938 to a Chicago concern headed by Louis Kanne. That company declared bankruptcy on January 31, 1940, and, having defaulted on the mortgage, the brewery was once again owned by Terre Haute Brewing Company. It was sold it almost immediately to a local investor.[135]

A selection of Terre Haute Brewing Co. post-Prohibition beers: Champagne Velvet, Bock, the classic 1960s label, Strong Ale, "Armstrong" Ale, Half and Half and Stout.

THBC was the first to date its beer with the bottling date on the

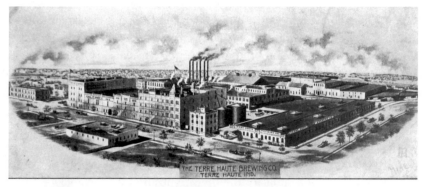

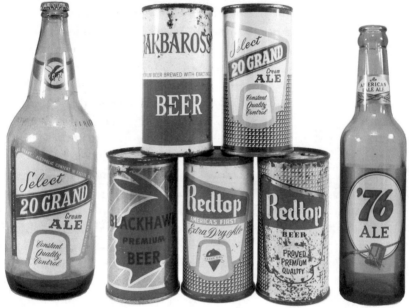

Plate of the Terre Haute Brewing plant from *Twentieth Century Souvenir of Terre Haute* (Moore & Langen Printing Co., 1903). Plus a selection of beers from the 1950s: Select 20 Grand Cream Ale, Barbarossa, Blackhawk, Redtop Extra Dry, Redtop and '76 Ale.

labels. It was also the first to use twist-off caps. In 1935, the bottling line was the largest in any brewery in America.

Champagne Velvet was the main brand starting in 1904. Other brands included 76 Ale, America's Pride, Blackhawk, Bock, Strong Ale, Ale, Half and Half, Stout and, starting in 1957, Redtop, Select 20 Grand Cream Ale and Barbarossa—names acquired from the Redtop Brewery of Cincinnati, Ohio.

Oscar Baur died in 1952 at the age of eighty-four while wintering in Florida.

The Atlantic Brewing Company of Chicago bought the company's assets in 1958 and operated it for one year under the name Terre Haute Brewing Corp. Atlantic closed the Terre Haute facility and moved production of Champagne Velvet and the Redtop brands to the Chicago plant.

The Champagne Velvet trademark, along with all the other Atlantic brands, ended up with Associated Brewing in 1971 (brewed in Evansville's Sterling Brewery). Production of Champagne Velvet in Evansville ended in the early 1990s. When the Evansville Brewing Co. went out of business in 1997, its brand names were bought by Pittsburgh Brewing, which passed them on to Pabst.

The original brewery is today the site of M. Mogger's Brewery pub on Ninth and Poplar Streets.

The Champagne Velvet name was bought back from Pabst by Mike Rowe in 2000 to use at the new Terre Haute Brewery (see "Modern-Era Breweries"), which was located in one remaining THBC building. That building is, at the time of this writing, used as the Vigo Brewery.

SEVENTH STREET BREWERY
1848–ABOUT 1860

This brewery was located on North Seventh Street between the canal and the railroad (now on the Indiana State University campus). It was owned by a person named Ballard. Max Reismann was the manager.[136]

ALBERT HERTWIG
ABOUT 1851–1865

This brewery was located on Eighth and Poplar Streets.

GLICK, 1854–1860
MOSES EASTER BREWING CO., 1860–1876
N.S. WHEAT, 1876–1880S

Brothers George W. and Henry S. Glick built a brewery in 1854 just to the rear of their store at First and Ohio Streets on the northwest corner of Water and Wabash Streets. Moses Easter owned a bakery in Sullivan, south of Terre Haute, which burned down on August 15, 1860.[137] At that time, he bought the Glick brewery.

Eugene Duenweg, an immigrant from Cologne, Germany, became the superintendent of the Moses Easter Brewing Co. in 1871. Eugene was Louis Duenweg's (of Fairbanks & Duenweg distillery) younger brother. From 1883, he was the local agent for Schlitz and Miller. His son, Max J. Duenweg, succeeded him in that business upon Eugene's death in 1902.

Easter closed the brewery in 1876 and sold it to N.S. Wheat, who was a successful coal dealer in the city.[138] In 1879, Wheat sold only 271 bbls of beer.[139] After the brewery closed, a flour mill occupied the site.[140]

HERMANN IMBREY
1872–1875

Located on the northwest corner of Seventh and Sycamore Streets, Imbrey's brewery was between the Wabash & Erie Canal and Chestnut Street, now on the Indiana State University campus. In January 1872, Imbrey sold seventy-two bbls of beer.[141] John Bergholz may have been a partner in this brewery or bought it from Imbrey.

PAULUS WALSER, 1874–1875
REINHOLD KLANT, 1875–1880

Paulus Walser started a brewery in 1874. In 1875, he sold it to Reinhold Klant. Capacity was only about two hundred bbls.

TERRE HAUTE BREWING CO.
1870S–1883

The first company named the Terre Haute Brewing Company was owned by Fred Feyh, Coelstein Kinzle and Theodore Kriescher in the 1870s and early 1880s. It was at the southwest corner of First and Ohio Streets.[142] This business was overrun by a disastrous flood in 1883 and did not reopen.

Theodore Kriescher, an immigrant from Germany, went on to work for Anton Mayer and owned a saloon and beer garden at 2116 South Third Street from 1889 through 1910.

HENRY BECKER'S WEISS BEER BREWERY, 1898–1908
CHARLES GRAF, 1908–1908

Henry Becker had a small (less than five hundred bbl capacity) brewery on the southwest corner of Ninth and Walnut Streets until he died in 1905. For

three years, it remained in his family's control under the leadership of his son, Henry J. Becker.

The business was sold to Charles J. Graf in 1908, but he closed it that same year.[143] One of the Graf beers was a Berliner Weiss sour-style beer, then and now rare to find outside the Berlin, Germany area.

PEOPLES' BREWING CO.
1905–1920

This brewery was located at First and Wilson Streets. Started with a stock filing of $200,000 on June 27, 1904, Peoples' first brew was on May 18, 1905, and that batch was released on July 31. Principals in the company included Ralph Charles, N. Murphy and John F. Hutchison.

Frantz Brogniez, an immigrant from Belgium, was the brewmaster, superintendent and main designer in the construction of the new brewery building. He had previously established breweries in Lichterville, Belgium, and Detroit's Tivoli Brewing in 1897. The plant was designed with a forty thousand

People's Brewing Co. mainstays were Celtic, Spalter and Special Brew.

bbl capacity, employed fifty people and had its own cooperage.

Henry C. Steeg, a former mayor of Terre Haute, was named president in 1906. Charles N. Murphy was treasurer. John William Bauer, a prominent local vegetable farmer, was also a stockholder.[144]

Peoples' made Celtic, Spalter and Special Brew brand beers, as well as a Bock, until Prohibition. The company motto was "The beer that speaks for itself."

During Prohibition, it reincorporated as the Peoples' Ice and Storage Company and made Celto cereal beverage, but the company didn't last to brew beer again. Brogniez went on to Houston's Magnolia Brewery, where he co-founded the Houston Symphony.[145]

East Central Indiana

ANDERSON

DOXEY'S BREWERY
1865–1866

Charles T. Doxey and William Craycraft built a brewery on Craycraft's property on West Eighth Street near Brown Street in 1865. In May of 1866 a fire in the night destroyed the building and it was never rebuilt.[146]

Doxey continued to operate a hotel, an opera house and factories producing handles and barrel staves in the near vicinity. His luck wasn't too good, though, as the barrel stave factory was also destroyed by fire in 1873 and rebuilt again in 1875. The opera house burned down in 1884, as did the handle factory. The opera house was replaced by the Doxey Music Hall, but it suffered a similar fate in 1893. In 1895, Doxey was the president and part owner of the Alexandria Plate Glass Works when it suffered a large fire.[147]

Doxey was elected a state senator in 1876 and a one-term U.S. representative in 1882. He ran for governor of Indiana in 1896 but lost.

Norton & Sullivan, Norton & Crowley, 1866–1882
T.M. Norton Brewing Co., 1882–1908
T.M. Norton and Sons Brewing Co., 1908–1918, 1934, 1937–1940

Thomas M. Norton, born in 1835 in Ireland, moved with his family at the age of six to Dayton, Ohio, where he was raised. In the 1860s, he worked for Louis Williams, brewing ale in Union City, Indiana.

In 1866, he moved to Anderson and started a brewery with Patrick Sullivan at 706–16 Central Avenue. This was located on the site of Alonzo Makepeace's steam gristmill on the west bank of the White River, quite near where Chief Anderson's Delaware tribe had made their home.[148]

At some point, Michael Crowley replaced Patrick Sullivan in the company name. It would seem that Crowley married one of Norton's daughters. In 1882, Norton separated from Crowley and renamed the company.

Thomas Norton retired in 1896, turning over the company and other business affairs to his sons, Martin C. (who became president) and William J. (secretary and treasurer).[149] Thomas died in 1907.

In 1897, the company added a four-story stone stock house to the brewery at a cost of $16,000.[150] It also had a private ice plant. In 1902, the company installed a fifty-ton ice-making machine.

Starting in 1910, a new brewing plant was constructed. Just before Prohibition, T.M. Norton produced twenty-five thousand bbls per year, with over seventy-five employees making Norton's, Old Pal, Gold Band, Export and Export Dry brands.

The company produced soft drinks and ice during Prohibition, thus keeping most of the equipment active and men employed. But in 1923, the company ran afoul of the T-Men for manufacturing real beer that was marketed in Cincinnati. On the evening of June 17, after two trucks were loaded with barrels at 1:00 a.m., authorities placed the drivers under arrest, seized the twenty-nine bbls and closed the plant. William J. Norton was subsequently sentenced to a prison in Atlanta.[151]

After Prohibition's repeal, the brewery reopened, spending a year trying to recover—but it was not successful, and the doors closed again in 1934. Another attempt in 1937 worked better, but output was minimal. It stopped trying in 1940. During this time, the company made Norton's Beer, Bock and Pilsener; Gold Band Beer and Lager; Old Stock Lager and Old Pal Beer.

The building became a Ralston Purina Feed Store in the 1950s and continued to produce ice for retail sale.

CAMBRIDGE CITY

CAMBRIDGE CITY BREWERY
BEFORE 1867–1887

Cleophas Straub was born in Württemberg, Germany, and was just three weeks old when the family moved to Ohio. In 1852, he tried mining in California "with more or less success." He returned east in 1866 and, with Peter Strieker, bought the Cambridge City Brewery. He bought Strieker's share almost immediately and carried on the business until 1887, when he sold it so it could become a bottling plant, which was employed by the Ingermann Brewery.[152]

In 1879, he sold just 366 bbls of beer.[153] According to an older resident, Straub's beer "didn't take and never became very popular."[154]

HENRY INGERMANN, 1863–1893
WILLIAM H. INGERMANN, 1893–1900
JOHN M. INGERMANN, 1900–1904
INGERMANN BREWING CO., 1904–1908

Henry Ingermann, an immigrant from Germany, located his brewery just east of the Whitewater River in Vandalia (now merged into Cambridge City), on the corner of Vandalia Avenue and Delaware Street. In 1879, he sold 390 bbls of beer.[155]

Cleophas Straub worked there after closing his own brewery in 1887. Later, a nephew (another Henry Ingermann), Charles Swim and Tom Enyart owned the brewery.

The beer was sold in pints and quarts with rubber stoppers as "Ingermann's Ale," with XXX or XXXX indicia. The brewery never brewed much more than five hundred bbls per year.

Workers at the brewery included Charles Keller, George Stombaugh, Elam Barefoot, Frank Mosbaugh, Luther Young and Henry's son, George Ingermann.

There is a reference to forty thousand shares of capital stock registered with the state by

A J.M. Ingermann XXX Ale blob-top bottle from the turn of the century.

Ingermann Brewing Company on October 26, 1906. This was a restart of the company by John M. Ingermann that did not succeed, as they closed the plant in 1908.

The Ingermann Brewery property was sold on September 21, 1912, at public auction to Daniel or Adam Kiser for $615. It subsequently was bought by the school system, and the land is part of the athletic fields at Lincoln High School.

Henry died in 1917. John M. Ingermann, Henry's son, continued to own a restaurant through at least 1915.[156] He was later the town marshal of Cambridge City and was killed in the line of duty in 1929.

An Ingermann descendant, Chris Ingermann is now an active and award-winning home-brewer in Indiana.

CONNERSVILLE

JOHN UHL
1857–1859

John Uhl and his new bride left their native Heidelberg, Germany, in 1850 (John at age twenty-two) to move to Cincinnati. There he found work as a barber—a job that included cupping, bleeding and other minor medical chores he had learned from his father, a medic in Napoleon's army.

In 1857, Uhl moved to Connersville and "purchased interest in a brewery." That business lasted two years. He then opened a cooperage that employed sixteen men and was sold to a consortium of people in the pork-packing business in 1865. He also started a mill on the Whitewater River, was a director of the First National Bank and became the treasurer of Connersville when it became a city in 1869.[157]

WENDEL HOFMANN
1863–1868

Wendel Hofmann, an immigrant from Grossrohrheim, Darmstadt, Germany, came to Connersville, where he owned a brewery until 1868. He then moved to St. Louis and later to Tell City, Indiana, where he owned a liquor business, theater and skating rink.[158]

VALENTINE BILLAN
1874–1884

Valentine Billan's brewery had a capacity of less than five hundred bbls per year.[159]

FOUNTAIN CITY (NEWPORT)

Newport was renamed Fountain City in 1879.

EDWARD MASON
1825–ABOUT 1826

The first brewery in Newport was started in 1825 by Edward S. Mason. After a time, it became so obnoxious to the citizens that they enacted the following novel plan, recorded in *The History of Wayne County, Indiana*, to abate the nuisance:

> *He had dug a hole in a low, flat place, adjacent to his business, for the supply of water for his beer, and placed a slab across the center for convenience in dipping up the water. It was not long before the water became stagnant, and the frogs took refuge in it, and the people set their heads to remove the whole establishment. Some unknown person, during the night, sawed the slab nearly through on the under side, and placed it in position again. Early in the morning the man went out for his bucket of water for his beer, stepped on the slab as usual, and it gave way, precipitating him into the pool. He was immersed in the water to the arm pits—it was so constructed that he could neither drown nor extricate himself—and as he was not in calling distance of any one he was not missed until breakfast time at his boarding house. Livina Puckett, living in the family (now Mrs. Reynolds), who went in search, found him cold and helpless in the pit he had dug himself. He was soon removed, and warmed and fed, and lost no time in taking down his sign and quitting the business.*

WILLIAM WAY
1828–ABOUT 1830

In his *Memoirs of Wayne County and the City of Richmond*, Henry Clay Fox wrote:

> *William Way moved to Liberty, Indiana, in 1835 and subsequently to Wisconsin. A brewery, started there in 1825, was abandoned on account of the hostility of the inhabitants toward it. In the year 1828, William Way started another, but it soon succumbed to the pressure of public opinion. In 1829, four saloons were present in Fountain City; in 1830, a temperance society was organized to resist their influence; a debate was opened on the question between the liquor men and the anti-liquor men; it occurred in public from 2 o'clock p.m. until after midnight. The temperance debaters were Dr. H.H. Way, Able Lomax, and Willis Davis. The representatives of the whiskey faction were John Huff, E. Lee, and Joseph Lomax. The debate is said to have been won by the anti-liquor men. This locality succeeded in getting rid of its saloons and is now free from their baneful influence.*

MUNCIE

FAY & GARST, 1875–1877
ALBERT J. GARST, 1877–1882
BARTLETT & GARST, 1882–1890

Albert J. Garst, born in 1846, had a butchery at 632 South Walnut Street when he and a man named Fay started a brewery in Muncie on South Illinois Avenue.[160]

Fay evidently left soon after, replaced by Asa Green, who worked for Garst and lived in the brewery. It was a small affair, selling only one hundred bbls in 1879.

By 1891, A.J. Garst owned a fruit and vegetable store at 221 South Walnut.

CHARLES ALVERY
1878–1879

This brewery was located on Ohio Avenue near the cemetery. Charles Alvery was born in 1841 in England.

Muncie Brewing Co.
1903–1910

John Birkenstock rebuilt a brewery in Allentown, Pennsylvania, in 1891, but it didn't work out too well. In 1897, he and Fred Horlacher built another brewery, which closed in 1902. Birkenstock then moved to Muncie, opening another brewery on the northwest corner of Hoyt and Willard Streets in 1904.

Birkenstock was an immigrant from Hessen Darmstadt, Germany, born in 1845. His wife, Elizabeth Scholl, was born in 1868 in the William Penn house in Philadelphia—the first house in America made of English brick.[161]

Brands included Peerless Pure Family Beer, Home Brew and Birkenstock Special.

This thriving company, which employed thirty-two people, was put out of business when Muncie went dry in a local-option election.[162] Ironically, the city went wet again six years later, just two years before Prohibition.

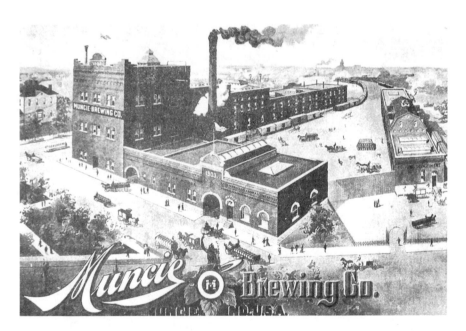

The Muncie Brewing Co. plant.

NEW CASTLE

PATRICK LEONARD
1874–1875

This small enterprise made less than one hundred bbls of beer total.[163]

NOBLESVILLE

JOSEPH XAFER
ABOUT 1868–1875

We don't know anything about this brewery, except that it was on Conner Street.

RICHMOND

In the book *The Old Pike: A History of the National Road, with Incidents, Accidents, and Anecdotes Thereon*, Thomas Brownfield Searight writes:

> *The first tavern of the road in Richmond was kept by Charles W. Starr. It was a regular old pike tavern with extensive stabling and drove yards attached occupying one fourth of a square on the northeast corner of Eighth formerly Fifth street. The building was of brick known in later years as the Tremont Hotel. It is still standing but not used as a hotel or tavern... Charles W. Starr was a man of medium size and of Quaker faith. He wore the Quaker garb had Quaker habits and was esteemed a good citizen.*

EZRA BOSWELL
1816–1831

Ezra Boswell, a Quaker, was a brewer in England before moving to North Carolina and then, in 1816, to Richmond, where he made beer and gingerbread and ran a beer shop located on Front Street north of Main (Front Street later became Fort Wayne Avenue).[164]

He continued the brewery until his death in 1831. He was also a clerk of the Richmond city council.

The first settlers of Richmond arrived in 1805. Proper streets weren't laid out until 1816. Richmond was incorporated as a city in 1818.

The brewery was located north of where the Wayne County Courthouse is now situated, near the present government offices on Fifth Street.

The facts here are replicated in many histories and newspaper accounts, except for reports that Boswell had a mutilated eye.[165] According to John T. Plummer in his *Reminiscences of the History of Richmond, Indiana*:

> *The First Brewery in Richmond was commenced by Ezra Boswell…about the time the town was incorporated. Of the quality of the beer we have now no opportunity of forming a judgment; but it is said that some of the Councilmen of that day—who, of course, served their fellow-citizens gratuitously—one day sent to Ezra for some of his brewing; and we presume, they quaffed it until they were satisfied; but, like all men in place, they, by this simple act, subjected themselves to the tongue of slander. By the citizens, who took it upon themselves to watch over the pecuniary interests of the place, a rumor was set afloat that the Councilmen were drinking beer at the expense of the corporation.*
>
> *The price of beer, sold at taverns, was in that day fixed by the court at 12½ cents a quart; while the same authority rated whiskey, per half-pint, at 12½ cents; the same quantity of common brandy, at 18¾ cents, and cognac, rum, and wine were to be sold at 37½ cents by the half pint.*

UNKNOWN
1827

Two men from London, England, came to Richmond in 1827 to start a brewery. The *Public Ledger* at the time reported this fact, but not their names. It hoped that "the wholesome beverage should take the place of the burning whisky which is now so common."

This brewery was in the building of the defunct distillery of Dr. Cushman & Co., which was later owned by a Dr. Warner before closing. "It was scarcely more successful than the distillery; and was soon discontinued."[166]

MAIN STREET BREWERY, CHRISTIAN BUHL, GEORGE BUHL, 1833–1865
HAMMON & WINTERLING, WINTERLING & PAULUS, 1865–1869
EMIL MINCK & CO., 1869–1899
MINCK BREWING CO.,1899–1912

According to the *Palladium Item & Sun Telegram* of November 15, 1945:

> *Christian Buhl, direct from Germany, came to Richmond as early as 1830, established a brewery on Main street, west side of the town, near*

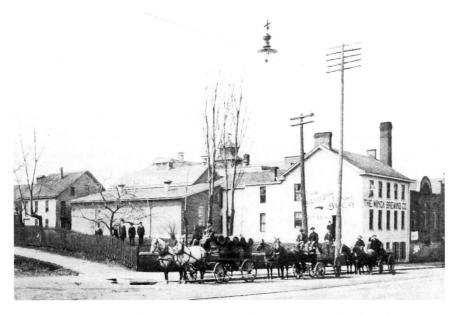

The Minck Brewery. From a plate at the Wayne County Historical Museum, dated "about 1900."

the National bridge [113 Main Street]. *It was extensively patronized, not only by the citizens, but by travelers and emigrants passing near it. At nearly every raising one or more kegs or buckets of Buhl's beer were drunk. The stream of small coin constantly flowing into his money drawer for a few years made him a comparatively rich man.*

Buhl first constructed a building for use as a tavern and expanded it in 1833 to include a brewery. The brewery and tavern were successful enough that the Buhl family purchased a large farm south of Richmond. Buhl died in 1861 at the age of sixty. His son, George, had by that time taken over the business as the Main Street Brewery before selling it to Winterling and partners.

In 1869, the business was purchased at a sheriff's sale by Emil Minck, an immigrant from Germany, who had worked in Columbus, Ohio, at the Hosier & Co. brewery. He bought the business so as not to lose money on loans he had made to the Winterling operation.[167]

Albert Morel was the president, and Adolph W. Blickwedel was the secretary when the Minck Brewing Co. was formed in September 1899. At this time, Emil Minck retired, and his sons went on to other businesses.[168]

The Minck family also had a pub at the corner of Sixth and North D run by William H. Minck.

According to W.A. Croshart in his article "Industries of Richmond" published in the *Historical Business Review* in 1881:

> He has made several improvements, among others has erected an ice house of frame and stone, 25x65 feet in size and 15 feet high, with a capacity for holding 300 tons of ice. The brewery in 45x75 feet, two stories, with large cellars and every equipment necessary for conducting a large business. On the premises, five large lots, are the brewery, ice house, dwelling and stables. The extent of business is now confined to this city and vicinity, Mr. Minck manufacturing a No. 1 quality of beer for family use. In this he has quite an extensive trade. He also bottles beer extensively…They are also maltsters, and make as good malt as can be had anywhere.

Minck's main brands were Select and Export.

Philip Halm was a brewer listed in the 1903 *Polk Richmond Directory*. Officers of the Minck Brewing Company when brewing ended for Prohibition were Lewis E. Iliff, president, and Adolph W. Blickwedel, secretary (he also had a tavern in the area). At the maximum, its capacity was reportedly four thousand bbls. There never was an ice-making system at this plant.[169]

Seemingly, there was an attempt to restart after Prohibition as the Richmond Brewing Co., but that did not last long and may not have produced any beer. The building became an auto parts store and was razed in 1960.

JOSEPH MARTISCHANG
1874–1883

This small brewery had a capacity of less than two hundred bbls. Joseph had previously been a cobbler. Upon his death in 1879, his wife, Margaret, took over the business.[170]

Richmond Bottlers

Bottlers of beer, soda, mineral water, etc., in Richmond and Cambridge City from 1860 to 1910 included:

H.W. Rosa and Son (later E.F. Rosa), bottling Christian Moerlein beer from Cincinnati
Louis B. Wrede at 1115 South E Street, bottling Hudepohl beer from Cincinnati
Hugh P. Taylor at 315 and 451 South Fifth Street
E.W. Klein at 617 Main Street
Eugene Morel at 409 Main Street
H.H. Ahaus at 505 South Ninth Street
George L. Klein at 215 South Fifth Street
Adam H. Kemper at 11 South Eighth Street
George M. Brucker at 429 Main Street
L.B. Thurman at 800 South E Street
F.W. Dirk

RIDGEVILLE

J.K. HAMMERLE
1874

Lays' brewery had production of 330 bbls and was open for just one year.
Joseph Lay and his son, Samuel Lay, moved their Joseph Lay Company, where they made brooms, from New York State to Ridgeville, Indiana, in 1886. "They took over an abandoned brewery (which looked something like an Eastern Orthodox church) and the buildings of a defunct college," according to company records.[171]

SHELBYVILLE

MARGARET STEPHAN
1874–1875

Fred Stephan, in 1849, at the age of thirteen, came with his family to Cincinnati from Freistodt, Germany, where he worked with his older brother at a brewery for two years.[172] He opened a brewery, which his wife, Margaret, inherited and closed. The business never made two hundred bbls of beer total.[173]

UNION CITY

WILLIAMS & NORTON
1860S

Louis Williams and Thomas M. Norton brewed ale in Union City in the 1860s. Norton left there in 1866 to move to Anderson and start another, much larger, brewery.[174]

WINCHESTER

CONRAD MEIER
1870S–1880

Conrad Meier from Bayreuth, Bavaria, moved to Winchester in 1873 and operated a bakery and brewery until 1880. The brewery had a maximum capacity of 355 bbls.

Indianapolis

A fter Indianapolis was platted and made the state capital in 1825, it grew quickly. The westward migration, the canal projects, the railroads, the building of the state government and, finally, the Civil War all contributed to the growth.

From 1861, Camp Sullivan (now Military Park) was used as a staging ground for Federal troops. This was within easy walking range of the downtown area and may help explain the growth of the tavern business in town.

The 1864 *City Directory* lists 57 saloons at a time when Indianapolis boasted about 20,000 citizens. By 1870, there were 129 saloons, and the population had more than doubled to 48,244. By 1895, Indianapolis boasted 403 "licensed liquor saloons."[175]

WERNWEG & YOUNG, 1834–1840
RENE FAUX, 1840–1842
JOHN MEIKEL, INDIANAPOLIS BREWERY, 1842–1873

William Wernweg and Walter Blake contracted with the National Road commission to build bridges in the central Indiana area in the 1830s. In 1834, John L. Young took Wernweg away from that to start the first commercial brewery in Indianapolis—on the south side of Maryland Street near West Street. The population of Indianapolis at that time was still only sixteen hundred people.

This brewery was sold to Rene Faux in 1840, and he kept it for about two years before starting another brewery with Charles Ghuss. Faux's

Saloons.

American, 25 S. Meridian.
Astor, Fey & Rammon, 9 N. Penn.
Leck Ed., 44 W. Washington.
Blues N., 48 S. Delaware.
Bork Eli, W. Indianapolis.
Burk George, 13 W. Washington.
Burt's Restaurant, 13 S. Illinois.
Bush & Hannum, 53 and 55 S. Ill.
Carroll's Saloon, 11 N. Illinois.
Caylor Santford, 220 E. Washington.
Central Restaurant, 6 W. Wash.
City Saloon, 53 and 55 S. Illinois.
Court House, cor. Wash. and Alabama, C. Monninger, proprietor.
Crystal Palace, E. Beck, proprietor, 44 W. Washington.
Cummings James, 194 W. Wash.
Dietz Adam, cor. Alabama and Fort Wayne ave.
Dietz Davis, 78 and 380 W. Washington.
Doty & Lee, opp. State House.
Eagle Saloon, 130 E. Washington.
East Empire, C. Lauer, proprietor, 162 E. Washington.
Empire, R. Beebe, proprietor, 28 W. Washngton.
Eurich & Schaffer, St. Nicholas Saloon, 7 N. Illinois.
Exchange, C. W. Hall, proprietor, N. Illinois.
Faber August, 73 S. Illinois.
Farmers', cor. Illinois and Georgia.
Florence's, F. Richter, proprietor, 13 N. Illinois.
Frenzell J. P., Kansas saloon, 83 and 85 S. Illinois.
Happe George, 81 S. Meridian.
Hofmeister Chris., 75 E. Wash.
Hug Martin, 14 E. Washington.
Johnson B. F., 212 W. Washington.
La Belle, D. Monninger, cor. Wash. and Kentucky ave.
Lang Louis, 13 E. Washington.
Little's Hotel, John Ledlie, prop'r.
Magnolia, 9 S. Illinois, S. A. Flagg, proprietor.
Matthes C., 163 E. Washington.
Mason M., cor. Illinois & Louisiana.
Miller Charles G., cor. Washington and East.
Morris House, R. Beebe.
National, 27 S. Meridian, G. Rhodius, proprietor.
Nebraska, Naltner & Naltner, proproitors, 14 Louisiana.
Niggerman Frederick, 186 E. Washington.
Oriental, S. Illinois.
Palmer House, R. Young, prop'r.
Paris, Eugene Ranard, proprietor, E. Washington.
Pearl Street, Thomas McBaker, proprietor.
Rennon J. B., 242 & 244 E. Washington.
St. Charles, 86 E. Washington, E. Haas, proprietors.
St. Nicholas, 7 N. Illinois, Eurich & Schaffer, proprietor.
State House, opp. State House, Doty & Lee, proprietors.
Station House, opp. Union Depot, F. Scheer, proprietor.
Telegraph Restaurant, 12 Louisiana, H. Walls, proprietor.
Union Hall, 107, 109, 111 and 113 E. Washington, M. Emmenegger.
Union, M. Hunter, proprietor, 81 E. Washington.
Verandah, opp. Union Depot, John Bussey, proprietor.
Wright C., 138 E. Washington.
Youngerman G., cor. Washington and Delaware.

Salt Agency.

Wasson J. H., N. W. cor. Washington and Meridian, Ohio River Salt Company.

Sash, Doors and Blinds.

Barr Jacob, 86 N. Alabama.
Byrkit & Beam, 60 S. Tennessee.
Kreglo, Blake & Co., cor. New York and Missouri.

Saw Manufacturer.

Atkins E. C., 155 S. Illinois.

Saw Mills.

Hill G. W., cor. East and Georgia.
Marsee J. R., near P. & I. Freight Depot.
Wells William F., Massachusetts ave., near city line.
Wishmire C. F., 189 N. Davidson.

Schools, Private.

Bronson G. W., Fifth Ward School House.
Carroll Miss Belle, Ohio, bet. Pennsylvania and Delaware, under Associate Reformed Church.

A list of saloons in Indianapolis from the 1864 *City Directory*.

partner, John Philip Meikel, kept on at this original site, albeit without much success. He bought the Carlisle House hotel on the south side of Washington Street, just west of West Street, in 1848 and transferred the brewery there. It thrived, outgrowing that location, and moved a block east to 399 West Washington Street sometime before 1870.

Meikel also dealt in real estate and laid out the Ransom Place neighborhood in 1865.[176] The financial panic of 1873 caused him to lose everything.

James McBride Shepherd joined Meikel's brewery after the Civil War and became the manager, "a position he continued for ten years."[177]

Ferdinand Brummer, Theodore Holler, Otto Jager, John Kissling, Peter Meyer and George Swan are listed as brewers in various editions of the *Indianapolis City Directory*.

RENE FAUX
1842–AFTER 1857

Rene Faux, an immigrant from France, bought the first brewery in Indianapolis, Wernweg and Young's enterprise. Two years later, he left partner John Meikel and started a new brewery on the east side of town, near Washington and College (then Noble) Streets, with a new partner, Charles Ghuss. They also sold yeast for home baking use.[178]

AUGUSTUS IMBERY
1857–1861

Augustus Imbery had a boardinghouse with an integral brewery located opposite the railroad depot, on South and Pennsylvania Streets, a half mile south of the city center.

DIETZ & HIEBNER, 1858
JACOB HIEBNER, 1859
A. JACQUET, 1860

This brewery was located at 278 East Washington Street. Jacob Hiebner and his partner split up when George Dietz went with E. Davis to operate the Washington Hall Saloon and Restaurant at 78–80 West Washington in 1860.[179]

Adolph Jacquet was a "French Wine Dealer" as well as a brewer.[180]

SCHMIDT & JAEGER, 1858–1859
C.F. SCHMIDT BREWING CO., 1858–1889
MERGED INTO INDIANAPOLIS BREWING CO., 1889–1920

Christian Frederick Schmidt and Charles Jaeger founded their brewery on a plot of land they bought for $250 on High and Wyoming Streets, east of what are now Madison Avenue and Morris Street. Schmidt was a twenty-seven-year-old immigrant from Germany.

Jaeger soon sold his interest to Schmidt, thinking Schmidt's management unsound and his expansion plans too aggressive. Schmidt bought a few lots in the area on speculation and sold them at a profit, allowing him the capital to expand the brewery operations.[181]

Soon, he built a larger plant on Terrace Street at Madison Avenue—two stories high and ninety-three by forty feet, with a two-and-a-half-story brick icehouse of sixty by eighty feet. This was located above a two-story ninety-four- by eighty-five-foot cellar. A separate icehouse could hold eighteen hundred tons. Stables and a malt house completed the plant. A bottling house was added in 1881.[182]

C.F. Schmidt made a bottom-fermented lager that was much closer in character to the European beers more familiar to many Hoosiers than the strong beers made in earlier days, when ordinary baking yeast was the norm.

Charles Abel, John Buhier, Louis Ehrmann, Ernest Ihrzohn, Henry Metzger and Joseph Resoh were brewers through this time, producing about fifteen hundred bbls per year.

In addition to owning the brewery, Schmidt was on the city council and was a director of the Guttenberg Printing & Publishing Co. He died in February 1872, and his widow, Caroline, operated the business with her brother, William Fieber, until 1874, when he died. She then took sole control until she died in 1887. Her sons, John William and Edward Schmidt, then took it over until the merger just two years later.

In 1879, C.F. Schmidt sold 25,288 bbls of beer.[183] The sales for the year 1882 reached nearly 60,000 bbls.[184] By 1884, the plant took up an entire block at McCarty, Alabama and Wyoming Streets—now completely covered by the Eli Lily corporate headquarters.

Brands included Bock, Budweiser, Cream Ale, Dublin Porter, Export, Stock Ale and Tonica. It also produced a malt extract called Valentine Beer.

Schmidt was merged into the Indianapolis Brewing Company in October 1889. By that time, it had agencies in Terre Haute, Crawfordsville, Columbus, Brazil, Rochester and Shelbyville and in Danville, Illinois.[185]

After the merger, each brewery (Schmidt, Maus and Lieber) continued its own brewing operations and brand recognition. John W. Schmidt was for many years on the board of the new company.

The C.F. Schmidt plant at McCarty and High Streets closed on May 27, 1920, after seventy years of brewing. John Schmidt's house is at 1410 North Delaware Street, the Propylaeum. It is open for lunch and afternoon tea. Tours are given by appointment.

GACK & BISER, 1859–1863
P. LIEBER BREWING CO., P. LIEBER AND CO., CITY BREWERY, 1863–1889
MERGED INTO INDIANAPOLIS BREWING CO., 1889–1896

Little information survives about the Gack & Biser brewery—not even the owners' first names. Many sources say the brewery was Gagg & Biser. We do know that their company was located between Pennsylvania and Madison Avenues, between South and Merrill Street, just south of the Imbery Brewery and two blocks west of the C.F. Schmidt Brewery.

Peter Lieber, an immigrant from Duesseldorf, Germany, came to the United States at the age of eighteen. He lived in Cincinnati with his older brother, Herman, and in New Ulm, Minnesota, before enlisting in the Union army. When General Oliver Morton was elected governor of Indiana in 1861, Peter became his private secretary.[186]

Peter, brother Herman and Charles Mayer bought Gack & Biser in 1863 and renamed it the P. Lieber Brewing Company.

Herman Carl, John Scherer, Conrad Schneider, Henry Voegele and Julius Schetter are listed as brewers in the 1865 *Indianapolis City Directory*.

The brewery relocated to 1330–40 Madison Avenue, south of Morris Street, constructing a bigger plant in 1878. In 1879, it sold about fifteen thousand bbls of beer.[187]

Mayer retired in the 1870s, and Peter Leiber bought his shares. Herman sold his interest in 1880 to William Schrever, and a reincorporation immediately took place. Joseph Geis was the head brewer at that time.[188]

The brands were Special Brew, Olden Time Ale, Porter, Tafel, Würzburger Style and Hoosier Beer.

Peter retired due to ill health in 1887 and returned to his boyhood home, Düesseldorf, where Grover Cleveland appointed him American consul in 1893. He continued in that post until World War I started. He died in 1915.

At the time of the merger, Albert Lieber, Peter's son, became the director, treasurer and manager of all three brewing arms of the Indianapolis

Brewing Company (IBC).[189] He was also on the boards of the Chicago Consolidated Brewing & Malting Co., the Jung Brewing Co. of Cincinnati and the Merchants National Bank in Indianapolis.[190]

Brewing in the Lieber plant continued until a fire on July 15, 1896. The IBC continued to use the Lieber name on Gold Medal, Special Brew and, during Prohibition, a Malt Extract, a nonalcoholic Ozotonic and a line of sodas, which included cola, root beer, cherry, ginger ale, lime cola, strawberry, orange and a concoction called sour mash.

Albert Lieber's grandson, Kurt Vonnegut, said in a 1976 interview that Gold Medal Beer had a secret ingredient: coffee.[191]

CAPITAL BREWERY
1864–1876

Frank M. Wright and W.S. Downer's Capital Brewery was located in what is now the middle of the IUPUI campus on Blake and New York Streets. By 1867, it had a dozen employees, including cellermen, bottlers, laborers, two bottle washers, a corker, a bookkeeper and Frederick Bolster as brewer. It also dealt in oysters and canned fruits.[192] William C. Richert was the brewer in 1870.

Brands included Pale Stock, Amber and Champagne Ale. Capital was the first in Indianapolis to make an ale versus a "strong beer," or "common beer," using wild yeasts, but when lagers proved more popular in heavily German Indianapolis, it succumbed to the competition from C.F. Schmidt's products.

HARTING & BROS.
1865–1877

Frederick and Henry H. Harting started this brewery just north of the C.F. Schmidt Brewery, at 7 Norwood Street. August Krist, Henry Kriger and Leonard Schmidt were the brewers.[193] Production in 1875 was 1,065 bbls.

CASPER MAUS & CO., 1865–1889
MERGED INTO INDIANAPOLIS BREWING CO., 1889–1948

Casper Maus, an immigrant from Eberbach, near Metz in the Alsace-Lorraine region of France, moved to Indianapolis in 1864 from New Alsace in Dearborn County, Indiana. There, he had been the justice of the peace and an enrolling officer for the Union army when the draft went into effect.

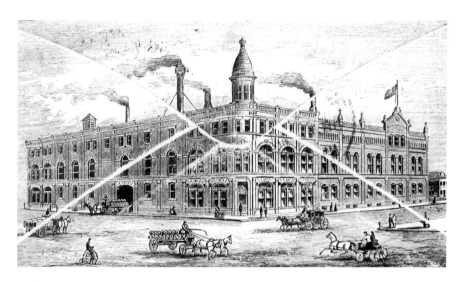

The Casper Maus factory on the back of a company envelope.

His gristmill was burned in 1863 by Morgan's Raiders, who also ransacked two breweries and sixteen saloons in New Alsace as they passed through.[194]

This brewery was located on the corner of New York and Agnes Streets (now University Boulevard). Early brewers were Frederick Dietrich, John Lederer, George Kalb and Henry Neiger.[195]

Most of Casper's six sons were active in the business. Oldest son Frank A. was in management, while Joseph H. and Clement A. were brewers in the 1870s. In 1879, they sold seven thousand bbls of beer.[196]

When Casper died in 1876, Frank, then thirty-eight years old, was well trained to take over the company. In 1877, Frank was elected to the Indianapolis City Council. One daughter, Josephine, married Joseph Charles Schaf, who worked at the brewery and went on to found the American Brewing Co.

Our subject company bought the Nashville (Tennessee) Brewery in 1878, only to sell it in 1889. Christian Moerlein Brewery of Cincinnati owned that company for a while, and then the William Gerst Brewing Co. was in business until 1954.

The major product was C. Maus' Bock Beer. C. Habich & Co. did the bottling. The first artificial ice plant in Indianapolis was installed at the Maus Brewery in 1881.

The plant continued brewing under the merger until it was converted into a distillery in early 1900. After closing in 1945, it was torn down in 1958 to make a parking lot for the IUPUI campus.

UNION BEER BREWERY, 1870–1874
PETER BALZ, 1874–1877
BALZ & CO., 1877–1879

The Union Beer Brewery was on Dunlap Street (near Morris Street), one block east of Madison Avenue and owned by Conrad Sponsel and Peter Balz.[197] It was reported to have had a production of 1,675 bbls per annum.[198]

Conrad Sponsel died in 1874, and Peter Balz continued the business. It was renamed in 1877 to Balz & Co. Alois Balz and John Hoffmann were listed as brewers in Polk's 1879 *City Directory*, but Balz & Co. did not report any beer sales to the United States Brewing Association and seems to have disappeared in that year.

ALBERT HITZELBERGER
1877–1888

Albert Hitzelberger ran a downtown saloon at 18 South Delaware Street, and in 1875 or 1877, he started a small brewery at that establishment, with John Walker as the brewer.[199]

INDIANAPOLIS BREWING CO., 1889–1948
PETER LIEBER, 1889–1896
C.F. SCHMIDT, 1889–1920
CASPER MAUS, 1889–1948

Three brewing companies (C.F. Schmidt, P. Lieber and Casper Maus) formed the basis of the Indianapolis Brewing Company (IBC), started by an "English syndicate" in 1889. Each brewery continued independent brewery operations.

The City of London Contract Corporation set up shop in the United States to buy brewery interests. The first was in Rochester, New York, where it bought Bartholomay and Genesee. Then, in New York City, it bought Emerald and Phoenix. More buyouts followed in Denver, Indianapolis, Cleveland, Toledo, Detroit, Baltimore, San Francisco, St. Louis (where it consolidated eighteen breweries), Chicago and Milwaukee.[200]

Albert Lieber, Peter Lieber's son, was the first managing director and president. Frederick Franeke (son-in-law of Peter Lieber) was vice-president, John P. Frenzel was secretary, and Otto Frenzel was treasurer.[201] Edward Daniels and Albert Baker were on the board of directors.[202]

By the turn of the century, the total output was 500,000 bbls annually, with one thousand workers. It had also introduced Progress, Tafel and Duesseldorfer brands. Exports to the Philippines, Cuba, Puerto Rico, China, South America and Africa augmented distribution to "all parts of the United States."[203]

The IBC embarked on a program to prove its beers were the best by entering lagers in many prestigious competitions. It won a gold medal for Duesseldorfer at the Paris Exposition of 1900. There was a "magnificent industrial parade" when the officers of the company returned with the medal. It also won the grand prize gold at the St. Louis World's Fair in 1904 and gold medals at Liege, Belgium, in 1905, Milan in 1906 and Madrid in 1907. Large advertising campaigns were centered on these accolades.

Pre-Prohibition brands included Wiener, Dublin Porter, Bock, Cream Ale, Budweiser, Stock Ale and Export from the C.F. Schmidt plant.

Special Brew, Tafel, Atrium, Gold Medal, Hoosier, Wurzburger and the nonalcoholic malt extract were produced at the Lieber plant until 1896, when it was closed.

Progress, Champagne, Dusseldorfer, Hop Ale, Half and Half, Pale Ale and Olden English Ale were made at the C. Maus plant, and limited bottlings were run for the Pennsylvania Railroad and the Ponce de Leon Hotel in Florida.

The Casper Maus plant was converted into a distillery in early 1900. After Prohibition, it converted back as the main brewery in the conglomerate.

By 1914, the combined company had five hundred employees, 210 head of horses and nine automobiles to produce thirty million bottles per year.[204]

Before and during Prohibition, the IBC made a malt tonic using the Tonica name, as well as Ozotonic and Gold Medal Cereal Beverages.

The C.F. Schmidt plant was closed in 1920. After Prohibition, several companies attempted to resurrect this brewery. John Beyer was the principal in one effort, which was to reuse the name Home Brewing Co. They bought the empty building as the International Brewing Co. and planned a $200,000 renovation. In July 1933, there were two fires at the Madison Avenue plant. One, in the evening, "swept through the four-story structure," and another, at three o'clock the next morning, was in the malt bins. The brewing equipment had not yet been installed in the new building, and the total damage was estimated by the fire department at about $4,000. International did have the building fully insured, but beer was never brewed there, and International disappeared.[205]

The IBC was reorganized once more in 1935 with $250,000 capital stock. It had a production capacity of 100,000 bbls annually. William E.

Clauer was president, and George J. Steinmetz was vice-president of this new company.

In 1938, the company appealed a case to the U.S. Supreme Court to fight Michigan's beer importation laws. Basically, Michigan prohibited importation of beer from states that discriminated against beer from Michigan. Indiana, beginning in 1935, required a license of $1,500 and a bond of $10,000 from distributors for a "port of entry" permit. IBC lost. This case (305 U.W. 391) has been referenced many times, including in G. Heileman's bankruptcy and in many cases about mail-order beer and wine sales.

Post-Prohibition brands were Mausner Lager Beer ("Like the Old Days"), Mausner Hy-Test at 4.5 percent alcohol by volume (ABV), Capital, Cream Velvet, Progress, Circle City, Crown Select, Deluxe Bock, Burgomaster, Burgomaster Bock, Pilsner Club, Indiana Club Pilsner and Bock, Jung's All Malt Pilsner, 20th Century Pale Beer, Efsie Lager and Derby. A Gold Medal line included Lager, Bock and October Ale. A Lieber line included Lager, Krausened Beer, Export and Bock.

Records from 1937 say that expenses for the company included $228,876 in payroll, materials costs of $219,762 and total taxes of $540,181.[206]

The year 1945 brought a rumor that the IBC would be sold to Schenly Distillers, which at that time owned Blatz, but Clauer refuted it.[207]

The last sale of the company happened in December 1945 to Alvin and Lawrence Bardin's newly purchased Eulberg Brewing Co. of Portage, Wisconsin, in order to make their Crown Select, Twentieth Century beers and Old Towne Lager for the Indianapolis market. The selling price was near $500,000. The Bardins announced plans to spend $200,000 in improvements, but the post–World War II era shortages caused that not to happen.

The IRS put a claim of $636,000 on the IBC in 1947. Attorney Joseph Nunan got the IRS to turn this into a $35,000 refund. It may have helped that Nunan had been the commissioner of the IRS from 1944 until 1947 and that the buying of the brewery in 1945 was financed by Frank McKinney, chairman of the Democratic National Committee.[208]

The IBC closed when the president, Lawrence Bardin, was arrested for income tax evasion.[209] He served six months in prison in 1948 and four more starting in 1953.

AMERICAN BREWING CO.
1897–1917

Joseph Charles Schaf was the president of the American Brewing Co. (ABC). He was the son-in-law of Frank Maus of the Casper Maus brewery.

The American Brewing Co. logo, from its letterhead.

Anthony J. Krass was vice-president, and Herman Habich was the secretary, treasurer and superintendent.

The brewery was located in a five-story complex that, after three plant additions, stretched from Market Street north to Ohio Street, just one block west of the state capitol building. It produced about thirty thousand bbls per year and had twenty-eight employees.

In 1899, ABC sold an option for the brewery to be included in a trust merger by an Eastern and English syndicate. This fell through before completion.

Its Bohemian brand was a lager that had an alcohol by volume (ABV) of 3.6 percent. Its ABC brand beer was 3.9 percent ABV.[210] Both percentages were about typical for the day. The brewery also made a wheat (weiss) beer, which was popular with the German population of Indianapolis.

ABC sponsored the Indianapolis ABCs Negro League baseball team. The team was previously the Birmingham Giants and the West Baden Sprudels. The team moved to Indianapolis in 1914 and was renamed to match the new sponsor. The ABCs won the Colored World Championship in 1916. The manager of the ABCs, Charles I. Taylor, had played with the Birmingham Giants and bought an interest in the American Brewing Co.[211]

The following ad ran in the *Indianapolis Star* on March 28, 1915:

BLUE LABEL
The Claypool Hotel serves American Brewing Co. Beers in both cafe and buffet. Its delicious flavor commends it to those who know there is at the same time the most convincing proof of its purity and character.

HOME BREWING CO., 1891–1901
AMERICAN HOME BREWING CO., 1901–1920

The Home Brewing Co. was organized in 1891 with $200,000 initial capital from ninety local stockholders. William P. Jungclaus was president, and Andrew Hagen was secretary and treasurer.

August Hook, an immigrant from Viernhelm, Germany, was one of the organizers of Home Brewing Co. and was the director of operations until he died of pneumonia on December 10, 1909, at age sixty. Before coming to Indianapolis, he was the brewmaster at the Lackmann Brewery in Cincinnati.

An expansion in 1897 saw a refrigeration machine installed and the plant expanded to a quarter of a city block. By 1907, it had twenty-five wagons delivering to the downtown area, employed sixty men in total and produced over fifty thousand bbls of beer.[212]

In 1901, the company was reorganized as the American Home Brewing Co., with Christian W. Waterman as president and August Hook as vice-president.[213] Rudolph Schaeffer later became president, and Adolph Schmidt became secretary. Another $200,000 was invested in 1903.[214]

Brands included Columbia, Indiana, Home Brew Pale Select, Stock Ale and Porter. Malt Extract and Homo near beer were made during Prohibition.

From a production capacity of sixty thousand bbls at its peak, Home Brewing did not make it through Prohibition.

Located on the south side of Washington Street at Shelby Street, the building still stands. A carved block reading "Bottling House" can be seen on the north side. It was used by the Majestic Tire and Rubber Company for many years.

CAPITAL CITY BREWING CO., 1905–1915
CITIZENS BREWING CO., 1915–1918
MID-WEST BREWING CO., 1933
RICHARD LIEBER BREWING CORP., 1933–1934
LIEBER BREWING CORP., 1934–1937
PHOENIX BREWING CORP., 1937–1938
AJAX BREWING CORP., 1938–1941

This brewery was located on West and Kansas Streets (now 1264 South West Street). The Capital City Brewing Co. filed $250,000 in capital stock on August 6, 1904. Charles Krause was president, John J. Giesen was vice-

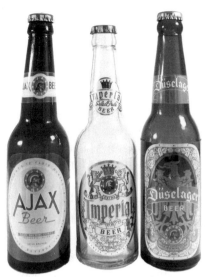

Above left: Colonel Richard Lieber. From *Indiana and Indianans: A History of Aboriginal and Territorial Indiana and the Century of Statehood* (American Historical Society, 1919).

Above right: Ajax bottles: Ajax Beer, Imperial Beer and Düselager Beer.

president and Victor Jose was secretary and treasurer. The startup money was used to build a full brewing plant with access to rail transport. It opened in 1905.[215]

Brands included Capital City Brew, T.T., Frauenlob (a dark beer) and, believe it or not, Camel's Milk. T.T. referred to the motto "Taste Tells."

There isn't much information about the Citizen's Brewing era. It seems to have limped along into Prohibition making Peerless Citizens beer.

Near the end of Prohibition, it was obvious that the dry times were over, and many breweries were restarting. In January 1933, Frank Borghoff, Clarence C. Arnold, Nathan T. Washburn and John J. Kennedy incorporated the Mid-West Brewing Company, Inc., to buy the old Citizens Brewing plant.

At this point, another gentleman enters the story—a man of great accomplishment and influence who was from a local brewing family. Colonel Richard Lieber was born in Düsseldorf, a nephew of Peter and Hermann Lieber of the P. Lieber Brewery. He moved to Indianapolis in 1891 and worked as a reporter at his father-in-law's *Indiana Tribune* until that newspaper was sold in 1907. At that time, he started a bottling company that made sodas and ginger ale.

Lieber was truly the father of the Indiana Parks System, having been the chairman of the National Conservation Congress held in Indianapolis in 1912. He personally raised donations to buy the land for Turkey Run and McCormick's Creek State Parks and was the first director of the Indiana Department of Conservation. He had traveled with Teddy Roosevelt and John Muir to the western to-be parklands in California. He was also instrumental in contracting with Bruno Schmitz to build the Soldiers' and Sailors' Monument in Indianapolis. Lieber State Park is named after him.

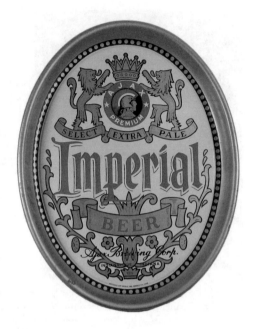

Advertising tray for Ajax Premium Select Extra Pale Imperial Beer.

By 1933, he was disgusted with the politics of the governor's appointments and the gutting of the state conservation programs, so he quit, returning to corporate life for a while by buying into the brewery that was immediately renamed for him.[216]

In 1934, Lieber Brewing Corp. was reincorporated with Richard Lieber as president, Ralph Lieber as vice-president, John J. Kennedy as secretary/ treasurer and John M. Simpson and Rollin P. Spiegel as directors.

In 1937, Richard Lieber went back to working for conservation causes. Merrill B. Johns replaced Lieber as president, and F.B. Evans became chairman of the board of the new Phoenix Brewing Co.[217]

Just one year later, another sale saw the plant become the Ajax Brewing Corp., with president and general manager J.L. Reuss. Jacob Guehring was the brewmaster.

In 1939, Fred J. Gerhardt replaced Reuss, who moved on to Centlivre Brewing in Fort Wayne.

Brands were Ajax, Ajax Dark, Ajax Bock, Imperial and Düselager. Just before World War II, Ajax closed, and the plant went idle.

Southeast Indiana

AURORA

S. SIEMANTEL
1858–1870

Simon Siemantel, an immigrant from Bavaria, bought an old Methodist church at the corner of Third and Bridgewater Streets, which he converted into a flour mill and brewery. He operated those businesses until 1870, when he sold the building as a working mill and opened a grocery and saloon.[218]

AURORA BREWING AND MALTING CO., 1870–1873
GREAT CRESCENT BREWERY, 1873–1890
CRESCENT BREWING CO., 1890–1899

Thomas Gaff, an immigrant from Scotland, learned distilling in Brooklyn at his uncle's knee. He, along with brothers James and John, opened a successful distillery in Philadelphia. After the economic panic of 1837, Thomas and James moved their business to Aurora, building the T. & J.W. Gaff & Co. distillery on the banks of Hogan Creek in 1843. It made bourbon, rye and Thistle Dew scotch whiskey. This location became the foot of Mechanic Street.[219] Later additions were made in many locations in the downtown area. The brothers owned many businesses in town, as well as several steamboats that transported the distillery and brewery products.

The Gaffs started the Aurora Brewing and Malting Company in 1870 at a cost of $150,000.[220] They renamed it Great Crescent Brewery in 1873. The major brand was Aurora Lager Beer. Very popular, it was prominent in Cincinnati and even exported to Germany. In 1879, they sold 30,731 bbls of beer and operated the largest brewery in the state of Indiana.[221]

A fire at the brewery on October 25, 1881, caused $150,000 in damage. It was insured for $43,500.[222] An explosion in January 1891 killed two men, Swift and Pfeister.

Brands produced in the brewery's last decade included Lager, Pilsener and Felsenbier. By this time, Great Crescent was producing eighty thousand bbls annually.

The brewery assets were sold in February 1890 to an English syndicate for $700,000. Jung's Brewery in Cincinnati was also bought at that time (for $800,000), the two forming Watneys' Cincinnati Breweries, Inc.[223] The company stopped brewing in Aurora in 1899, selling the Crescent Brewery at a loss, garnering only $50,000. It never reopened.[224]

The Gaffs were involved in other businesses, including a dry goods and grocery store, and Thomas was the president of the First National Bank. The Aurora Fire Company was started in 1876 in the Gaff distillery building. The brothers also owned steamboats and even silver mines in Nevada.

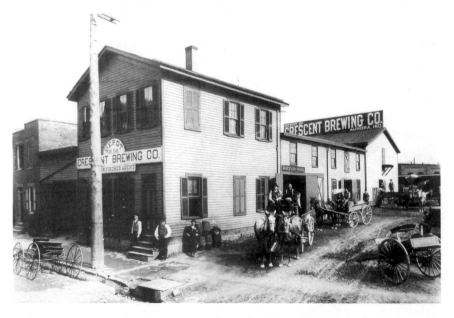

The Crescent Brewing Co. depot from a picture at the new Great Crescent Brewery.

Gaff & Co. also had, starting in 1867, a plant in Columbus, Indiana, making Cerealine, the first dry breakfast food, similar to cornflakes but made from uncooked grits. It moved that production to Indianapolis in the late 1800s.

Gaff's home, Hillforest Mansion, is a National Historic Landmark and is open for tours.

BATESVILLE

BATESVILLE BREWERY
LATE 1860S

Shortly after the Civil War, John Zuber owned the Batesville Brewery.

BROOKVILLE

Four small breweries are listed as having been in operation in Brookville. Three, owned by Godfried Seibel, Adam Stock and Conrad Wissel, operated in the 1870s.[225]

JOHN BUSSARD
1874–1882

The fourth brewery in Brookville was owned by John A. Bussard. This may have been in Franklin County, outside the town of Brookville, either in Brookville Township or Highland Township. It lasted until at least 1882.

COLUMBUS

Elizabeth Seeling had a small brewery in the Columbus area during the 1870s.[226]

AUGUST SCHREIBER
1868–1885

Schreiber made up to one thousand bbls per year. His brewery was located at the south end of Jackson Street, near the Madison & Indianapolis Railroad.[227]

DOVER

BALTHASAR HAMMERLE
1840S–LATE 1850S

In 1833, Balthasar Hammerle, an immigrant from Wersterville, Gelheim, Bavaria, moved his family to Dover in Dearborn County and bought fifty acres of land for fifty dollars. His occupation was tailoring, but this proved to be unprofitable, so he built a brewery. He continued his brewery until 1856, when he turned over the business to his son.[228]

LAWRENCEBURG

GEORGE ROSS
1845–1857

George Ross constructed his Lawrenceburgh (later to drop the "h") brewery in an old cotton mill and "could make 20 bbls of beer each day."[229]

BECKENHOLDT BREWERY
1845–1860

John Beckenholdt, an immigrant from Germany, resided in Newtown and maintained his brewery until he died in 1860.[230] Newtown, in Dearborn County, no longer exists; it was incorporated as a city just northwest of Lawrenceburg in 1846 and is now within the city limits.

KOSMOS FREDRICK, 1850–1857
J.B. GARNIER, 1857–1866
GEBHARD AND HAUCK, 1866–1868?

Kosmos Fredrick had a fairly small brewery in town. In 1857, John B. Garnier, finding his sales greater than the production capacity at his brewery, bought Fredrick's business. Garnier sold the plant in 1866, when a larger facility was ready.[231]

Gebhard and Hauck had a lime and cement business in Lawrenceburg and added this brewery business to their activities when it became available. They kept the brewery in operation until at least 1868.[232]

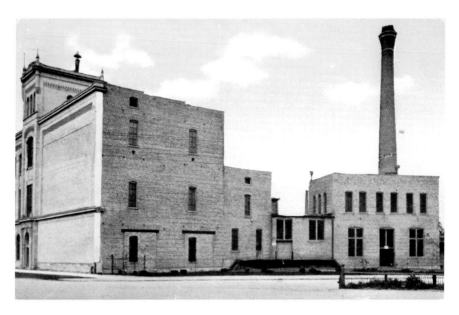

An early twentieth-century postcard of the Hammond Brewing Co. building.

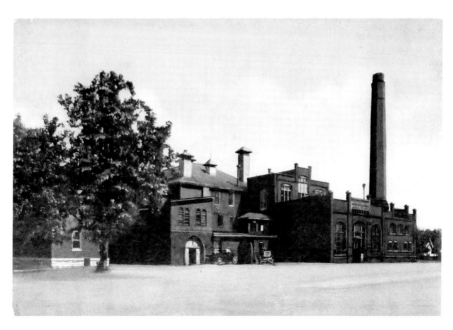

An Eagle Brewery postcard.

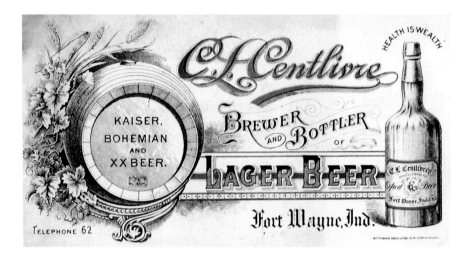

Above: C.L. Centlivre business card.

Below, left: A Centlivre Factory postcard, plus an assortment of Centlivre beers through the ages: 1862 Classic Beer, "Little Nick" Nickl Plate, Classic beer from World War II, a flattop can and Old German Style Beer (a Renner brand).

Below, right: Centlivre Brewing Export Beer in a corked, blob-top bottle.

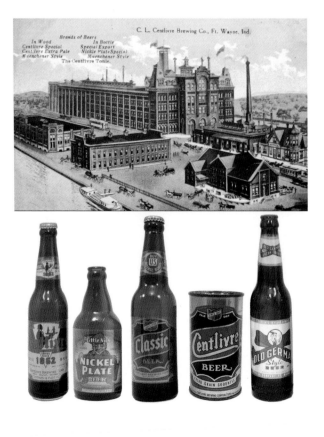

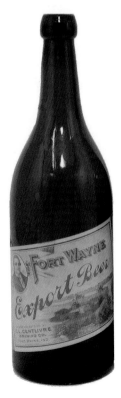

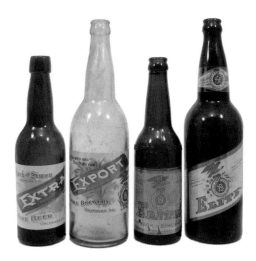

Right: Some Hack & Simon bottles: Extra, Export and Elite.

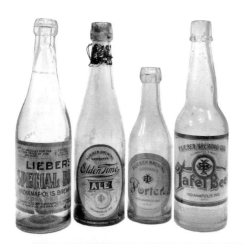

Left and Below: Some pre-Prohibition Lieber beer bottles: Special Beer, Olden Time Ale, Porter and Tafel Beer. Plus a printer's sheet of an ad for Lieber's nonalcoholic Ozotonic: "A boon to nursing mothers and their babies as well. Replenishes fresh, healthy blood, worn out tissues, keeping both mother & child mentally and physically vigorous.... Makes baby chubby and restful. Restores mental and physical vigor. Makes people feel and look young. Enhances good complexion—natural beauty."

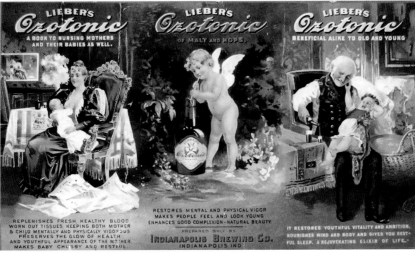

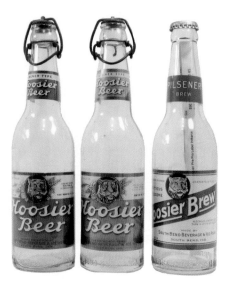

Left: Prohibition Hoosier near beer bottles.

Below: Post-Prohibition Hoosier Beer packaging.

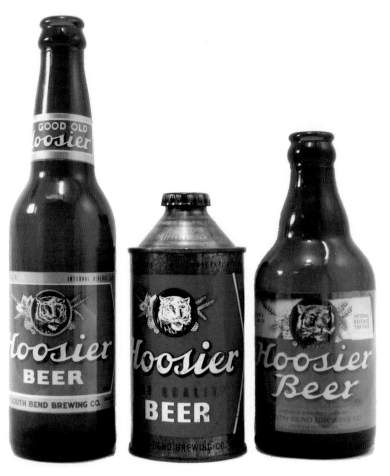

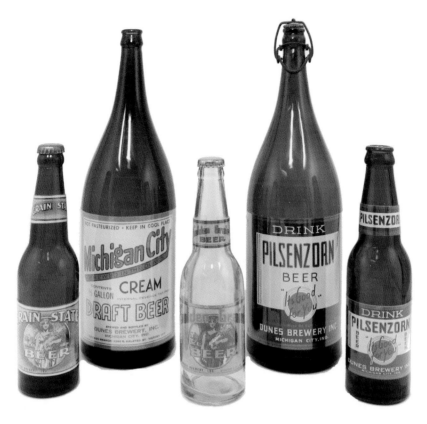

Above: A selection of Zorn bottles from pre- and post-Prohibition.

Below: T.M. Norton beers: Bock, Gold Band, Old Pal, Old Stock and Pilsener.

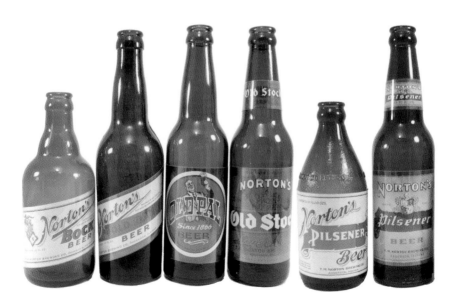

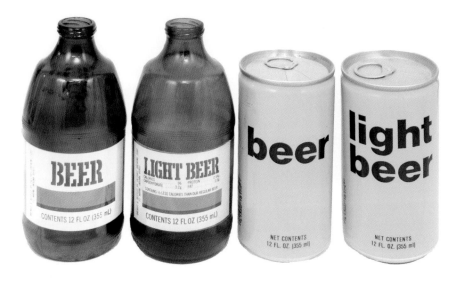

Above: Generic beer and light beer made by Falstaff in Fort Wayne.

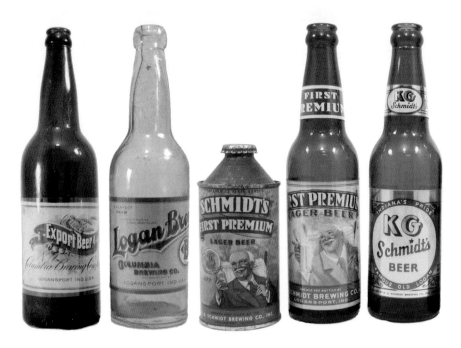

Above: Columbia and Schmidt's beers: Columbia Export and Logan Brew; Schmidt's First Premium and Indiana's Pride.

Opposite: A lithograph of the brands produced by the Schmidt Branch of the Indianapolis Brewing Co.

Row 1: Ram, Rock Bottom Downtown Indianapolis, Wildcat and Glacier's End.
Row 2: Brugge Brasserie, Sun King, John Templet of Half Moon and Andrew Lewis of the Brass Monkey.
Row 3: Lafayette Brewing Co., Jessica and Chris Johnson of People's and Chuck Kircilek of Back Road.
Row 4: Barb Kehe of Duneland, Sam Strupeck of Shoreline and Mishawaka Brewing Co. *Row 5*: Big Woods Brewing Co., Line at Dark Lord Day at Three Floyds and New Albanian Bank Street Brewhouse.

Opoosite bottom: *Row 1*: Dan and Lani Valas of Great Crescent, LiL' Charlies Steakhouse & Grill and Bloomington Brewing.
Row 2: Upland Brewing, Mark Snelling, Frank and Julie Forster and friends of Bee Creek and Power House Brewing.
Row 3: Crown Brewing, Turoni's, Little Cheers, Falcon bottles and Todd Grantham of Mad Anthony.
Row 4: The Oyster Bar, Warbird cans, Granite City in Fort Wayne, and Oaken Barrel,
Row 5: Brickworks Brewing, the last day at Indianapolis Brewing, Broad Ripple Brewpub, Alcatraz and CircleV bottles.

Row 1: Jeff Eaton of Barley Island, Roderick Landess of New Boswell, Tucker bottles and South Bend Brewery logo. *Row 2*: Brian Wiggs of Nine G Brewing Co., Terre Haute/Vigo Brewing Co. and Aberdeen Brewing Co. *Row 3*: Lynn and Tom Uban of Figure Eight, Goodfellows and Wilbur Brewing brew house.

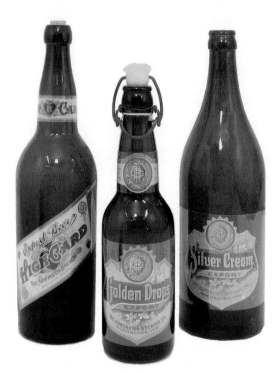

Huntington Brewery bottles:
High Card, Golden Drops and
Silver Cream.

J.O. Cole's White Seal
Extra Export and
Golden Export bottles
and a Peru Brewing
Company Bock.

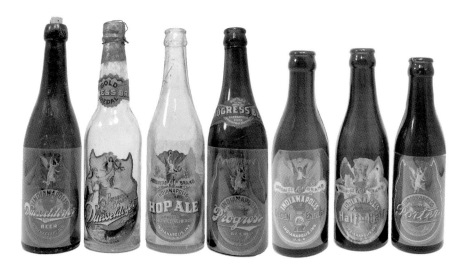

Indianapolis Brewing Co. Progress Brand bottles: Düsseldorfer Style Beer, Hop Ale, Progress Beer, Olden English, Half and Half and Porter.

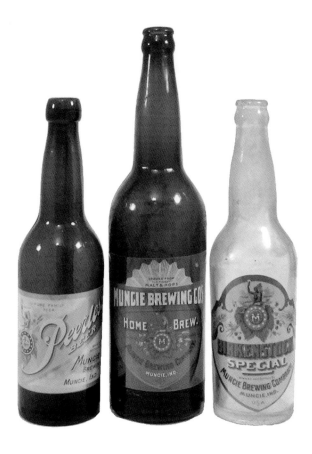

Muncie Brewing Co. bottles: Peerless, Home Brew and Birkenstock Special.

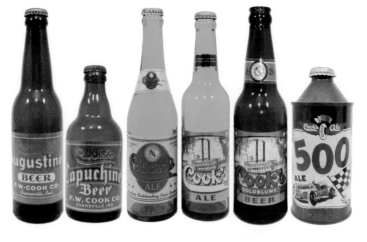

A selection of post-Prohibition Cook's beers: Augustiner, Capuchiner, Cook's Ale, Goldblume and 500 Ale.

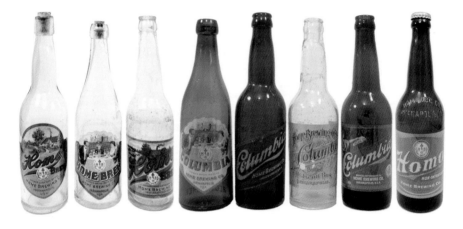

Three Home Brewing Co. bottles, four Columbia brand bottles and Homo Prohibition near beer.

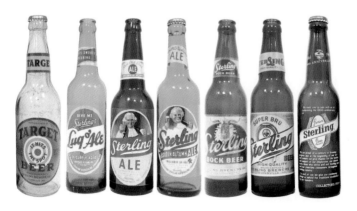

Some Sterling Brewers Inc. bottles: Target, Lug o' Ale, Sterling Ale, Golden Autumn Ale, Bock, Super Bru and a 100th anniversary painted bottle called a "Collector's Item."

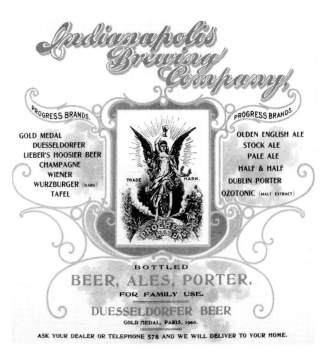

Left: A consolidated Indianapolis Brewing Company sales card.

Below: Representative cans produced by the Sterling Brewers Association: 20 Grand Cream Ale, Pfeiffer, 9-0-5, Cook's Export, Tropical Ale, Bavarian's Select Beer and Champagne Velvet.

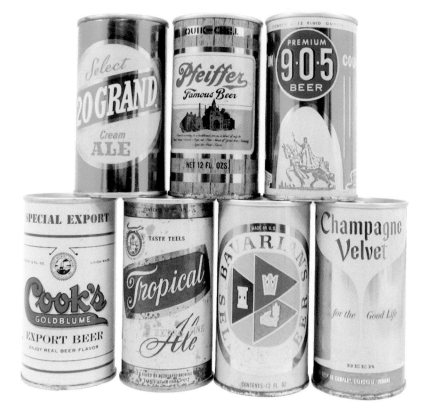

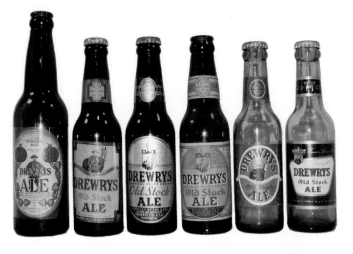

Selection of Drewrys Strong Ale and Old Stock Ale bottles.

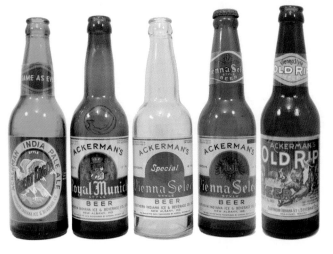

Ackerman's bottles: India Pale Ale, Royal Munich, Special Vienna Select, Vienna Select and Old Rip.

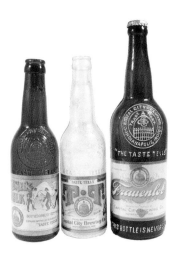

Far left: Capital City Brewing Co. bottles: Camel's Milk, T.T. and Frauenlob.

Troy Model Brewery bottles: Kunklers Gold Standard and Pearl of Troy.

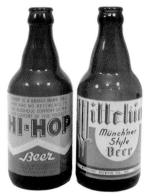

Above: Old European Brewery and Colonial Brewery bottles produced by the Evansville Brewing Co. in 1996 and 1997.

Left: Wittekindt beer stubbie bottles: Hi-Hop and Münch'ner Style Beer.

A bit of the Derrick Morris collection.

J.B. Garnier Malt House and Brewery
1855–1916

John B. Garnier, an immigrant from France, began a malt house in Lawrenceburg in 1840 and later owned a distillery. The malting business proved profitable by selling to distilleries in nearby Aurora and Cincinnati.

In 1855, he started brewing on a ten bbl system in a small building at Third and Shipping Streets. Knowing the malting business, he made well-received beer, and he soon needed a larger plant. In 1857, Garnier bought the rival Kosmos Fredrick Brewery.

With his brother, August, John erected a new building at Third and Shipping Streets in 1866, selling the Fredrick facility to Gebhard & Hauck. In 1879, Garnier sold 2,542 bbls of beer.[233]

According to the *History of Dearborn and Ohio Counties, Indiana* (1885):

> *The building for manufacturing purposes is 100x100 feet, two and a half stories high, with three lager beer cellars, 100x17 feet, and sixteen feet high, with malting rooms, with a capacity for malting 150 bushels of grain per day. The capacity of the brewery is fifty barrels per day. The brewery gives employment to twelve or fifteen persons, and pays out annually for labor $10,000, and for materials to be used in the process of manufacturing, the sum of $70,000, and if run at its full capacity, the General Government would realize a revenue tax of over $15,000. The trade is confined to the State of Indiana. The value of real estate and surrounding property is $50,000. Mr. John B. Garnier is a native of France. When he arrived in this country he was without any means, and commenced without any capital, but by his industry and economy, has become one of our wealthiest citizens.*

Upon John's death in 1897, son-in-law Victor Oberting took over the business. Oberting was the chief of the fire department and a state representative in the 1900s. In 1906, he patented a device (#828,048) to encourage flies to leave houses through a net cone.[234]

The Garnier Brewery closed officially in 1916, but there are suggestions that it didn't close completely.

On October 21, 1918, the *Fort Wayne News and Sentinel* reported that a "revenue collector poured into the Ohio River 470 barrels of beer seized at the Garnier Brewery here under the prohibition law."

MADISON

JACOB SALMON BREWERY, MADISON BREWERY, 1823–1852
MATHIAS GREINER, M. GREINER & SONS BREWERY, 1852–1877
JOHN GREINER BREWERY, GREINER & CO., 1877–1881
MADISON BREWING CO., 1881–1918

The Jacob Salmon Brewery was established in 1823 at the east end of Second Street (now Indiana 56). It was also known as the Old Salmon Brewery because Jacob was known as "Ol' Man Salmon." Alfred Salmon was a part of the company as well.

As early as 1833, Salmon was buying hops and barley from local farmers, which he malted himself. Hops cost 12¼ cents per pound and barley about 40 cents.

Mathias Greiner took over the Jacob Salmon Brewery, and the family prospered for the next thirty years. Expansions included the construction of a new, large brewery at 220–26 Park Avenue, on the west side of Ferry Street.

According to the 1964 *Madison Mirror*:

> *The main building was 40 x 40, four stories. The beer pump was in the basement, also the hop jack and grain receiver. On the first floor was found the mash tub, Bandelot cooler and beer kettle, the hot and cold water tanks and grain mill were on the second floor, and a large surface cooler in the upper story.*
>
> *Directly east of the brewing house was the engine room and ice manufactory, which was occupied by the engine and ice machine. In the cellar, a pump, for facilitating the handling of beer, the ice water pump and ice tanks, each 13x13 ft. and 6½ high, holding 40 tons of ice. The engine room was the spot for the boilers section, containing two five-flue boilers 52 inch diameter and 20 feet in length; and the doctor for feeding the boilers, the cellars and fermenting rooms were also kept at a temperature of 24 to 26 degrees by brine pipes from the ice machine. Their machine turned out 6 to 10 tons of ice daily, which was sold in the city and surrounding towns.*

In the late 1860s, Frank Fehr, an immigrant from Germany, worked for the Greiners as the manager. In 1868, he moved to Louisville's Schillinger Brewery, and in 1872, he bought the Otto Brewery there, which he renamed City Brewery. By 1901, it was Louisville's biggest brewery, and the company lasted until 1964.[235]

In 1879, Greiner sold 2,523 bbls of beer.[236] We're not sure why the Greiner family left this successful business, but a new company, Madison Brewing Co., Inc., was formed in 1881 with a capital stock of $100,000. Officials included John B. Ross, president; Charles A. Korbly, secretary; Thomas A. Payne, treasurer; A.C. Greiner, superintendent; and James Hill, director. Ross represented the National Branch Bank of Madison; Korbly was a lawyer; and A.C. was Mathias Greiner's son. Hill was an Indiana senator who led the fight, in 1882, against a prohibition amendment to the Indiana Constitution.[237]

The brewery's Madison XXX Ale was distributed as far away as New Orleans.[238] Other beers included Lager, Pilsener, Bohemian, Extra Brew, Export, Bon Ton and Extra Brand and XXX Porter.[239]

George Greusling bottled Madison beer at his plant located at 614 Jefferson Street. In 1910, Madison contracted with the Jacob Metzger Co. in Indianapolis to bottle and distribute its beer, joining an agent in Columbus, Indiana. At its peak, twenty employees produced fourteen thousand bbls.

With Prohibition, the Madison Brewing Co. went bankrupt and disappeared on February 2, 1918. In later years, this building was a grocery, farm store, machine shop and warehouse.

A restart of the brewery was attempted after Prohibition. It was projected to begin production in March 1937, but it doesn't seem that this actually happened.[240]

According to River to Rail, a digital history project by the Madison–Jefferson County Public Library and the Jefferson County Historical Society:

> [T]here was a rivalry between the Weber Brewery and Greiner's about town. If bar owners promised to use only one beer in their establishment they got a pretty good reduction in the price. Supposedly, if a patron had a preference for one beer over the other, he could only patronize certain bars because most did not carry both brands.

P. SCHEIK
1841–1845

This brewery was located on Jefferson Street, north of Fourth Street, occupying a half block on the north side of town. The building became a canning factory.[241]

McQuiston's Brewery, About 1855–About 1858
Adam Weber, About 1858–1864
Union Brewery, 1864–1912

William McQuiston, a Scotsman, had a brewery that was located at the southwest corner of Vine and Main Cross Streets, according to an 1855 map.[242] He sold it shortly thereafter to Adam Weber, an Alsatian immigrant who had brewing experience in France.

Peter Weber inherited his father's brewery. He rebuilt it in grand style directly across the street in 1876. It is said that a better well in the basement at that location allowed him to produce over five thousand bbls of beer annually. The Weber family lived next door at 608 West Main Street.

The building was 50 by 148 feet and was equipped with internal grain elevators and a malting room capable of handling three hundred bushels. A fermenting cellar held "15 or 20 large tanks, each holding sixty-five barrels of fermenting beer."[243]

This fine structure was used by the Hampton Cracker Co. and other businesses until a fire destroyed it in 1939.[244]

Peter Weber later became a partner in Weber and Schillinger Brewery in Louisville and bought it outright in 1891, renaming it Phoenix Brewing Company. However, he died that same year.[245] His son, Charles A. Weber, was president of the Union Brewery from 1892 until its closing in 1912.

George Appel & Son,
West End Brewery
1859–1873

George J. Appel was the owner and brewer of this smaller brewery on the west end of Third Street, near what is now Indiana 7. He died in 1873, and later the building was used by Coyle's pop factory.[246]

Belser & Geisbauer
Madison Brewery
1859–1878

William F. Belser and Charles Geisbauer owned the first Madison Brewery on Main Street between Fourth and Fifth Streets. It had a peak capacity of almost four thousand bbls.[247]

John Butz
1860s–1873

John Butz's Brewery was up the hill from town, on Walnut Street (now U.S. 421). It was built in the 1860s and taken over by his widow, Elizabeth, upon his death. It burned to the ground in January 1873.

Napoleon

Nicholas Morbach
1874–1882

A brewery in the town of Napoleon was owned by Nicholas Morbach from 1874 until 1882. This was a small brewery that produced about three hundred bbls of beer annually.[248] Morbach was also a justice of the peace; in 1854 he built the town hall, and from 1859 through 1864, he was the city's postmaster.[249]

Andrew Meyer, a German immigrant, was the brewmaster and operated the Union Exchange, "selling beer, whiskey and choice wines."[250]

New Alsace

Martin Wilhelm, 1850s–1865
Joseph Zix, 1865–1895

Joseph Zix emigrated from Baden-Baden, Germany, in 1848 at the age of twenty-three with his father's family and a new bride. He moved to a farm near Sunman in the area of the present town of Penntown (then Pennsylvaniaburgh). The family moved near New Alsace in 1864, and Joseph bought Martin Wilhelm's small brewing operation the next year.

Joseph's son Michael took it over in 1877.[251] It reported selling 190 bbls of beer in 1879.[252] Michael sold the business to his younger brother, George A., in 1889.[253]

PETER WELTNER, BEFORE 1863–1866
NEW ALSACE BREWERY, 1866–1897

Notably, Morgan's Raiders did not destroy Peter Weltner's brewery in 1863, but they did burn a flour mill owned by Casper Maus, who subsequently moved to Indianapolis and opened a large brewery.

In her book *Thunderbolt: Revisit Southeastern Indiana with John Hunt Morgan*, Lora Schmidt Cahill writes:

> *New Alsace was a tiny hamlet on Tanner's Creek, settled by German Catholic immigrants. The population of the town was 600, it had two brass bands, four dance halls, two breweries, and sixteen saloons in 1863, these helped quench the thirst of the hot dusty raiders, all of the establishments were soon cleaned out...*
>
> *Near New Alsace, the raiders confiscated a Peter Weltner Brewery beer wagon, which they took with them as they headed east. The men in advance quenched their thirst and the beer wagon was then allowed to drop back through the column, allowing the other raiders the same opportunity. Due to the scorching hot day and jolting wagon much of the brew was lost in foam. Hobson's following force, had no such cooling refreshment on that hot summer day.*

Martin Meyer moved from Dubuque, Iowa, to New Alsace and bought the New Alsace Brewery from Peter Weltner. It grew from a mere two hundred bbls to almost one thousand bbls during the 1880s and 1890s. Meyer died at age sixty-four in 1897, and the brewery died with him.

NORTH VERNON (VERNON)

MICHAEL GOODING
1860–1861

Michael Gooding owned a brewery in Vernon in 1860. He enlisted in the Union army in April 1961, was promoted to colonel, was injured and captured and died in Murfreesboro, Tennessee, in November 1864.[254]

BRUNETT & NASAY
1859–1878

The 1868 *Chandler Co.'s Business Directory for Indiana* lists a brewery owned by Brunett & Nasay near the Madison & Indianapolis Railroad in North Vernon.

JOHN SCHIERLING
1874–1884

Another small brewery in North Vernon was owned by John Schierling from 1874 through 1884. It made about 150 bbls of beer annually.[255]

OLDENBURG

HENRY ROELL, 1857–1867
BALTHASAR ROELL, B. ROELL & CO., 1867–1905

Henry Roell's father moved his family from Bavaria to Dearborn County in 1854, when Henry was twenty. Three years later, Henry went from working on the family farm to brewing, first in St. Peter and then in Oldenburg.[256] When he went back to agriculture in 1867, his brother, Balthasar Roell, took over the brewery. It reported selling 805 bbls of beer in 1879.[257]

Henry had thirteen children, starting in 1862, and in 1870, he opened a store.

A report by the Indiana Bureau of Statistics in 1896 listed the brewery in Oldenburg with a "value of $3,000, in which 3 men are employed, to whom were paid during past year in wages $1,800. Cost of material, $3,000, and manufactured product, $7,000."

OSGOOD

JOHN WAGNER
1874–1875

A brewery owned by John Wagner, a German immigrant, was operating in the town of Osgood in 1874 and 1875.[258] It made less than four hundred bbls total.[259]

ST. LEON

L. BISCHOFF
1878–1880

L. Bischoff owned a very small brewery in St. Leon from 1878 through 1880. It never made more than forty bbls of beer in any one year.[260]

ST. PETER

HENRY ROELL, 1857

Henry Roell's brewery in St. Peter opened in 1857 and was moved shortly after to Oldenburg.

JOHN BUSOLD
1878–1884

John H. Busold had a brewery in St. Peter from 1878 until 1884.[261] It made 240 bbls of beer in its first year in business.

SALEM

The *Indiana State Gazetteer and Business Directory* of 1859 includes in the list of manufacturing facilities in Salem "one brewery."

SEYMOUR

J.D. Kaufmann owned a brewery in Seymour from 1874 until 1882. Martin Dammerich owned a brewery in Seymour from 1874 until 1884.[262] Each of these breweries had a capacity of almost three hundred bbls.[263]

SUNMAN/PENNTOWN

The *Versailles Despatch*, on Friday, October 8, 1858, reported:

> [Penntown] *is not notorious for anything, scarsely, except that it is* [in]
> *fact declining in morality, and that the minyer is about to toke the place. Its*
> *buildings are neither neat or comfortable, nor have they been whitewashed*
> *for the last five or six years. It contains three stores, and some seven places*
> *of dealing out intemperance.*

SCHNEIDER
BEFORE 1867–1882

Jacob Schneider started his brewery on the family farm about halfway between Sunman and Penntown, a short distance east of what is now Indiana 101. He bought local hops for brewing purposes.[264]

P. Schneider owned this brewery from 1879 until 1882. This was a small industry in the area, capable of less than five hundred bbls annually.[265]

WEST HARRISON

GEORGE KOCHER
1882–1891

According to the *History of Cincinnati and Hamilton County, Ohio* (1894):

> *George Kocher, retired farmer and brewer, Harrison, was born in Germany*
> [on] *April 23, 1827, son of Frank and Barbara Kocher. His father*
> *emigrated to this country in 1878, and located in Dearborn county, Ind., on*
> *a farm, where he remained until his death, in 1883. Their son* [George]
> *came to this country in March, 1847, at the age of twenty…In 1882 he*
> *went to Harrison and engaged in the brewing business, conducting same*
> *until 1891, when he retired to private life.*

George's son, Anthony, worked with him in this brewery, serving in the capacity of bookkeeper and bill collector for a number of years.

New Albany–Jeffersonville

BOTTOMLEY & AINSLIE, 1832–1841
CITY BREWERY, 1842–1873
PAUL REISING BREWING CO., 1873–1915
SOUTHERN INDIANA BREWING CO., 1915–1918
SOUTHERN INDIANA ICE & BEVERAGE CO., 1918–1923
SOUTHERN INDIANA ICE CO., 1923–1933
SOUTHERN INDIANA ICE & BEVERAGE CO. (ACKERMAN'S BREWERY), 1933–1935

Hew Ainslie, an immigrant from Scotland and a well-known poet, joined the New Harmony community in 1825. When New Harmony folded, he went to Cincinnati, where he was a partner in a brewery with Messieurs Price and Wood. Later, he opened a brewery in Louisville that was destroyed in the flood of 1832.[266]

Coming back across the Ohio River, he opened the Bottomley and Ainslie brewery in New Albany that same year and started making ales and porters. The plant was destroyed by fire two years later.[267] He was listed in the city directory as a maltster in 1841 and then dropped out of brewing. By 1842, he was working in a foundry.

The brewery was rebuilt and operated as the City Brewery by:

Joseph & George Kealchle (1842–1848)
John Yeager (Jager? Yager?; 1848–1856)
Bath & Rickle (1856–1859)
David Bath (1859–1860)
Paul Reising (1861–1873)

Paul Reising was an immigrant from Hoestein, Bavaria, where his father was the burgomaster (mayor). He came to Louisville in 1854 and worked at the Otto Brewery. Three years later, he bought the Metcalfe Brewery.[268]

In 1861, Reising sold the Metcalfe Brewery and, with Peter None, bought the City Brewery at a sheriff's sale. At that time, the building was only 1,200 square feet with a capacity of fifteen hundred bbls.[269] By expansions, notably in 1866, he grew capacity to three thousand bbls by 1879.[270] At this time, the plant was two stories, 115 by 50 feet, with a 40- by 18-foot beer cellar. It also featured an icehouse above and a 40- by 50-foot malt cellar and employed ten men.[271]

Louis Schmidt moved from Prussia to be the foreman and brewmaster in 1878. He left a year later to become an importer of wine and liquors. In 1882, he bought the Main Street Brewery.[272]

Schmidt was followed as brewmaster by Veit Nirmaier, who would go on to buy the State Street Brewery in 1899.[273]

Reising's son-in-law, Frederick C. Kistner, became a partner in the firm in July 1884.[274]

After more expansions, by 1891, the capacity was up to twelve thousand bbl, and the brewery had its own malting plant, refrigeration unit and ice machine.[275] It made lager and common beer. Ye Old Beer, Kaiser and Rathskeller Brew were the brewery's main brands, with other beers such as a Bock Beer produced seasonally.

Paul Reising died in 1897, at the age of seventy-seven, leaving an estate of about $125,000—including the brewery. His son-in-law, Fred C. Kistner, had taken over the operations of the brewery by that time.[276] Reising's daughter (Fred's wife, Mary) was

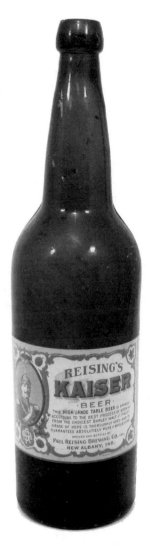

Reising's Kaiser Beer bottle. "This High Grade Table Beer is brewed according to the best process of brewing from the choicest barley malt / finest grade of hops is thoroughly aged and is guaranteed absolutely pure / wholesome."

the executor of the estate and financial manager of the company. She died in 1902, putting the business and family wealth into a trust for her children.[277]

John Meyer became the manager of the brewery upon Reising's death. He was also the manager of the crosstown Pank-Weinmann Brewing Company. In May 1899, the two firms merged, and both factories continued to operate for a short time. In 1912, the Paul Reising Brewery was sold to John Meyer.

After 1910, Imperial, Culmbacher, Bohemian Lager, Pale Export and Sparkling Common beers became the staples.

In 1913, H.C. Meinhardt became the president, overseeing thirty employees.[278] Meinhardt moved on in 1915 to start a mail-order firm in Chicago. During his short reign, he made many improvements and was a charismatic owner who created a lot of publicity for the company. The brewery even produced its own monthly magazine, *Open Talk*, which consisted of short motivational and anti-Prohibition articles, odd facts and what were even then corny jokes:

> *Teacher—Where was the Magna Carta signed?*
> *Intelligent Boy—At the bottom, sir.*

During this time, Peter Deering was the brewery superintendent. The brewery had seven wagons and thirty employees, including two traveling salesmen "who cover the local territory." Capacity was twenty-five thousand bbls.[279]

It is said that some bad beer was distributed in 1914, which helped lead to a financial decline and bankruptcy in March 1915, but signs show troubles deeper than that. The Pank-Weinmann operation was closed by then and had been a financial drain. The brewery had just come out with some new beer styles to reinvigorate the customer base, but the plant was getting old, and the new owners would have to make many improvements, such as an entirely new and up-to-date bottling plant.[280]

Plans for modernization that would double the capacity of the brewery were made but never came to pass.

Michael Schrick bought the bankrupt Paul Reising Brewing Co. property in June 1915 for $34,000 and renamed it the Southern Indiana Brewing Co.[281] At the onset of Prohibition, the name was changed to the Southern Indiana Ice & Beverage Co., and in March 1917, they brought out Hop-O and Hop-O Dark near beers. In 1919, Prohibition drinks were still selling well, and Schrick added a large ice plant to the facilities.

In September 1921, Prohibition agents closed the plant after Hop-O was found to contain several percent alcohol—some say as high as 7 percent.[282] The situation was complicated by an attempt to bribe a treasury agent. On March 17, 1922, the *New York Times* reported:

INDIANA BREWER INDICTED
Louisville, Ky. March 16—Indictments charging bribery were returned by a Federal Grand Jury here today against Michael Schrick, former President of the Southern Indiana Brewing Company, and J.H. Booth, both of New Albany, Ind. They are alleged to have attempted to bribe J.L. Asher, Federal prohibition agent, with money and commissions amounting to $100,000 a year to get assistance of that official in transporting illegal beer to Louisville from New Albany. They were released on bond.

Federal agents, who said they were concealed in a closet, told the Grand Jury the two men were trapped in Asher's room in a hotel here in January while Schrick and Booth were in the act of paying Asher the first installment of $2,000.

The *Marion* [Ohio] *Daily Star* reported on January 3, 1924:

Indianapolis, Jan 3—Judge Albert B Anderson today promised a rigid investigation of alleged promises of immunity from criminal action to high officials of the prohibition division at Washington to Michael Schrick, a brewery owner of New Albany, Indiana. Roy A Haynes, director prohibition enforcement said Mr. Andrews, chief of the bureau of litigation at the department, and John Owen, former campaign manager of Senator James U Watson and alleged go-between, were named by Schrick today.

In 1927, the plant and facilities were bought by Claude N. Boone, becoming the Southern Indiana Ice Company.

Philip Ackerman and Frank Senn opened the Senn and Ackerman Brewing Co. in Louisville in 1876. It thrived and was merged into the Central Consumers Corp. in 1901, though it closed in 1916.

Philip Ackerman became the brewmaster and superintendent of the reincorporated SII&BC after Prohibition, overseeing a one hundred bbl brewing plant. A $50,000 refurbishment was made, and 3.2 percent beer rolled out of the plant on September 7, 1933.[283] The factory was locally known as Ackerman's Brewery.

Brands included Amsterdamer Bock, Great Eagle, Gold Crest, Imperial Double Stout, India Pale Ale, Daniel Boone, Ackerman's Royal Munich, Vienna Select and Old Rip. The brewery, unable to make a profit in a competitive city, closed on November 15, 1935.[284]

This brewery was located on Fourth and Spring Streets. The building was used by the Polar Ice Co. until 1969, when the lot became a Holiday Inn Express.

METCALFE BREWERY, 1847–1857
PAUL REISING, 1857–1861
MAIN STREET BREWERY, 1861–1886
JACOB HORNUNG BREWERY, 1886–1889
INDIANA BREWING CO., 1889–1895
PANK-WEINMANN BREWING CO., 1895–1899
PAUL REISING BREWING CO., 1899

Colonel Joseph Metcalfe owned the Oakland Race Course in Louisville in the 1830s. He started a brewery in New Albany in 1847 that he sold, in 1856, to William Grainger, who then sold it to Paul Reising in 1857. Reising sold it to Martin Kaelin in 1861, and he renamed it Main Street Brewery.[285]

By 1868, it occupied a two-story building on the west side of Upper Vincennes Street between Main and Stone Streets. This was forty by sixty feet, with two lagering cellars. It employed five men and had a capacity totaling thirty-six hundred bbls.[286]

Kaelin sold it to Louis Schmidt in 1882. Schmidt was an immigrant from Prussia who moved to New Albany to be the brewmaster and foreman at the Paul Reising Brewery.

Schmidt sold to Jacob Hornung and George Washington Atkins in 1883. Both men were experienced in the field, Hornung as foreman and Atkins as a hostler at the Market Street Brewery.[287]

In 1886, Atkins left, and the business came under the sole proprietorship of Jacob Hornung. The Jacob Hornung Brewery made bottled lager beer.

Hornung made many investments in the plant, including ice-making machinery and a deep well that never found suitable water. This latter effort cost him about $5,000, leaving him in debt and unable to install equipment he had purchased from the Market Street Brewery in 1884. Unable to find a way to liquidate some of the assets and return to solid financial footing, he shot himself in the head in his office on April 3, 1889.[288]

An investment group formed a new company with $100,000 capital in May 1889; it bought the brewery and renamed it the Indiana Brewing Co. Gustav

J.H. Pank portrait. From *The City of Louisville and a Glimpse of Kentucky* (Young Ewing Allison, 1887).

Weinmann was the general manager. Other principals included President E.W. Herman, also the president of the Kentucky Malting Co. of Louisville; and J.H. Pank, secretary.[289]

The group immediately enlarged the plant, building a five-story brick structure and installing the equipment purchased from the Market Street Brewery five years earlier. This new building included a malt room on the top floor. The brewery was able to produce batches of 150 bbls of beer with an annual capacity of twenty-five thousand bbls. It is said that this building was the largest in New Albany at the time.[290] Moritz Eck was the foreman and brewer. He "learned his trade in the large brewing establishments of Germany."[291]

In 1895, it became the Pank-Weinmann Brewing Company. J.H. Pank was the secretary/treasurer of the Kentucky Malting Co. in Louisville and part owner of the J.H. Pank Malting Company in Chicago.

Pank-Weinmann seems to have overreached its abilities and finances and never made a profit. In May 1899, the Paul Reising Brewing Co. bought the operation and continued production for a short time.[292]

MARKET STREET BREWERY, 1856–1884
JULIUS GEBHARD & CO., ENTERPRISE BREWERY, 1884–1886
NEW ALBANY BREWING CO., 1886–1887
GEBHARD & BATE BREWING CO., 1887–1888
NATIONAL BREWERY, 1888–1891

Peter Buchheit was born Jean Pierre Buchheit in Schweyen, Lorraine, France. In 1847, at the age of twenty-seven, he moved to New Albany and later started the Market Street Brewery behind his home.

Ten years later, the brewery occupied three buildings—two, thirty by sixty feet, and one, eighteen by sixty feet. It covered nearly the entire block between Market and Spring Streets on the west side of Tenth Street. It employed four people, who roomed with the family.[293]

A fire in 1875 did considerable damage, but the brewery immediately rebuilt with brick buildings, iron roofs, an elevator and new equipment. In 1879, it produced almost thirty-five hundred bbls.[294]

On September 22, 1875, the *New Albany Ledger Standard* reported:

> *This morning at 6 ½ o'clock, the alarm of fire was sounded and it was discovered that the extensive brewery of Peter Buchheit was on fire.*
>
> *When the alarm was given the three engines, the Sanderson, Jefferson and Washington, were prompt in action, and did efficient work in subduing the flames, which required three quarters of an hour. The cause of the fire is not known.*
>
> *The citizens gathered from all quarters and rendered timely assistance. The building contained two thousand bushels of malt and a quantity of barley. The basement was filled with beer, which will be damaged by becoming heated. The malt, which was consumed, is valued at $2,500, barley valued at $1,000.*

Lagering cellars, included in this renovation, could hold 609 tons of ice. Market Street had another off-site icehouse that held 1,000 tons.[295] A malting kiln was also on site.

Peter died in 1877, and the business was taken over by his wife, Barbara. She was an immigrant from Bavaria whom Peter had married in New Albany in 1850.

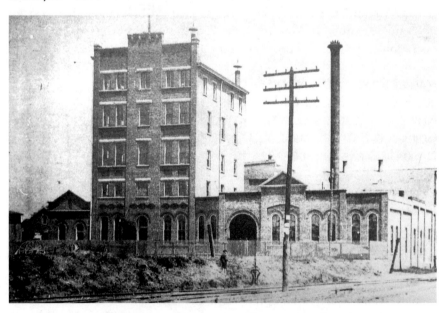

Market Street Brewery, from a picture in the New Albany Public Library. The photo is undated but titled "New Albany Brewing Co."

In January 1884, Barbara sold the equipment to the Main Street Brewing Co. and the building to Julius Gebhard and a gentleman named Helmekamp (or Helmecamp); it became the Enterprise Brewery.[296]

Two years later, Enterprise was effectively bought out by Charles Burger and Herman Kirchhoff. Gebhard became the superintendent. His son, Frank Gebhard, then twenty-one years of age, was involved in this new firm that was renamed the New Albany Brewing Co. It started with a capital stock of $15,000.[297]

They stopped using the malting kilns at the plant, buying malt instead of barley (possibly from the Falls City Malt House of Louisville). Capacity at that time was about three thousand bbls.

Burger and Kirchhoff retired from the firm in October 1886. E.R. Bate, Julius Gebhard and one other person ended up with the company and changed the name to Gebhard & Bate Brewing Co.; however, they did not properly register the new corporation name. This became important when a debt to the Cincinnati Cooperage Company was held on appeal to be personally owed by Bate.

Andrew Schlosser bought the brewery in 1888 and renamed it the National Brewery, but this effort did not last long. In 1899, he tried again with the State Street Brewery.

After 1891, the Market Street site was used as the Nevian ice factory for a while. Two buildings are still standing. The icehouse was an apartment building for some time but is now vacant. The vaulted fermenting and storage cellars are still under this structure. A church now occupies the storage and grain building.[298]

SPRING BREWERY, 1865–1891
PETER ENGEL, 1891–1902
ENGEL & NADORFF BROS., 1902–1907

Opened in 1865 by Anton Sohn at 1113 Vincennes, between Locust and Chartres Streets, the Spring Brewery was inherited by his wife, Louisa Sohn, in 1874. About this time, it made almost five hundred bbls annually.[299]

Frank Nadorff bought into the business in 1877, and his wife, Threcy Nadorff, inherited it in 1884.

Peter E. Engle bought the business in 1891. The plant then included a grain warehouse, a washhouse, a steam-heated mash room, a beer cellar, an icehouse, a wagon shed and a pond. City water was also installed. Maximum capacity was three thousand bbls.

The Nadorff family also owned the Nadorff & Bro. Brewery in Louisville from 1884 until 1901, when they sold to Central Consumers Corp., a consortium of four Louisiana breweries, and again became associated with our subject business. The family still owns the Anheuser-Busch distributorship in New Albany.

Henry Lang, 1875–1880
Kirchgessner & Seng, 1880–1884
J. Kirchgessner, 1884–1891
City Brewing Co., 1891–1899

Henry Lang Jr. started his brewery on the northwest corner of Maple and Graham (then French) Streets in Jeffersonville in 1875. He reported selling 429 bbls of beer in 1879.[300]

Sold to J. Kirchgessner and Seng in 1880, it became the City Brewing Co. in 1891 (some sources say 1893), more than twenty years after the original City Brewery became Paul Reising Brewing.

City Brewing had a maximum capacity of three thousand bbls.[301] The main brand was Pima Export.

Terstegge & Co., 1888–1914
State Street Brewery, 1914–1918

The Terstegge family had long been involved in many manufacturing interests in the region, including ironworks, making stoves and other appliances. They ran this brewery at 1401 State Street (west side of State, opposite Green Street) for two years, after which it passed through many hands, including:

Frederick S. Ruoff (1890–1893)
Bochardt & Birk (1893–1898)
Edward Birk (1898–1899)
Andres Schlosser (1899)
Veit Nirmaier (1899–1918)

Nirmaier named it the State Street Brewery in 1914 or 1915.[302] He had learned brewing in Maudach, Germany, and had been the foreman at the Paul Reising Brewery for fifteen years. Under his tutelage, the flagship was a cream beer known as Nirmaier's Common.

State Street had four men employed in 1911 and cut ice from its own pond on the property.[303]

Veit died in January 1915, and his widow and sons continued the business. A windstorm in 1917 severely damaged the building. Repairs were made, but the plant closed at the onset of Prohibition.[304] They planned to convert the plant to a cannery, but it sat idle until it was torn down in 1936.[305]

Bottlers

New Albany, like most cities, had a number of bottling plants in the late 1800s, but beer bottling moved slowly in-house for most breweries after it was allowed, starting in 1890. Joseph P. Renn's Sanitary Bottling Works was one of the biggest plants. It was established in 1865 at 601–03 State Street and lasted until 1943, with a wide variety of products, including ice cream.

In the late 1800s, F. & P. Bochart at 145 State Street bottled Reising's beer and others, including those of the Madison Brewing Co. It also bottled ginger ale and cider. In 1894, the State Street Bottling Works leased a mineral spring from a nearby farmer to sell bottled mineral water in the surrounding area.[306]

The City Bottling Works at 423–25 State Street was established in 1887 by Charles A. Kochenrath. He sold it in 1912 to Otto W. Christman, who stayed open until Prohibition. It bottled Frank Fehr Brewing Company's Lager Beer and Ale from Louisville. It also sold mineral water, ginger ale, cider and seltzer water.[307]

Other companies included F. Wunderlich Co. and W.M. Wilcox, John O. Greene & F.A. Mitchell & Co.

WHERE THE GOOD SOFT DRINKS
ARE MADE

...The Sanitary...
Bottling Works

BETTER KNOWN AS

Joe Renn's Bottling Works

BOTTLING PURE SOFT DRINKS

Established forty years ago by Renn & Feiock. After five years of partnership Feiock's interest was purchased by Mr. Joe Renn. In 1879 Joe Renn sold out to his son, Joe Renn, Jr., the present owner. Since the present ownership the one ambition has been to manufacture and bottle the best, purest and most sanitary soft drinks possible. His success is attested to by his ever increasing trade.

VISITORS ALWAYS WELCOME

Home Phone 219-a 601-603 State St.

A Sanitary Bottling Works ad in the *Great New Albany Centennial Celebration Program*, 1913.

Taverns

Early New Albany was a bustling riverfront town that, although not rivaling Louisville, was the jumping-off point for settlers west along the Ohio and Wabash Rivers because it was and is located downstream of the Falls of the Ohio. A Mrs. Robinson, David Hale and Elihu Marsh opened inns as early as 1814. Lodging was set at 12½ cents and meals at 37½ cents. Stable space cost another 37½ cents. Beer was typically a nickel.

By 1830, there were thirteen taverns or inns in the area bounded by Upper Fourth Street and Lower Fourth Street and a half mile north of the river. Names such as Robinson, Hale, Marsh, Roberts, Woodruff, Tuley, Bell, Swan, Black Horse, Young, Israel, State Street, King, Farmers and Tabler have disappeared, but this area is being rejuvenated and hopefully will bring back some of that feeling.

Taverns sold mainly distilled spirits like white lightning, but beer was also important to the menu, as was hard cider. Early on, many customers came from Louisville, from the New Harmony Colony or from upstream in Madison. Louisville brewing goes back to possibly 1808, when Elisha Applegate moved to the then-small outpost and brewed beer for a short time.

The *Souvenir History Book of the 1913 New Albany Centennial Celebration* says:

> *Taverns were an important and almost necessary adjunct to the building up of a community in the early days. New Albany had plenty of them then as she has now. Strange to relate, but it is a matter of court record, that a Mrs. Robinson kept the first tavern in what is now part of New Albany—a place for the wayfarer and the beast that carried him between New Albany and the Post at Vincennes. Men who were the ancestors of the "first families" in later years became tavern keepers. To mention all their names would take up a page...The first ones paid no license, but so soon as the village was incorporated taven keepers were not only required to pay a license, but to give bond...The tavern keeper of old, like some of the modern ones, was of good moral character but there were others and they kept what was known then as "doggeries."*

Southwest Indiana

CANNELTON

WILLIAM & JACOB HECK
1865–1872

William Heck Sr., an immigrant from Nassau, Germany, sold his share of the grocery store he and his older brother Jacob owned in Cannelton and opened a brewery at Washington and Sixth Streets in 1865. He also operated a coal mine on his farm in the area and was a justice of the peace.[308]

His son, Frederick Heck, built a new building on the site in 1891 where he started a saloon. This is still operating as Mike's Bar & Grill.[309]

JACOB HUBER & CO.
1860S–1884

Jacob Huber, an immigrant from Dillsdorf, near Zurich, Switzerland, was a baker in Cannelton until he opened his brewery at Fifth and Mason Streets in the 1860s. In 1879, it sold 373 bbls of beer.[310]

FERDINAND

There were several small breweries in Ferdinand in the nineteenth century, including those of Herman Wilbers (about 1875) and John Dickman (about 1891).[311]

HENRY RUHKAMP
1875–1891

Henry B. Ruhkamp Jr. started brewing in 1875. In 1879, he produced 775 bbls of beer.[312] Inherited by his wife, Elizabeth, about 1885, the brewery closed in 1891. Maximum capacity was about 1,500 bbls.

STALLMAN & HAUG, 1888–1895
FERDINAND BREWING CO., 1895–1916

The brewery was started by John Haug and someone named Stallman. A person named Kunkler joined the firm in 1892 and left in 1895. At that time, they renamed the company Ferdinand Brewing Co.[313] Peak capacity was three thousand bbls, and it employed three people.[314]

HAYSVILLE

A small brewery in Haysville was started and closed by John Neukam in 1890.[315]

JOHN KRODEL
1871–1897

John B. Krodel started this brewery on his family's farm at age twenty-three.[316] His wife, Barbara (née Hoffman but not related to the John G.F. Hoffman family), continued the brewery for five years after John died in 1892. They never made more than five hundred bbls of beer in any year.

JOHN HOFFMAN
1874–1883

John G.F. Hoffman emigrated from Germany in 1848 and shortly thereafter settled near Haysville, where he opened a store in town and later a brewery. The latter closed upon his death in August 1883.[317] Hoffman was also a justice of the peace.

Huntingburg

Joseph Schubler had a small brewery in Huntingburg about 1875.[318] A pottery in Huntingburg was also tangentially involved in the brewing business. According to *The History of the UHL Pottery Company*:

> *During prohibition we made thousands of barrel shaped beer steins for Blatz and Sterling for promoting the sale of their malt extract which was used in the making of "home brew." They gave a mug with each purchase. This business of course ended with prohibition, as did our 1 gal. jug business with the local bootleggers who would come to our plant and haul them away by the truck load and carload. We never asked any questions, just took their money.*

Huntingburg Brewing Co.
1894–1918

The Huntingburg Brewing Co. (First and Main Streets) owners were Andreas and Henry Fritch and Charles and Henry Moenkhaus. Charles Moenkhaus also owned the St. George Hotel and, in 1896, bought out his partners' interests in the brewery. Later, he became president of the Huntingburg First Bank.

This brewery's primary beer was a Common Ale at 2 percent ABV.[319] At its peak in 1913, Huntingburg had fifteen employees.[320]

Jasper

Arbagast Volmer, 1849–1860
Hochgesang, 1861–1884
Habig & Eckstein, 1884–1889
Excelsior Brewery, 1889–1916

This brewery was opened on Jackson and Twelfth Streets before the Civil War by Arbagast R. Volmer, who evidently sold the equipment to Edward Andrew Hochgesang when he joined the army. Volmer died of diarrhea while in service in November 1862.

Hochgesang was a local brick manufacturer and masonry contractor. It took him from October 1860 until November 1861 to build a new brick building and start brewing.

Upon his death, his brother-in-law, Anton Habig, and Habig's brother-in-law, Martin Eckstein, bought the business from his widow and produced about eighteen hundred bbls of Jasper Common Draft Beer the next year.[321]

Habig bought out Eckstein in 1889 and renamed the business the Excelsior Brewery. Anton's son, Frank Habig, inherited the business.

The Excelsior was a two-story ramshackle building, but it produced about two thousand bbls of beer annually and had six employees.[322]

IGNATZ ECKERT
ABOUT 1857–ABOUT 1875

Ignatz Eckert emigrated from Pfaffenweiler, Baden, Germany, to Jasper at the age of eleven with his family. Among other business interests, including manufacturing spokes, he "established a brewery which he continued eighteen years."[323]

MOUNT VERNON

The 1868 *Business Directory for Indiana* lists two breweries in Mount Vernon. One was owned by Ziegler and Riekert. The other was the City Brewery (Appel & Sons, proprietors) on the corner of Water and Main Streets—not to be confused with George Appel & Sons' West End Brewery in Madison, which was also open in 1868.

FREIDRICH KUHLENSCHMIDT
1840S

Freidrich Kuhlenschmidt immigrated to the United States from Lippe, Germany, and had a brewery in Mount Vernon for a short time in the late 1840s. He was in his late twenties at that time. His family then moved to Evansville and operated a restaurant, grocery and rooming house at 300 Fulton Street.[324]

NEW BOSTON

On October 20, 1893, the *Rockport Democrat* reported, "Frank Paulus died last Wednesday. For fifteen years he conducted a brewery just West of this place [New Boston]. The funeral service was the largest gathering of its kind ever seen in Huff Township."

Bill Paulus of Bellbrook, Ohio, adds:

> *I have also learned that in compiling information on the history of Troy,
> Indiana, Frank Baertich interviewed some family members who remembered
> that Frank Paulus had had confrontations with members of the local
> Women's Christian Temperance Union during this period.*
>
> *The Paulus family came to Fulda, Indiana, in 1848 from the Oberpfalz
> region in Bavaria.* [Frank moved to New Boston in 1861.] *I
> also learned that the acreage he owned had a natural cistern and coal
> outcroppings enough to support a brewing operation.*

NEW HARMONY

A brewery and two distilleries operated as part of the Rappite Colony in
New Harmony in the 1820s. The brewery was at the intersection of Brewery
and North Streets; catty-corner was a distillery.

In his book *The Angel and the Serpent*, William E. Wilson writes:

> *Some of the beer was enjoyed by the local Harmonists but most was sold in
> other towns on the Ohio and Wabash Rivers. The product of the distilleries
> was all sent to other areas as far away as Pittsburgh and New Orleans.*
>
> *In their numerous industries, the ingenious Harmonists availed
> themselves of various sources of power. Most singular and
> spectacular—indeed, almost unique in that region in their day—were
> the steam engine that operated their cotton mill and, later, their threshing
> machine...From our modern point of view, more unusual than either
> of these sources of power was a large dog that walked a treadwheel on
> a platform twelve feet above the floor of the brewery, pumping water
> for the brew. Big as this dog was, he must have been spelled by another
> like him from time to time, for the Harmonist brewery produced five
> hundred gallons a day.*

The colony started to wind down in 1823 and was sold in 1825, when the
Rappites moved back to Pennsylvania. The brewery and distilling operations
did not continue under the more prim Owen incarnation that succeeded the
Rappites in this location.

NEWBURGH

EAGLE BREWERY
1865–1881

In 1847, Charles Brizius emigrated from Birkenfeld, Prussia, where he was a butcher. He started this small brewery on the corner of Drury and Gray Streets, and his son, August, worked there for a while before moving to Evansville and taking up the butcher's trade.[325]

The Eagle Brewery sold 378 bbls of beer in 1879.[326] It closed when the owners turned the plant into a flour mill.

PARKER'S SETTLEMENT

HOFMANN & SPECK
1865–1881

William Hofmann, an immigrant from Kaiserlauten, Rhinepfalz, Germany, settled in Posey County in 1850 and, with Philip Speck, owned a brewery in Parker's Settlement. Hofmann died in 1876.[327]

PETERSBURG

JOHN MISENHELTER
ABOUT 1868–ABOUT 1881

This brewery was located on Vincennes Road, now Indiana 61, north of town.

PRINCETON

ANTON RUTENFRANZ
ABOUT 1868

Rutenfranz owned a brewery and a saloon in Princeton after the Civil War.

Rockport

Bartley Ringler, Rockport Brewery
1850s–At least 1868

Ringler also made apple and peach brandy.[328]

Saint Meinrad

Saint Meinrad Archabbey
1860–1861

The Saint Meinrad Archabbey had a brewery in 1860 located in front of the Abbey property on what is now Brewery Street. The group leased it out to a lay brewer in 1861, but there are no records of that effort being successful.

Brother Gabriel Hodges said in BYO Magazine in 2004:

> *Though the Meinrad monks' 1855 plan to build a brewery was spoiled by forerunners of the early twentieth-century prohibition laws, the brothers successfully created a brewery in 1860—this time in the name of health. The monk who constructed the brewery said the beer would aid in the digestion of bacon, which dominated the brothers' diet.*
>
> *Although the monks finally succeeded in building their own brewery, their first brew was a total failure. The mash was fed to the hogs, which enjoyed much improved digestion, no doubt. In 1861, the abbey leased its brewery to a gentleman in town. It soon became primarily a town operation.*[329]

Tell City

Tell City was founded by the Swiss Colonization Society of Cincinnati. German-speaking folks from Switzerland had settled in Ohio but wanted to have a city of their own. In 1857, the SCS bought what land was owned by residents and planned a city with straight, wide streets. Shares in the society bought a plot of land, and the leftover money was used to fund start-up companies.[330]

BECKER & BEUTER, 1858–1859
CHARLES BECKER, ALOIS BECKER, 1859–1894
GUSTAVUS HUTHSTEINER, 1894–1897
TELL CITY BREWING CO., 1897–1918

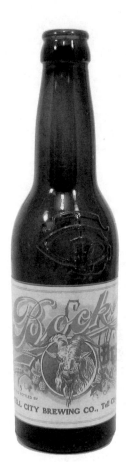

A Tell City Bock bottle.

Charles Becker, an immigrant from Prussia, came to Cincinnati in 1855 and worked in a brewery until moving to Tell City at its opening in 1858. He and Alois Beuter opened the first brewery, on the east side of Ninth Street between Washington and Pestalozzi Streets, sponsored by the Swiss Colonization Society.[331]

Beuter left the business after one year, but Becker continued by himself, making common beer. In 1870, he built a three-story brick plant at a cost of $3,000. This new plant allowed him to switch to making lager.[332] In 1879, he sold 430 bbls of beer.[333]

In about 1884, Charles passed the business to his son, Alois. The brewer, Joseph Lienhart, died in 1894.[334]

That same year, the company passed to Gustavus Huthsteiner, another immigrant from Prussia. He had been a clerk and a schoolteacher. Later, he was county treasurer and an Indiana state representative.[335]

In 1897, a new corporation bought the old Becker firm and formed the Tell City Brewing Co. Officers were R. Windpfennig, president; Julius John Wichser, vice-president; John Begert, secretary; R. Einsiedler, treasurer; and Otto Kneische, general manager.[336]

They soon enlarged the plant and started bottling in 1900. Maximum capacity was six thousand bbls. Brands included AC, Primo Lager and Bock. It closed at the onset of Prohibition.

REIS & ENDEBROCK
1859–1865

These two gentlemen started a brewery with a $300 loan from the Swiss Colonization Society. When it failed, the building was used by the Tell City Planing-Mill Company.

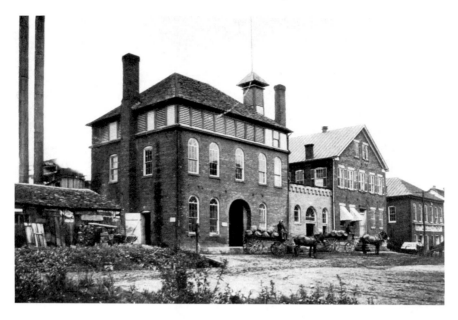

A Tell City Brewing Co. postcard, postmarked 1904.

Peter Schreck
1859

Peter Schreck, an immigrant from probably Baden, Germany, was a maltster in Milwaukee before obtaining a $300 loan from the Swiss Colonization Society and moving to Tell City to open a brewery on two lots. This effort failed, and by 1863, he had moved to Gallatin, Illinois.[337]

Frederick Voelke Jr.
Tell City Brewery
1861–1910

Frederick Voelke owned a brewery in Troy from 1850. His son, Frederick Jr., ran the brewery from 1856 and moved in 1861 to form the Tell City Brewery. The Tell City Brewery sold 776 bbls of beer in 1879.[338] The brewery was closed shortly before Frederick Voelke Jr.'s death in 1911.

August Krogman, an immigrant from Holstein, Germany, worked in a brewery in Davenport, Iowa, and opened a "manufacture of Bourbon, whiskey, and apple and peach brandies" in Tell City in 1863. August's son, William Krogman, married Claudine Voelke, daughter of Frederick Jr., owner of the Tell City Brewery. William continued the distillery business until at least 1916.[339]

TROY

FREDERICK VOELKE, 1850–1856
FREDERICK VOELKE JR., 1856–1861

Frederick Voelke, an immigrant from Cassel, Prussia, ran a brewery from 1850 until 1856, when his son, Frederick Jr., took over the operation. He closed it five years later to form the Tell City Brewery. The Voelke operation was capable of "probably over 1,000 barrels of beer annually."[340]

HEINZE & THAENY, 1874–1877
JOHN THAENY, 1877–1884
JOHN S. WINTERATH, 1884–1895
JACOB KUNKLER, 1895–1905
TROY MODEL BREWERY, 1905–1913

We have found very little on the early history of this brewery, except a list of owners. John Thaeny sold 745 bbls of beer in 1879.[341]

Troy Model Brewery was started in March 1905 with $40,000 of capital stock. It had nine employees.[342] By 1909, it was making beer, pop and seltzer and had fifteen employees.[343]

Brands included Kunklers Gold Standard and Pearl of Troy. The brewery and ice plant were destroyed by a fire on May 10, 1913, and never rebuilt.[344]

VINCENNES

J. & WILLIAM L. COLEMAN
1818–1819

In 1817, the Bank of Vincennes was authorized as the official bank in Indiana. Money was easy to come by, and many businesses were started. William L. Coleman, a probate court judge, joined the rush. Unfortunately, the financial panic of 1819 came too soon for him to weather the storm.

Jacob Kautz
About 1862–About 1868

Kautz's small-scale brewery was located where the B&O freight depot stood on Water Street. Anton Simon worked in this brewery for a few of his teenage years in the early 1860s, before becoming a principal in the Eagle Brewery in 1874.

John Kuhn
About 1868–About 1873

John Kuhn brewed lager and manufactured yeast on the site of the St. John's Hotel at Water and Church Streets.

John Ebner, Harrison Brewery, 1859–1868
C.F. Phful, 1868–1872
Block, 1872–1874
Hack & Simon, Eagle Brewery, 1875–1930

John Ebner, born in Alsace, France, moved to Vincennes in 1849 and saved up enough money to start a bakery and a grocery (which burned in 1855). He then worked to get the capital to build a brewery, which he did in 1859. Having other interests, he put the brewery up for sale in 1866 but, finding no buyers, leased the plant to a succession of people, who did not succeed.[345] Ebner went on to start the John Ebner Ice Co. in 1880.

A man named Block ended up suing Ebner for not providing maintenance of the facility. His rent was $125 per month. During his operation, the capacity was about four thousand bbls.

Eugene Hack and Anton Simon rented the facility in 1874 and started brewing on January 1, 1875. Being successful and seeing the need to expand, they bought the brewery from Ebner the next year. They immediately refitted the plant and expanded it to two city blocks. It achieved final capacity of over eighteen thousand bbls and employed ninety men.[346]

Eugene Hack emigrated from Württemberg, Germany, in 1867. He worked at a grocery store before teaming with Simon. He was the director of the German National Bank and the Vincennes Board of Trade and Board of Education.

Anton Simon emigrated from Alsace, France, in 1862. He also worked at a grocery store and was employed at the Jacob Kautz brewery starting in 1867.

Eugene Hack. From *History of Old Vincennes and Knox County, Indiana*, Vol. 2 (1911).

In 1869, he married John Ebner's daughter, Caroline. In 1871, he left the brewery to start a candy business, which he abandoned when he and Hack entered the brewing business together. He was the vice-president of the Vincennes Board of Trade.[347]

By 1886, they had agents and refrigerated storage in Washington, Jasper and Princeton, Indiana, as well as Carmi and Olney, Illinois. In 1890, they installed an ice-making machine. Previously, they had collected ice from Crystal Lake. A bottling line was added in 1896.

John Ebner's son, also John, continued working at the Eagle Brewery until his death in 1889. Eugene Hack's son, Julius "Dude" Hack, was the last president of the company. At its peak, the company employed twenty-five people and had a capacity of twenty-five thousand bbls.

Brands were Bock, Erlanger, Extra, Export and Elite, which was pronounced "E-Lite."

During Prohibition, Eagle made near beer, but the plant closed in 1930. From 1937 until 1949, the plant was used by the W.P. Squibb Distillery of Lawrenceburg. From 1954 through 1990, it was used for classrooms at Vincennes University.

In 2002–03 the Vincennes/Knox County Preservation Foundation raised $250,000 for the renovation of the office of the Eagle Brewery, now owned by Vincennes University (VU). VU wanted to tear down the building, first erected in 1885, for parking. Later, university president John Gregg supported the restoration of the building, which is now on the National Register of Historic Places.

Evansville

E vansville was an important port on the Ohio River before the Civil War, and it doubled in size during that conflict. In 1860, there were already ten breweries serving a population of eleven thousand people. By 1870, it boasted fifteen breweries and a population of twenty-one thousand.

Normal attrition sorted out the weak and small endeavors, and by 1880, there were only two breweries left. The Old Brewery and its associated Fulton Avenue Brewery made up the smaller of the two. The City Brewery of F.W. Cook was growing larger. Both were descendants of the original brewery set up by Jacob Rice and Fred Kroener.

Evansville brewing companies changed hands many times. This city also has the longest brewing history of any in Indiana. Except for the two prohibition periods, there has been brewing in town since 1837.

RICE & KROENER, OLD BREWERY, 1837–1853
KROENER & SON, 1853–1877
ULLMER & HOEDT, 1877–1884
ULLMER, REITMAN & SCHULTE, FULTON AVENUE BREWERY, 1884–1894
MERGED INTO THE EVANSVILLE BREWING ASSOCIATION
OLD BREWERY CO., 1880–1890

Jacob Rice and his brother-in-law, Fred Kroener, established the Old Brewery on the northeast corner of Fulton and Indiana Streets in Lamasco (now part of Evansville) in 1837. Previously, they had partnered in a bakery business and a boardinghouse.

In 1853, they split, with Rice going on to other interests before entering into the City Brewery with F.W. Cook and Kroener keeping the Old Brewery with his son, John. Rice was paid $3,500 for his interest in the brewery. Peak production at this facility was 3,090 bbls.

In 1867, John Kroener left the company to start the Washington Brewery. He was replaced temporarily by George A. Bittrolff, and Bittrolff was replaced in 1869 by Fred Kroener's son, Casimer.[348]

Bottled beer became more important for the company in 1875, when Fred Kroener & Co. was set up on First Street as "Dealers in Bottled Ale, Porter, and Lager Beer." Otto Brandley was a partner in this venture, which lasted until in-plant bottling was allowed in 1890.[349]

Charles Wilhelm Ullmer and Ferdinand Hoedt, immigrants from Russia and Baden, Germany, respectively, bought the business from the Kroeners in 1877. Ullmer was the business manager, and Hoedt was the brewer, his father and grandfather having been brewers in Heidelberg.

In 1879, they sold 6,119 bbls of beer and ale.[350] In August 1880, Ullmer & Hoedt spun the Old Brewery into a new corporation, with William Heileman as president, George A. Bittrolff as secretary and treasurer and Joseph J. Reitz as the manager.[351]

In 1881, the parent company opened a new plant, the Fulton Avenue Brewery, diagonally across the street from the Old Brewery. This new plant was four stories high, 74 by 116 feet and had a 720-square-foot ice cellar. With vessels that could hold up to three hundred bbls, the brewery could produce up to eighteen thousand bbls per year.[352]

The Old Brewery plant continued operation until two walls were blown down and the roof collapsed in a violent storm in March 1890. Six men were at work at the time, three of whom died.[353]

Peak production at the Fulton Avenue Brewery was twenty-five thousand bbls annually. Pilsener, Kulmbacher and Export-style beers were the mainstays. The Rheingold brand originated at the Fulton Avenue Brewery.

Charles Schulte and Henry Reitman, also immigrants from Prussia and Germany, owned a prosperous sawmill business in the area, making hardwoods and timber for railroads and bridges. They bought into the Fulton Avenue Brewery in 1884, when Ferdinand Hoedt left. Schulte later became director of the German National Bank of Evansville.[354]

The Fulton Avenue Brewery is one of three that consolidated into the Evansville Brewing Association in 1894. The others were John Hartmetz & Son and Evansville Brewing Co.

Frederick Richert
About 1850–About 1865

August Schieber was born in Württemberg, Germany, on February 7, 1841, a son of Frederick and Magdalena Schieber, residents of the town of Stuggart. August's father died when he was seven. His mother married a second time, this time to Frederick Richert, and in 1848, Richert brought his family to the United States. They located in Evansville, where he established a brewery. August Schieber was reared in Evansville, educated in its schools and variously employed in his stepfather's brewery; he also learned the cooper's trade.[355]

Shortly after the Civil War, the Richert family moved to Mount Vernon, Indiana, and built the Flower House hotel.

Rice & Cook, City Brewery, 1853–1885
F.W. Cook Brewing Co., 1885–1918
F.W. Cook Co., 1933–1955

The City Brewery was founded by Frederick Washington Cook and his stepfather's brother, Louis Rice. Rice managed the brewery, and Cook looked after the business details. Initial capital was $330. Half of that sum was supplied by Cook's stepfather, Jacob Rice, who had just left the Old Brewery.

According to an article by Bish Thompson in the *Evansville Courier and Press* on May 15, 1965, "[Frederick] operated a one-horse, one-barrel cart, dipping out of the barrel into pails, pitchers, bowls, old hats and other containers trotted out from homes along his route."

In 1857, Louis Rice left the firm, selling his interest in the City Brewery to his brother, Jacob, for $3,500. Jacob and Frederick immediately rebuilt the brewery, including a malt house and a large lagering cellar (they had previously only made ale). This is said to have been the first lager brewed in the area.[356]

Louis went on to start the Eagle Brewery with Henry Wingert in 1861 and then bought the Union Brewery in 1863.

Brewers throughout the next twenty years included George Hild, Henry Boettger, Herman Huck, Nicholas Kissel, Fred Stocker, John Walter, Jacob Eibel, John Guhl, Joseph Jung, Jacob Lang, William Martin, Henry Moll, Andreas Schuttheus, Anton Wiegert, Fred Roth, John Pregler, John Lucks, William Martini, William Reibel, August Straub and Alexander Weber.[357]

In 1873, Jacob Rice died in an accident. When Jacob's widow, Christiana Rice, died in 1878, F.W. Cook inherited the entire business, then producing over seventeen thousand bbls of beer annually.[358]

Seven years later, the firm was incorporated. F.W. Cook Sr. was president and general manager, F.W. Cook Jr. was vice-president, George M. Daussman was secretary and treasurer and Philip P. Puder was the general agent. Gus B. Mann was also a stockholder. Henry F. Froelich was the chief engineer. Andrew Wollenberger, an immigrant from Bavaria, was the foreman and had previously been employed at breweries in Cincinnati.

According to the *History of Vanderburgh County* (1889):

> *While the product of the F.W. Cook Brewing Co.—the famous "Pilsener Beer"—has become a household word and is the most popular beverage in this part of the country, it has also won an enviable reputation abroad, especially in the southern states, and large quantities of it are daily being shipped to all the principal cities of the south. Purity, brilliancy and deliciousness of the flavor, together with its sparkling, foaming qualities, is what has made the Pilsener of the F.W. Cook Brewing Co. so popular wherever it has been introduced.*

By 1889, Cook produced seventy-five thousand bbls and employed 110 men. Wages were approximately $75,000. It used 185,000 bushels of malt and 115,000 pounds of hops.[359]

A fire destroyed the brewery and offices in December 1891, causing $50,000 in damages.[360] The structures were immediately rebuilt, reopening in March 1893 with a capacity of 300,000 bbls annually. A refrigeration plant was also added at this time.[361]

Frederick W. Cook was also a city councilman, an Indiana state representative and the president of the Evansville Suburban Newburgh Traction Company (an interurban railroad) and the District Telegraph Company. He also owned the Cook Investment Company and Cook Realty, which operated Evansville's largest amusement park—Cook Park.

By 1910, production reached 600,000 bbls. Names used included Goldblume, Pilsner, Pale Lager, Budweiser, Tonicum, Extra Export Lager, Standard and Pilsener. It also produced Cook-Ola and Cook's Dry near beer during Prohibition.

The Louisville & Nashville Railroad (L&N) took a case to the U.S. Supreme Court in 1912 against Cook because the L&N refused to accept shipments from Evansville to dry counties in Kentucky. Cook had won in circuit court and received an injunction forcing the L&N to ship kegs and cases of beer. The Supreme Court upheld this ruling.[362]

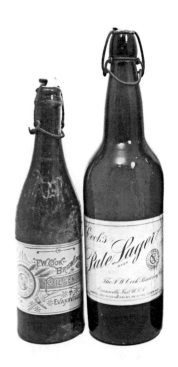

Above: Frederick W. Cook. From *History of Vanderburgh County, Indiana* (Brant & Fuller, 1889).

Right: Early swing-top bottles of F.W. Cook's beer: Pilsner and Pale Lager.

Upon F.W. Cook's death in 1913 (at the age of eighty-one) his son, Henry E. Cook, ran the business until his death in 1929. Then, Henry's brother, Charles Cook, took over the business.

Beers after Prohibition divided into older names, including Goldblume, Bock and Ale, and new names included Augustiner and Capuchiner. Eventually, the Goldblume brand became the flagship with Special and Bock variants. More specialized and lower production beers were also made, such as Tropical Extra Fine Ale. Labels were changed to include a steamboat to help sales in the southern states.

In 1935 and 1936, Cook's sponsored a semiprofessional baseball team, Cook's Goldblumes. Adolph B. Schmidt, then in his seventies, was president of the company during this era and was also president of the Indiana Brewers' Association.

In 1948, Tony Hulman of Indianapolis Motor Speedway fame bought controlling interest. Hulman elevated an Evansville attorney named Ortmeyer from vice-president and secretary of the company to have complete control of the brewery.[363] They also introduced Cook's 500 Ale.

When the workers went on strike in June 1955, wanting equal pay to Sterling's employees, Hulman closed the plant in September of that year.

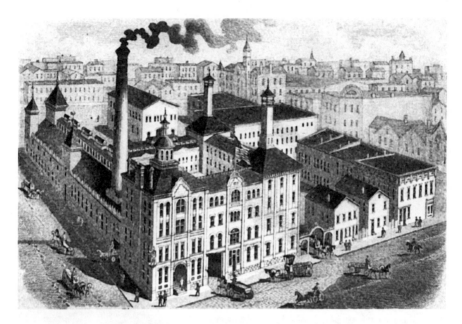

A stylized drawing of the F.W. Cook Brewing Company plant. From *Perspective Map of the City of Evansville* (American Publishing Co., 1888).

Approximately 102 years of brewing history ended at that time.[364] Capacity was 750,000 bbls. The corporation existed until 1961 but did no brewing.

The entire plant, located on the block bordered by Main, Sycamore, Seventh and Eighth Streets, was torn down in 1965 to make way for a Civic Center, including the Evansville Jail and Courts building.

The Goldblume brand was sold and brewed in other locations until 1972—even by the crosstown rival Fulton Avenue Brewery, owned then by Associated Brewing Co.

JOHN SCHUELER, 1857–1863
LOUIS RICE & CO., UNION BREWERY, 1863–1869

John Schueler made common and lager with brewers John Guhl and Charles Nicholaus on the northwest corner of Vine and Fifth Streets. Louis Rice, Jacob Rice's stepson, bought and renamed the business Union Brewery in 1863. He had left the City Brewery to strike out on his own and was involved in Henry Wingert's Eagle Brewery.

Louis's stepbrother, Jacob Rice Jr., joined Louis just before they closed in 1869.[365]

The land was purchased by the county in 1873, and the courthouse was built on this site in 1887. The buildings having sat empty and derelict for eighteen years.

John Emrich, 1858–1866
Evansville Brewery, 1866–1867
Stumpf & Eisfelder, 1868–1870
M. Stumpf, 1870–1876

John Emrich started his brewery in downtown Evansville on the southwest corner of Ingle and Sixth Streets. In 1866, Michael Stumpf and Ulrich Endres bought the operation and renamed it the Evansville Brewery. They made ale, lager and common beer.

Frederick Eisfelder replaced Enders in 1868 but left within two years, leaving Stumpf as the sole proprietor.

John Roth Jr. was brought in as business manager in 1875, but the brewery closed the next year.[366] The firm produced, at most, thirteen hundred bbls of beer annually.[367]

Crescent City Brewery
1858–1870

Joseph Jauch and Herman Wack made ale, lager and common beer at this small establishment on Market Street between Fourth Street and Honest John. It was located just south of where Third and Fourth Streets go under the Lloyd Expressway. Both of the founders left in 1865. Joseph Jauch started the Olive Branch Brewery, and Herman Wack bought the Franklin Brewery. At this time, Andrew Jauch and Ferdinand Hirschberger took over. Joseph Bortzmeier took Jauch's interest in 1870, just before the brewery closed.[368]

Wingert & Rice, 1858–1862
Henry Wingert, Eagle Brewery, 1862–1869

Louis Rice left his stepfather's City Brewery in 1857. He and Henry Wingert started a brewery, but Rice left four years later to buy the Union Brewery.[369]

This establishment is noted in the 1861 *City Directory* as being on the west side of Pearl Street between Front and Third Streets in Lamasco, the area northwest of downtown Evansville between First Avenue and Pigeon Creek. Pearl and Front Streets do not exist anymore.

The Eagle Brewery made ale, lager and common beer.[370]

August Schaeffer, Franklin Brewery, 1861–1866
Herman Wack, 1866–1868
Fred Weber & Bro., 1868–1877
Weber & Rupp, 1877–1878

August Schaeffer located his brewery a block north of the Old Brewery, on the west side of Fourth Avenue at Franklin Street. It was first called the Franklin Brewery in 1865.

In 1866, Herman Wack left the Crescent City Brewery and bought Schaeffer's enterprise, installing Jacob Stockmeier as the brewer. Within two years, Fred and Charles Weber bought out Wack and renamed the brewery after themselves. They made ale, lager and common beer.

George Rupp bought out Charles's share a year before the company disappeared.[371] The company continued for a while, producing malt for other breweries and bottling beer for Ullmer and Hoedt.

Philip G. Klappert
1863–1869

Klappert built his brewery west of Pigeon Creek, on the northwest corner of Franklin Street and Twelfth Avenue, in the Independence district.[372] After he gave up the brewing business, he became a grocer.

Henry Schneider, 1863–1876
John Hartmetz & Son, 1876–1894
Merged into the Evansville Brewing Association

In 1863, Henry Schneider started a brewery on West Heights Road in "Babytown," now Harmony Way at Maryland Street. [373]

In 1865, Franz Rettig (no relation to the Franz Rettig of the Wabash Brewery) started a brewery in Louisville and produced the Sterling beer brand. The company went through many hands and several bankruptcies until it was sold at a sheriff's auction in 1873 to John and Charles (Karl) Hartmetz, brothers from Rheinpfalz, Germany. Charles, the older of the two, handled the business, and John was the brewer, having worked at several breweries in Germany.

John and Charles decided to go their separate ways when Schneider's brewery, then producing about six hundred bbls of beer annually, went up for sale in 1876.[374]

Legend says they flipped a coin to see who would stay in Louisville and who would move to Evansville. John moved to Evansville.

Charles died in 1888, and the brewery in Louisville was sold by his widow to John Oertel in 1892. He produced Oertels '92 in honor of that date. That brewery closed in 1967.

The Hartmetz Brewery used "sterling" as a lower-case superlative description. Hartmetz also changed from common beer to making Pilsner lager. At its peak, it made about fifty thousand bbls annually.[375]

Hartmetz's eldest son, Charles F., joined the business in 1891, and he was the guiding force in the creation of the Evansville Brewing Association in 1894. When the merger occurred, John Hartmetz retired and moved back to Germany. The old facility continued to be used as a malt house by the Evansville Brewing Association until 1910.

John's younger son, Otto Hartmetz, was literally born in the brewery and was active in the business until he stepped down in 1958 at age seventy-seven from his position as vice-president in charge of production at Sterling Brewers Inc. He was also on the board of the Old National Bank and a prominent auto dealer in Evansville, selling Saxon, Maxwell, Oldsmobile, Chalmers, Franklin, Marmon and Dodge cars.[376]

JOHN KROENER & CO.
WASHINGTON BREWERY
1867–1869

ohn Kroener was the son of Fred Kroener of the Old Brewery and a partner in that firm. In 1867, he left to try his own hand at operating a brewery, located near what is now Sixth Avenue, just north of the Lloyd Expressway. It only lasted three years.

JAUCH & SPECK
OLIVE BRANCH BREWERY
1866–1870

Joseph Jauch left the Crescent City Brewery in 1865 and, with Peter Speck, started this small brewery at the north end of Seventh Avenue. Peter Speck, an immigrant from Germany, was born in 1820. He fled Germany after being involved in the failed March Revolution of 1848. He was a blacksmith in Evansville for many years.[377]

GEORGE J. FISCHER
1867–1870

Fischer lived one block west of the brewery, which was located on the southeast corner of Franklin Street and Wabash Avenue.

FAHNLEY, KUHN, & CO.
WESTERN BREWERY, 1868–1874

Jacob Fahnley and Valentine Kuhn owned this brewery at 85 Main Street in downtown Evansville. Leopold Forster also had a financial interest. It made lager and Original Evansville XX Ale.

EVANSVILLE BREWING CO.
1891–1894
MERGED INTO THE EVANSVILLE BREWING ASSOCIATION

The Evansville Brewing Co. was formed in 1891 by a group of men including Henry C. Wimberg. At the consolidation of the three breweries into the Evansville Brewing Association, Wimberg was made president. He immigrated to America at the age of seventeen from Oldenburg, Germany, where he had worked in his father's tavern. In Evansville, he owned a tavern for twelve years. Later, he was a city councilman, the police and fire commissioner and a director of the Old State National Bank.

The main brand of this brewery, located at Fourth and Ingle Streets, was Minnehaha beer.[378]

EVANSVILLE BREWING ASSOCIATION, 1894–1918
STERLING PRODUCTS CO., 1918–1933
STERLING BREWERS INC., 1933–1964

In 1880, there were ten breweries in Evansville. By 1890, there were three. These last three all prospered, but Cook's—with a new facility and good marketing—grew the fastest. By 1890, Cook's had a capacity of about seventy-five thousand bbls. The other two together just equaled this number: Fulton Avenue Brewery at about fifty thousand bbls and Hartmetz at about twenty-five thousand.

In many other cities—New York, Chicago, Baltimore, Detroit, Boston, Philadelphia, San Francisco and, in 1887, Indianapolis—English

syndicates had bought up and merged breweries throughout the 1880s. By 1890, many price wars had erupted as these bigger firms tried to enlarge their market share. In Chicago, the price of beer came down from $6.00 per barrel to $3.50.[379] So it was that F.W. Cook decided to do the same price-cutting.

That led to the formation of the Evansville Brewing Association. The Fulton Avenue Brewery, Hartmetz & Son, and the newer Evansville Brewing Company re-formed as a single corporation. An economic panic in 1893 no doubt also figured into their decision to merge.

The Fulton Avenue Brewery had built a brand new plant in 1881 and was the biggest facility, so it was the choice to be the lead brewery. The Hartmetz brewery was outside of town and had poor access to transportation, but it had a malt house that was kept in use. The downtown Evansville Brewing Co. was smaller, but its owner, Henry Wimburg, was chosen as the first president of the new corporation. The board of directors included Charles and John Hartmetz, Charles Ullmer and Henry Stockfleth.

Charles F. Hartmetz's younger brother, Otto, eventually became the master brewer and vice-president of the company. He retired in 1958.

Henry Wimbug's sons, Henry A. and John G., managed branch sales offices in Indianapolis and Memphis. Another son, Louis W. Wimburg, became the bookkeeper of the Evansville Brewing Association at age nineteen.[380]

They kept the Rheingold (Fulton Avenue) and Sterling (Hartmetz) brands as the flagship beers but still made Minnehaha (EBC). Pale, Pale Export, Erlanger, EBA Pale and Bohemian Creamdale were also produced. Branding of EBA beers was changed slightly to use a horseshoe and the motto "Good Luck Brand."

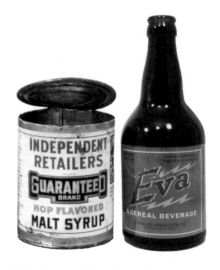

The new enterprise seems to have had a lot of capital to work with. Wimberg invested in an airplane venture in 1898 (the Farmer Flying Machine), and Otto Hartmetz bought interest in the Simplicity Auto Co.[381]

Then came Prohibition. The association's name was changed to Sterling Products Co., and the product

Malt Syrup and Eva Cereal Beverage, produced by the Sterling Products Co. during Prohibition.

line switched to Target brand ketchup and chili sauce. It also sold ice and leased unused storage space to auto dealers and wholesalers.[382]

Also keeping the company afloat were its nonalcoholic cereal beverages (near beers): Sterling Dark Beverage and Eva. Sterling continued to appeal to older customers, and Eva, with new bright, electric-bolt packaging, was aimed at new customers.

The mainstay and the company's top moneymaker during this time, as it was for many breweries, was malt extract. Sterling's was named Independent Retailers Malt Syrup. Rich and sweet, it could be used in baking, in baby foods and, coincidentally, when boiled and combined with hops and yeast could make a decent home-brewed beer. It also sold a similar un-hopped syrup called Cheerio Malt Extract.

In July 1924, Sterling suffered a fire that caused $311,000 in damage.[383]

When Prohibition ended, Sterling was ready to get back in the beer business. It had a large plant, people with experience in brewing and funds to market its products. The company was renamed Sterling Brewers, Inc., and production started as soon as legally possible.

From 1933 until 1936, Sterling produced Drewrys beers for Drewrys U.S.A., a subsidiary of Drewrys in Canada. These included Ale, Half and Half and October Ale. This arrangement entailed investment by the Canadian company to install more fermenters and aging tanks in the Fulton Avenue plant. In 1936, Drewrys bought the Meussel Brewery in South Bend, Indiana, and moved their production there.

About 1935, Sterling sponsored a semiprofessional "colored" baseball team called the Sterling Beers.

In 1937, it built a second brewery in Freeport, Illinois, to increase production. It made 50,000 bbls per year in addition to the 500,000 bbls made in Evansville. This plant closed in 1939, the same year Charles F. Hartmetz died.

After Prohibition, the Sterling Pilsners were augmented by short-lived Target and Lug o' Ale brands, along with Sterling Ale, Golden Autumn Ale and Bock beers. After World War II, a new brand, Super Bru Pilsner, was introduced.

In 1940, Sterling invaded the South by setting up Sterling Distributors, Inc., in Birmingham, Alabama, in the person of Sam Nakos, who had previously been affiliated with F.W. Cook's. The Sterling brand continued to be popular in the Southeast until the end of its brewing in Evansville in 1997.[384]

Richard T. Riney was president starting in 1934 and in 1963 was named chairman of the board. He also served for many years as president of the Indiana Brewers' Association and in 1949 was elected secretary of the United States Brewers Foundation.[385]

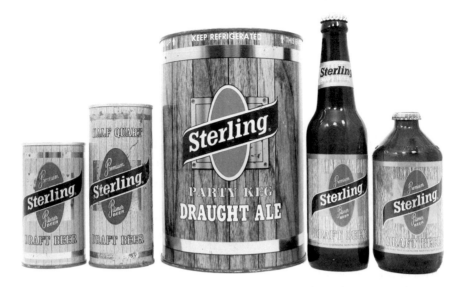

A range of Sterling beer containers in twelve ounce, sixteen ounce and one gallon sizes.

Marking its 100th anniversary in 1963, Sterling released a collector's edition painted bottle. At that time, J.J. Lederle was the president, director and chairman of the executive committee. G. Byron Allis was treasurer, and Herman L. McCray was secretary. Directors were Danile J. Zutt, James L. Nugent, Howard W. Bootz, John H. Wall and Robert D. Orr, who later became governor of Indiana.

The vice-president in charge of production and master brewer in the 1960s was Carl Meubauer. Under his supervision, a six-hundred-bottle-per-minute bottling line and an even faster canning line were installed. The company had over three hundred employees and paid $40,000 in taxes each day.

Packaging included cans, longneck returnable bottles, non-returnable stubbies, pints, quarts, resealable half gallons and even one-gallon cans.

The Sterling logo was updated through the years to keep up with modern times. Bigmouth bottles were invented at Sterling in the early 1960s.

Sterling ended as an Evansville-controlled entity in 1964, when it was purchased for $6.5 million in cash and approximately $500,000 in Associated Brewing Co. stock. Associated had been built by Pfeiffer of Detroit and had previously swallowed Schmidts of St. Paul and Piels of New York. It subsequently purchased Drewrys of South Bend in 1965. These acquisitions made Associated the tenth-largest brewing concern in the United States.[386]

WILLIAM J. WITTEKINDT BREWING CO. INC.
1935–1941

Adolph Wittekindt & Son were coopers in Evansville as far back as 1906, employing as many as twenty-three people.[387] Near the end of Prohibition, H. William Wittekindt, the "son" and then owner, thought a brewery in the family would be worth a try. He sent his son, William J., to a brewers' school in Chicago in 1932 for eighteen months and then to Munich, Germany, for a year's apprenticeship before starting their brewery at 11 South Kentucky Avenue (now covered by the Lloyd Expressway near U.S. 41).

Wittekindt's brands were Hi Hop and Münch'ner Style Beer. Later, they explained why the brewery closed: "We didn't sell enough beer."[388]

STERLING BREWERS ASSOCIATION, ASSOCIATED BREWING CO., 1964–1972
G. HEILEMAN, 1972–1988

Pfeiffer Brewing Co. started business in 1934 in Detroit and grew to good size—the tenth largest in the United States in 1950. In the '60s Anheuser-Busch, Schlitz, Falstaff, Carling, Pabst, Ballantine, Hamm, Shaefer, Miller and others were gobbling up the national market with extensive advertising campaigns. Pfeiffer and Stroh's in Detroit both remained regional breweries, but Pfeiffer had aspirations to bigger things. They bought the Jacob Schmidt Brewing Co. of St. Paul and the Piels Brothers brewery of Brooklyn.

In 1962, the company name changed to Associated Brewing Co. and merged with Detroit's E&B Brewing Co. In 1964, it bought Sterling Brewers, Inc., for $6.5 million in cash and 122,000 shares of stock worth almost $500,000. The next year, Drewrys was added to the conglomerate.

By 1969, Associated was again the tenth largest brewing company in America and was returning a profit, but there was no growth in any of the brands. In fact, even with all the acquisitions, it had barely doubled its production from 1950 (from 1.6 million to 3.7 million bbls). Consolidation seemed to be the answer, so most of its breweries were mothballed, and Evansville produced most of the brands in the portfolio.

Brands brewed corporation wide included 9-0-5, Barbarossa, Bavarian, Champagne Velvet, Cook's, Drewrys, E&B, Edelweiss, Frankenmuth, Great Lakes, Hampden-Harvard, Home, Katz, North Star, Old Dutch, Pfeiffer, Piels, Prost, Regal, Schmidt, Redtop, Sterling, Tropical and Twenty Grand.

Capitalizing on the bigmouth bottle pioneered by Sterling, Associated introduced Mickey's Big Mouth at the Evansville plant in 1970. This brand later passed through a succession of hands and is still being marketed by Miller Brewing.

G. Heileman, based in La Crosse, Wisconsin, stepped in to add the Associated family to its brood of breweries in 1972 after a year of negotiations. Heileman immediately closed the Drewrys plant in South Bend.

The United States Justice Department tried to block the merger, but the courts found that no monopolization would occur because neither company had nationwide marketing power. It did, however, block Heileman's attempted purchase of Schlitz in 1981.

Heileman had been on an expansion-by-buying spree since 1959 and had already swallowed Kingsbury (1959), Fox Head (1962), Braumeister (1963), Gluek (1964), Duluth Brewing (1966), Wiedemann (1967), Oertel of Louisville (1967) and Blatz (1969 via Pabst).[389]

Heileman also acquired Grain Belt (1976), Rainier (1977), Falls City of Louisville (1978, including the Drummond Brothers brand), Carling (1979), Champale (1986) and C. Schmidt of Philadelphia (1987).[390] Peak production was 900,000 bbls annually.[391]

Heileman stopped brewing in Evansville in March 1988 due to being over capacity in its other plants. The plant was shuttered in May at the cost of 135 jobs.[392] It was sold to local investors and became the Evansville Brewing Company, reopening after a three-month closure.

EVANSVILLE BREWING CO.
1988–1997

A group of local investors led by two founding owners, John Durnin and Mark Mattingly, reopened the Associated brewery on September 21, 1988, after G. Heileman closed it due to being over capacity throughout its brewing empire. Durnin co-owned the Koch Label Co. that printed labels for beer bottles. Mattingly was a local attorney.[393]

The head brewer was Ken Griffiths, and the plant had a 1.2

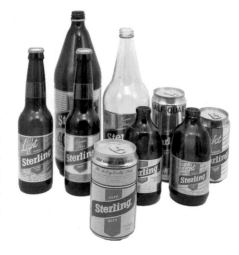

A range of Sterling beer containers made by the Evansville Brewing Co. in the 1990s.

million bbl annual capacity, employing about ninety people. The first CEO was Mark Mattingly, and the last was Steven Cook. Headquarters were at 1301 Lloyd Expressway, in the Fulton Avenue plant first constructed in 1881. John Hellweg was the president.

In addition to Sterling, the Evansville Brewing Company (EBC) made Champagne Velvet, Cook's, Drewrys, Drummond Brothers, Falls City, Lemp, Penn and Weidemann beers. Light and nonalcoholic versions of many of these beers were also brewed. Birell was licensed from Hürlimann Brewery in Zürich, Switzerland.

The busiest person in the company seems to have been Terry Southerland, director of marketing. EBC's in-house brands weren't enough to keep the company afloat, so Southerland found many other possibilities in connection with other companies.

Brands contract-brewed for marketing companies included Bad Frog, Cave Creek, Coldsburg, Evansville, Gringo, Jackaroo, Joe's Freakin', Mo's Maxim, Red White and Brew, Rainbow Ridge, River City, Scorpion Malt Liquor, State Street (Chicago), The Eagle and Zebra. New Frontier Brewing of Vinton, Iowa, had the EBC make Premium Amber Lager, the first certified organic beer in the country.[394]

Specialty one-offs could also be contracted for bars, restaurants, celebrations and marketing efforts. Some of these were Birds Brew, Brigade, Harley Davidson Daytona 1991, Dirt Cheap, Dog Pound, Havana Gold, Iron Horse, John Gilbert's Riverboat, Hey Mon, Mardi Gras, Prime Time, Santa Claus, Steel Curtain and Whoomp. Treasure Bay was made for a casino in Biloxi, Mississippi.

The Gerst Haus restaurant in Nashville, Tennessee, had Gerst Amber made in the 1990s. A Gerst Haus opened in Evansville in 1997, just as the EBC closed. Production of Gerst beers moved to Pittsburgh Brewing Co. and, in 2011, to Nashville's Yazoo Brewing Co.

Novelty and fruit beers were also on the table. EBC made beers such as 1993's Bicycle Beer's Veri Berry, Misty Lime and Apricot Stone for a marketing company in Chicago;[395] Zebra Raspberry and Peach beer; and even Champagne Velvet with berry and grape flavors.

A lot of beers were sent overseas. EBC made house-branded beers for all four big supermarket chains in England—ASDA, Sainsbury's, Tesco's and Waitrose.

Trying to capitalize on the growing microbrewery trend in 1996, EBC started a line of beers under the Old European Brewery Co. and Colonial Brewery Co. names. These beers had names such as St. Johnsbury Porter, Bison Wheat, Highland Stout, Otto Bruckman Bavarian Bock, India Pale

Ale, Jacob Rosenberger & Son Munich Dark, Angus MacDougall Scottish Red, Gustav Werner Alt Amber, Wurch & Warnke Pilsner, Allegheny Cream Ale, Dunham Castle London Nutty Brown Ale and American Brown Ale.

German exports included Red Eagle and Star of America. El Rey beer was exported to Mexico. A distributor in Saudi Arabia got nonalcoholic beers.

Exports to Japan and South Korea included Drewrys, Drummond Brothers, Gerst, Lager Black, Lager Red, Rocky Mountain, Steamer, Sterling and Wyoming. Drummond Brothers was the second-largest imported beer in Japan, with up to 500,000 cases per month heading that way.[396]

Brazil got Alex, All Beer, American Lager, ISA, the Eagle, NS2 (a lemon-flavored brew), Squirrel, Sundown, Wyoming, Upstate and Vai-Vai.[397]

Combining boutique brands and exports, many football teams in Brazil had their own beers brewed by EBC. By 1994, Evansville Brewing Co. sold almost 40 percent of its beer overseas.

On top of all these contracted beers, EBC did produce its own brands. Sterling was augmented by Hoosier Red, which was brewed quarterly with a label that changed according to the season.[398] EBC ended up buying State Street Brewing of Chicago. EBC marketers hoped to gain considerable local shares, but Old Style and Goose Island got there first.[399]

Sainsbury's promotion of Indiana Gold in England was based on Evansville being called "the most miserable place on the face of the earth," which angered the Evansville mayor and other city fathers.[400] Sainsbury's positioned Indiana Gold as a sub-premium brand, pricing it at a 15 percent discount from major brands.[401]

In 1996, a shipment of 241,246 cases of Drummond Brothers beer headed to Japan went bad due to leaky cans. The distributor, Daiai Inc. of Tokyo, sued EBC for more than $6 million, leading to the collapse of the company.[402] Unable to find a buyer or the funds to pay off debts, Evansville Brewing Co. declared bankruptcy and closed on October 1, 1997. Ironically, it was awarded a gold medal at the Great American Beer Festival for Drummond Brothers, deemed the best American lager, three days later.

Except for Old European and Colonial, the brands EBC owned were sold to Pittsburgh Brewing for $850,000.[403] The Sterling brand is now owned by Iron City Brewing in Pittsburgh, which bought the Pittsburgh Brewing Company.

This was still a large brewery right up to its closing, with ninety-two employees. In November and December 1997, workers packaged up the product in-house—about 12 million cans.[404] An auction the next April disposed of all the equipment.

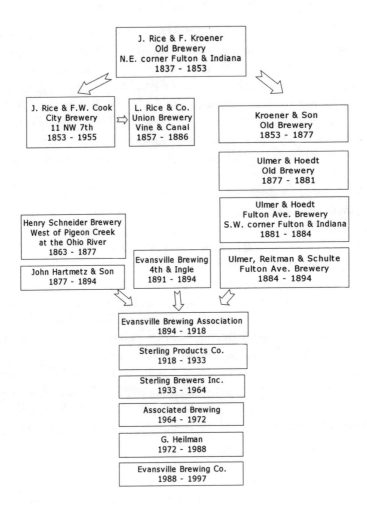

So ended the last big brewery in Indiana—from 1816 in Richmond and New Harmony all the way through Terre Haute, Theime & Wagner, Indianapolis Brewing, Muessel, F.W. Cook, Spring, Guenther & Zwereck, Madison, Centlivre, Reising, Kamm, Zorn, Hack & Simon, Crown, Rettig, Marion, Berghoff, Norton and more. After 181 years, the last of the giants died.

By that time, though, a new brewing age had begun, spawned by a new Indianapolis Brewing Co. The movement was mothered by a new kind of brewery—the brewpub—in the form of John Hill's Broad Ripple Brewing Co. When Evansville Brewing closed, there were already nineteen new microbreweries in Indiana. The story goes on.

Modern-Era Breweries

The revived Indianapolis Brewing Co. signaled a return to brewing in Indiana. Only Evansville Brewing Company was still left in operation after the industry dominance of a few companies that caused the South Bend Brewing Association, Hoff Brau, Lafayette Brewing Co., Kamm, Kiley, F.W. Cook and, finally, the Terre Haute Brewing Co. to falter. Consolidations and buyouts of the 1970s saw Drewrys, Old Crown and Falstaff shuffle off. The last holdout tried hard to compete by producing many brands made to look like new start-up microbreweries, but the economies of scale worked against it.

A quick glance at the bold entries in Table 2 shows three phases of the modern era:

1) Early years through 1996. Most of these breweries are still in operation.
2) Growth years through 2001. A few new, well-organized, beer-oriented companies grew spectacularly, while chain and small brewpubs disappeared as fast as they opened.
3) The glorious free-for-all from 2007 onward. Almost everyone with a brew kettle is now getting in on the act. Small, even tiny, breweries are finding that they can make a living or augment their restaurants effectively because people have come to equate microbreweries and brewpubs with good food and good beer, no matter how small the square footage. Selling beer at the brewery, by the growler, is also proving to be a workable business plan.

Note: This chapter is arranged alphabetically by city. Table 2 is a chronological cross-reference.

TABLE 2. MODERN-ERA BREWERIES
(BOLD INDICATES STÏLL OPEN)

BREWERY	PAGE	CITY	DATES OF OPERATION
Indianapolis Brewing	191	Indianapolis	1989–97, 1997–2003, owned by Oaken Barrel
Broad Ripple Brewing	191	Indianapolis	1990–Present
Mishawaka Brewing	199	Mishawaka, Elkhart	1992–2011
Lafayette Brewing	196	Lafayette	1992–Present
Bloomington Brewing	184	Bloomington	1994–Present
Oaken Barrel Brewing	190	Greenwood	1994–Present
Alcatraz Brewing	192	Indianapolis	1995–2011
Circle V Brewing	192	Indianapolis	1996–2001
Turoni's Pizzeria & Brewery	187	Evansville	1996–Present
Rock Bottom Restaurant (Downtown)	192	Indianapolis	1996–Present
Three Floyds Brewing	199	Hammond, Munster	1996–Present
Back Road Brewery	197	La Porte	1996–Present
Wildcat Brewing	193	Indianapolis	1996–2000
Tucker Brewing	203	Salem	1996–99
Silver Creek Brewing	203	Sellersburg	1999–2001
Falcon Brewery	188	Fort Wayne	1997
Duneland Brewhouse	198	Michigan City	1997–2004
Firkin Brewpub The Little Cheers	187	Evansville	1997–98 2004–06
Glacier's End Brewing	193	Indianapolis	1997–99

Modern-Era Breweries

Brewery	Page	City	Dates of Operation
Just Brew It	199	Mishawaka	1997–2000
Hops Grill Brewery	193	Indianapolis	1998–99
Mad Anthony Brewing	188	Fort Wayne	1998–Present
Upland Brewing	185	Bloomington	1998–Present
Barley Island Brewing	202	Noblesville	1999–Present
South Bend Brewing	203	South Bend	1999–00
Aberdeen Brewing	205	Valparaiso	2000–04
Ram Restaurant	194	Indianapolis	2000–Present
Goodfellows Brewing	205	Whitehall	2000–01
Terre Haute Brewing **Vigo Brewing**	204	Terre Haute	2000–05 2007–Present
Oyster Bar	188	Fort Wayne	2001–04
New Albanian Brewing	201	New Albany	2001–Present
Warbird Brewing	189	Fort Wayne	2004–09
Brugge Brasserie	194	Indianapolis	2005–Present
Nine G Brewing	203	South Bend	2005–07
Rock Bottom Restaurant (86th St.)	192	Indianapolis	2005–Present
Shoreline Brewery	198	Michigan City	2005–Present
Half Moon Restaurant	196	Kokomo	2007–Present
Power House Brewing	186	Columbus	2007–Present
Granite City Food and Brewery	189	Fort Wayne	2008–Present
	189	Mishawaka	2009–Present
	189	Indianapolis	2008–Present
Brass Monkey Brewing	193	Kokomo	2008–09
Crown Brewing	186	Crown Point	2008–Present
Great Crescent Brewery	183	Aurora	2008–Present

Brewery	Page	City	Dates of Operation
Bee Creek Brewery	185	Brazil	2009–Present
Sun King Brewery	194	Indianapolis	2009–Present
Brickworks Brewing	190	Hobart	2009–10
LiL Charlies Steakhouse and Grill	184	Batesville	2009–Present
Big Woods Brewery	200	Nashville	2009–Present
People's Brewing Co.	197	Lafayette	2009–Present
Wilbur Brewhause	206	Wilbur	10–Present
Figure Eight Brewing	205	Valparaiso	2010–Present
New Boswell	202	Richmond	2010–Present
Bier Brewery and Taproom	195	Indianapolis	2010–Present
Flat 12 Bierwerks	195	Indianapolis	2010–Present
Thr3e Wise Men	195	Indianapolis	2011–Present

After the great consolidation of breweries throughout America, only beer from overseas was available for those who wanted something different from mass-merchandised lagers. England and Ireland provided most of these styles in the form of pale ales, porters and stouts, with German wheat and pilsner beers also popular. There still wasn't a lot of choice, and anyone who wanted could try virtually every new beer that came on to the local market.

The 1980s saw many new microbreweries and brewpubs open, mainly on the coasts. Indiana's first new brewery to open in thirty years appeared in 1987; it was the new Indianapolis Brewing Company. The next twenty-three years have seen fifty-three breweries open in Indiana.

Most of these companies were and are making ales, and most make a wide variety of styles. Specialty and seasonal offerings are brewed regularly, and that's part of the fun—the diversity keeps customers interested. Extreme ranges of existing styles and development of new styles have made some Indiana breweries world famous.

Competition between these modern-era breweries has been almost nonexistent. The craft beer market in Indiana is usually quoted at about 2 percent of the total beer market, and Indiana breweries account for only a

small percent of that number. It is normal for local breweries to share supplies, yeast strains, malt and hops and even collaborate on beers and recipes.

All but a few breweries serve a local area—sometimes just one on-site restaurant (a brewpub). Many self-distribute to accounts within one hundred miles. Advertising budgets are all but nonexistent. Most are family owned and support very few employees.

Only two distributors distribute Indiana craft beer statewide. In 2010, World Class Beverages and its parent company, Monarch Beverages, had contracts with Barley Island, Mishawaka, Oaken Barrel, Three Floyds and Upland. A smaller distributor, Cavalier, had contracts with Mad Anthony, New Albanian and Peoples.

The Brewers of Indiana Guild was formed as a trade association for the brewery owners led by John Hill of the Broad Ripple Brewpub. It has worked for legislation that, for instance, gave breweries the authority to sell carryout beer on Sundays (passed in 2010). It has also sponsored many charitable events, including an annual beer festival that serves beer samples to about four thousand attendees and raises money for charity. In 2009, the festival raised about $30,000 for the Leukemia and Lymphoma Society.

Beer names or styles listed below are representative of the individual brewery's unique or most famous products. The breweries usually have many products available.

More information about many of these breweries, including interviews with the principals, can be found in three contemporary books: Rita Kohn and Kris Arnold's *True Brew* (IU Press, 2010), Douglas A. Wissing's *Indiana, One Pint at a Time* (2010) and John Holl and Nate Schweber's *Indiana Breweries* (Stackpole Books, 2011).

Aurora

Great Crescent Brewery
315 Importing Street
WWW.GCBEER.COM
812-655-2435

Dan and Lani Valas decided to start a small brewery in their hometown of Aurora and named it after the Gaff's brewery of the nineteenth century. Starting with a fifteen-gallon semiautomated brewing system, they sold beer in 2¼-gallon mini kegs and two-quart growlers over the counter in the front of the store.

Finding a ready customer base, they offered their beer in restaurants and liquor stores as far away as New Albany. In 2010, they moved to bigger quarters and increased to a ten-barrel system in a forty-seven-thousand-square-foot warehouse built in the 1840s for the J.W. Gaff distillery.

Batesville

Lil' Charlies Steakhouse and Grill
504 East Pearl Street
WWW.LILCHARLIES.COM
812-934-6392

Kip and Tricia Miller started the LiL' Charlies restaurant in 1999 in an old house on the east side of Batesville. It became quite a popular place, and ten years later they teamed with a CIA-trained chef Adam Israel to become a popular stop for travelers, in addition to their local clientele.

In 2009, they bought the neighboring house to add a full-service bar and a small brewery, with Israel as the brewer. They source wort from the Carolina Brewery and ferment on-site, saving much time while presenting fresh beer.

Bloomington

Bloomington Brewing Co.
1795 East Tenth Street
BBC.BLOOMINGTON.COM
812-323-2112

Jeff Mease and then-wife Lennie Busch ran a pizza delivery service and then started an upscale pizza shop in a strip mall across the street from some Indiana University dorms in 1982. Five years later, they hired Russ Levitt from the Broad Ripple Brewpub to set up Bloomington's first brewery. Brewer Floyd Rosenbaum often presents a pale ale simultaneously under CO_2 and nitrogen, and on two hand-pulls, as cask-conditioned beer dry hopped with two different varieties of hops.

Bloomington beer is available at many pubs in the area. In 2010, the owners opened a new off-site brewery to meet that trade and to eventually produce bottled beer. They also have an organic farm that grows some of the restaurant food, as well as Cascade hops.

UPLAND BREWING CO.
350 WEST ELEVENTH STREET
WWW.UPLANDBEER.COM
812-336-2337

Marc Sattinger had a large print shop on the northwest side of Bloomington in the 1980s and 1990s. He closed that enterprise in 1997 and hired Russ Levitt to convert the building into a brewpub, which opened in April of the next year.

It grew to become the largest brewery in Indiana by 2004. Sattinger retired in 2006 and sold the business to local entrepreneur Doug Dayhoff, who further expanded the brewery, added solar heating and instituted many environmental and charitable activities centered on the beer. Preservation Pilsner supports land trusts across the state. Upland Wheat makes up over 40 percent of production, with Dragonfly IPA right behind.

Head Brewers were, in succession: Russ Levitt, Ed Hermann, Matt Hill, Ken Price and Caleb Staton. Staton started making an annual batch of Lambic beers in 2007, with Cherry, Strawberry, Raspberry, Peach, Blueberry, Kiwi, Persimmon, Blackberry and a spiced Dark Wild Ale.

In 2010, Upland opened a tasting room at Forty-ninth Street and College Avenue in Indianapolis, with plans to install a nano-brewery.

BRAZIL

BEE CREEK BREWERY
WWW.BEECREEKBREWERY.COM
812-240-1147

Dr. Frank Forster; his wife, Julie, a nurse; her brother, Mark Snelling, an engineer; and some friends had a home-brewing passion. Together they started the Bee Creek Brewery in a pole barn on the Forster cattle ranch outside Brazil. By 2009, they had a six bbl system and were distributing their beer to pubs in Terre Haute and bottling for distribution all over the state.

Their signature Hoosier Honey Wheat is made with honey from a farm in Martinsville. Drew Lindsay and Mike Godsey are the brewers along with Snelling.

Columbus

Power House Brewing Co.
322 Fourth Street
WWW.POWERHOUSEBREWINGCO.COM
812-375-8800

Three years after opening a beer- and music-oriented pub, Jon Myers and Doug Memering took the opportunity to buy a historic downtown bar, the Columbus Bar, that dates back to 1939. To further Jon's home-brewing interests, he stuffed a twenty-gallon brewhouse in the front window in 2007. This is a separate company—the Power House Brewing Co.—which is, at the time of this writing, the smallest licensed brewery in Indiana, making twenty gallons per batch. The bar continues to serve a wide range of beer and, due to the small brewing size, usually has only a couple of Power House beers on tap.

Crown Point

Crown Brewing Co.
211 South East Street
WWW.CROWNBREWING.COM
219-663-4545

Local financier Tim Walsh and businessman Dave Bryan were the main forces behind the formation of this brewery, housed in the old boiler house of the Lake County Jail, from which John Dillinger famously escaped using a wooden gun. They brought in Jim Cibak, formerly of Goose Island Brewery, to build and run the brewery. He left in 2009, and Steve Mazylewski took his place at the mash paddle.

Technically, it's not a brewpub, but rather a brewery with a taproom that also sells beer through an adjacent pizza restaurant.

EVANSVILLE

TURONI'S PIZZERIA & BREWERY
408 NORTH MAIN STREET
WWW.TURONIS.COM
812-424-9871

Turoni's is a popular local pizzeria on the near north side of Evansville, dating back to 1963. Jerry Turner, whose family owns Turoni's, expanded the business in 1996, adding more seating and a brewery to provide their own beer, following the trend at the time.

Jerry's son, Tom Turner, was the first brewer, until Eric Watson was brought in from Ohio. Quickly, it became the home of a home-brew club, and when Watson left in 2004, a local home-brewer, Jack Frey, stepped into his shoes without a pause.

Turner bought the Forget-Me-Not-Inn in Evansville in 1990 and, in 2009, built a new restaurant in neighboring Newburgh. Its beers are available only at those three locations.

FIRKIN BREWPUB
THE LITTLE CHEERS
329 MAIN STREET

The then two-year-old Firkin pub, located in the basement of a downtown bank, found room in a disused vault to install a fourteen bbl brewing system. Local home-brewer Nathaniel Cruise did the brewing, but it didn't last. New management created a new name and brought back Cruise in 2004 for another try. Prices were right, but the beer was really quite bland. They discontinued brewing again in 2006.

FORT WAYNE

A beer marketing company, the Fort Wayne Brewing Co., sold O'Malley's Lost Irish Ale from 1993 through about 1995. This beer was brewed by the Indianapolis Brewing Co. and later by the Frankenmuth Brewery in Michigan. Jim McIntyre was the founder, with help from Mark Melchi, formerly a brewer at Falstaff and the owner of the Munchie Emporium.

FALCON BREWERY
424 EAST WAYNE STREET

In January 1997, Andrew Ley and Richard Williams started this microbrewery in the basement of the former downtown Harlequins Restaurant located in an old house. They made British and Belgian ales and sold them upstairs in a small taproom and in sixteen-ounce bottles. This effort barely got off the ground and died a quiet death.

MAD ANTHONY BREWING CO.
2002 BROADWAY
WWW.MADBREW.COM
260-426-2537

Oaken Barrel assistant brewer Todd Grantham, Blaine Stuckey and Jeff Neels bought a local restaurant and bar, the Munchie Emporium, in the mid-1990s. The location had been a Krogers market and Meyer's Drugstore in previous lives. A year later, Grantham put a seven bbl brewery behind glass at the bar, and Mad Anthony became a true brewpub.

They expanded in 2001 by adding a fifteen bbl brewhouse in a separate building out back that allowed them to bottle their beer for distribution statewide.

Tied houses were opened in Auburn in 2003 and Warsaw in 2005, both in closed department stores. In 2008, Mad Anthony licensed a restaurant in Elkhart to use its name and pour its beers. This was located in an old theater building; it closed in 2010.

OYSTER BAR BISTRO & BREWERY
1509 DUPONT ROAD

Steve Gard's small south-side upscale seafood restaurant decided to add a comparatively large fifteen bbl brewery when he added a north-side location, but it didn't seem to work. The north-side restaurant and bar survive, but brewing ended after only three years.

The brewer was Fort Wayne local Matt Hill, who later went on to Upland in Bloomington and Warbird back in Fort Wayne.

WARBIRD BREWING CO.
10515 MAJIC PORT LANE

Local psychiatrist Dave Holmes combined his two side interests by creating a brewery that was themed on World War II fighter planes. The signature T-6 Red Ale was named for his personal trainer airplane.

Matt Hill returned to Fort Wayne as the brewer on Holmes's eighteen bbl system, and an extensive canning line was installed. Warbird was one of the very first microbreweries to can its beer.

Unfortunately, canned craft beer was not yet accepted in the industry, and Holmes had problems getting distribution. Warbird sold the canning line in 2007 and moved to bottled beer. Again unfortunately, the initial expense was crushing, and the creation of the highly regarded Shanty Irish Ale was not enough to keep the plant open.

GRANITE CITY FOOD & BREWERY
3809 COLDWATER ROAD
FORT WAYNE
260-471-3030

6501 GRAPE ROAD
MISHAWAKA
574-243-0900

150 WEST NINETY-SIXTH STREET
INDIANAPOLIS
317-218-7185
WWW.GCFB.NET

Granite City is a decidedly non-local brewpub chain based in St. Cloud, Minnesota. The now twenty-six mega-pubs throughout the Midwest receive wort in trucks to be fermented on-site by local personnel. The central brewery in Ellsworth, Iowa, provides all of this wort.

The initial brewers at these Granite City locations were Matthew Burrous (Ft. Wayne), Rachel Dessenberger (Mishawaka), and Kendra Travez (Indianapolis).

GREENWOOD

OAKEN BARREL BREWING CO.
50 NORTH AIRPORT PARKWAY
WWW.OAKENBARREL.COM
317-887-2287

Oaken Barrel was formed by Bill Fulton, Brook Belli and Kwang Casey in a strip mall near I-65, east of Greenwood. Brook Belli was the brewer on the fifteen bbl system until he left in 2004 due to health issues. Ken Price, formerly with Upland of Bloomington, became the brewer at that time. Ken left in 2006 to go to Yazoo Brewing Co. in Nashville, Tennessee. Jeff Helms then became the brewer. He was followed by Mark Havens in 2009.

Notably, Tonya Cornett, originally of Muncie, Indiana, was an assistant brewer at Oaken Barrel before going to Bend, Oregon, as brewmaster of the Bend Brewing Co. She was named Champion Brewer at the Brewers Association's World Beer Cup in 2008.

When the Indianapolis Brewing Co. folded in 1997, Oaken Barrel bought the facility and produced bottled beer there for six years.

Oaken Barrel was the Champion Brewery of the Indiana State Fair's Brewers Cup in 2005, 2006, 2008, 2009 and 2010.

HOBART

BRICKWORKS BREWING CO.
327 MAIN STREET
2009–2010

Tom and Nancy Coster named their downtown brewpub Brickworks to honor the local industry. Opened in September 2009, it quickly became a staple of the local community. The downtown location was a Kroger grocery store when it was built in 1940 and had since become a pharmacy and a furniture store. The tanks behind glass were a modern offset to the brick walls, murals and woodcarvings throughout the restaurant.

After less than a year in business, they had run out of money, so they were forced to close in July 2010, when the building owner cancelled their lease after a contractor put a lien on the building.

INDIANAPOLIS

In 2009, Granite City Food and Brewery opened a location in Indianapolis. See the Fort Wayne section for details.

INDIANAPOLIS BREWING CO.
OAKEN BARREL BREWING CO.
3250 NORTH POST ROAD
SUITE 285

Restaurateurs Rick Harris and Tom Peters started the first Indianapolis brewery in forty-one years in an industrial park on the east side of town. John Battles and Tony Diggs were the brewers. They paid homage to the previous IBC by branding beers Main Street and Duesseldorfer. These brands were quickly picked up by over two hundred restaurants and bars in Indianapolis, and most liquor stores sold their twelve-ounce and twenty-two-ounce bottles. IBC also brewed beer under contract for Pike Place in Oregon; the Kentucky Brewing Co. of Lexington; the Fort Wayne Brewing Co. (O'Malley's); Pacific Hop Exchange of Novato, California; and Beer Across America, a beer-of-the-month club.

When IBC quit, the Oaken Barrel brewpub of Greenwood bought the facility to produce its bottled beer. This proved to be a distraction from the main business, so the equipment was removed in March 2003.

BROAD RIPPLE BREWING CO.
842 EAST SIXTY-FIFTH STREET
WWW.BROADRIPPLEBREWPUB.COM
317-253-2739

Founded by John Hill, an immigrant from Yorkshire, England, Broad Ripple Brewing Co. (BRBP) was the first and probably the most successful Indiana brewpub of the modern era. The theme is a true mimic of an English pub. Since Indiana state law didn't yet allow for brewpubs, Hill had to form two companies: the Broad Ripple Brewing Co. and the Broad Ripple Brewpub. Until 1993, he had to keg beer and hand truck it outside and then back into the restaurant side.

The first brewer was Gil Alberding, who is now a unit leader for MillerCoors. He was replaced by Greg Emig in late 1991. Greg left in 1993 to found the Lafayette Brewing Co. The third brewer, Ted Miller, founded the Brugge Brasserie in 2005. The fourth and current brewer is Kevin Matalucci. Hill was a founder of the Brewers of Indiana Guild trade association.

ALCATRAZ BREWING CO.
49 WEST MARYLAND STREET
WWW.ALCATRAZBREWING.COM
317-488-1230

One of a chain of restaurants and brewpubs out of San Francisco, Alcatraz was located in the Circle City Mall in downtown Indianapolis. It closed in January 2011, when the owner, Tavistock Restaurants, sold the location to California Pizza Kitchen. Panamanian immigrant Omar Castrellón was the brewer there almost from its opening until 2009, when he left to help open a new brewery in Indianapolis—Thr3e Wise Men.

CIRCLE V BREWING CO.
8310 CRAIG STREET

Founded by Mark Vojnovich near the Castleton Shopping Mall, Circle V featured a then-rare wood-fired pizza oven and calamari. In 1996, it made about 650 bbls of beer.[405] It started bottling in 1998 and closed the food operations on April 19, 1999, changing focus to become a production brewery.

Beers from Circle V's fifteen bbl system (with thirty barrel fermenters) were received well and distributed as far as Milwaukee, Louisville and Pennsylvania, but the rent in the strip mall proved onerous and was the main cause of the company's demise.

Brewer Vojnovich ("V") went on to other jobs in the local brewing scene. Dave Colt, the assistant brewer at Circle V, went on to become the head brewer at the Ram and a founder of Sun King. The brewing equipment went to the Cricket Hill Brewing Co. in Fairfield, New York.

ROCK BOTTOM RESTAURANT & BREWERY
10 W. WASHINGTON ST
317-955-9900

2801 LAKE CIRCLE DR.
317-471-8840
WWW.ROCKBOTTOM.COM

Another chain brewpub moved into Indiana the same year as the Ram. Rock Bottom's downtown location's brewers have been Bill Smith; Will Gaffney; Dave Chichura, who moved to Mountain Sun in Boulder, Colorado, in 2003;

Clay Robinson, who went to the Ram and then co-founded Sun King; Tim Marshall, who went to Chicago's Rock Bottom in 2004; Dustin Boyer, who went on to manage a tavern and then moved to Sun King; Jon Simmons, who moved to the Ram in 2008; and Jerry Sutherlin.

A second brewpub, complete with its own brewery, was opened on the northwest side of Indianapolis in 2005. The first brewer there was Brian Boyer, who installed the brewery and filled in until Ian Wilson, an immigrant from Scotland, came from England's Shepherd Neame Brewery to take over. Ian went to a Chicago brewery within the Rock Bottom chain in 2006, and Liz Laughlin from Portland, Oregon, replaced him.

WILDCAT BREWING CO.
9111 MICHIGAN ROAD

This was an extract brewpub added to a Bombay Bicycle Club chain restaurant in December 1996. Reviews of the beers were not good, and it closed after about three years in business. The chain tried this same formula at its restaurants in Clearwater and Jacksonville, Florida, and they fared no better.

GLACIER'S END BREWING CO.
6020 EAST EIGHTY-SECOND STREET

At one time, Darin Floyd was a brewer at Huber Brewing in Monroe, Wisconsin, and the head brewer at the Weinkeller Brewpub in Chicago making Berghoff beers. In 1997, he, Richard Leagre and Andy Rogers bought Spat's Restaurant inside the Castleton Square Mall on the north side of Indianapolis. After a $1,000 "name the brewpub" contest, they opened Glacier's End in November.

They made about 750 bbls in less than two years in business. The general reaction was that the beers were very malty and sweet. Some of the equipment ended up at the Cumberland Brewpub in Louisville.[406]

HOPS RESTAURANT BAR BREWERY
5485 EAST EIGHTY-SECOND STREET

This chain out of Florida expanded throughout the country in the 1990s but has only four units still open.

RAM RESTAURANT & BREWERY
140 SOUTH ILLINOIS STREET
WWW.THERAM.COM
317-955-9900

A chain brewpub from a company based in Lakewood, Washington, the Ram's Indianapolis branch went into a downtown space previously occupied by the short-lived Planet Hollywood, a celebrity-owned restaurant chain.

John Hanley was the first brewer. He was succeeded in 2002 by Dave Colt, who, in 2008, left to found Sun King with his previous assistant, Clay Robinson. John Simmons took over then as head brewer. Simmons left in 2010 and was replaced by Andrew Castner, previously the assistant brewer at Oaken Barrel.

Ram opened a satellite restaurant in Fishers in 2005. In 2007, Ram was the Champion Brewery of the Indiana State Fair.

BRUGGE BRASSERIE
1011A EAST WESTFIELD BOULEVARD
WWW.BRUGGEBRASSERIE.COM
317-255-0978

Ted Miller left the Broad Ripple Brewpub and traveled to Southeast Asia to set up breweries. He returned to Indianapolis in 2004, where he and his wife, Shannon, started a small Belgian-themed brewpub in the Broad Ripple area. A larger upstairs bar and restaurant were added in 2009.

Notably, Abraham Benrubi, a Hollywood television actor known for a role in *ER*, is a part owner of the company.

The company bought the Terre Haute Brewery in 2007, renaming it Vigo Brewing Co. Production of Brugge beers subsequently was moved to the Vigo facility.

SUN KING BREWING CO.
135 NORTH COLLEGE AVENUE
WWW.SUNKINGBREWING.COM
317-602-3701

Local brewers Dave Colt and Clay Robinson are the principals of this downtown warehouse brewery, along with Steve Koers, Andy Fagg and Omar Robinson (Clay's father). Sun King grew quickly to be the third-largest Indiana brewery by hosting many beer dinners and other events.

They also turned "to fans and followers on social media and ask[ed] them to ask for our beer at their favorite local watering hole, and within a few weeks bars and restaurants started calling and asking for our beers."

In 2010, they installed a canning line to put Osiris Pale Ale and Sunlight Cream Ale on store shelves, sixteen ounces at a time. Also in 2010, Adrian Ball and Dustin Boyer joined the brewing team.

BIER BREWERY AND TAPROOM
5133 EAST SIXTY-FIFTH STREET
WWW.BIERBREWERY.COM
317-253-2437

Darren Conner, after spending some time brewing at Oaken Barrel, joined Anita Johnson's Indianapolis home-brew store, Great Fermentations, as the main guy and in-house brewer where he stayed for ten years. In 2010, he moved a few hundred feet down the storefront to open his own small brewery, which weekly serves up to seven beers for tasting and growlers to go.

FLAT 12 BIERWERKS
414 NORTH DORMAN STREET
WWW.FLAT12.ME
317-635-2337

Four guys and a Twitter page formed this forty bbls brewhouse just east of downtown Indianapolis. Fifteen-year local home-brewer Rob Caputo is the brewmaster. Their grand opening was on December 30, 2010.

THR3E WISE MEN
1021 BROAD RIPPLE AVENUE
WWW.THR3EWISEMEN.COM
317-255-5151

Scott Wise owns six beer pubs in Indiana, Lafayette, Muncie and Bloomington and three in Indianapolis. It was only natural that they should be producing their own beer. To that end, he started a brewpub in the highly competitive Broad Ripple area, just blocks from the Broad Ripple Brewpub and Brugge Brasserie.

Brewer Omar Castrellón moved from the Alcatraz just before it closed to set up Wise's brewhouse and produce beer for all seven locations.

KOKOMO

HALF MOON RESTAURANT AND BREWERY
4051 SOUTH LAFOUNTAIN STREET
WWW.HALFMOONBREWERY.COM
765-455-2739

Local entrepreneur Chris Roegner wanted to open a restaurant, so he surveyed the Kokomo scene and found that the busiest bar in town was the one with the biggest lineup of beers. That was convincing enough to tell him he needed a special beer menu and the best way was to build a brewpub. He sourced a 3.5 bbl system and set out to find a brewer. John Templet moved from Little Rock's Bosco's Brewery and has been the only brewer at Half Moon.

BRASS MONKEY BREWING CO.
115 EAST SYCAMORE STREET

Started by local home-brewer Andrew Lewis, the Brass Monkey was located in the basement of the Sycamore Marketplace in downtown Kokomo. He used cut-open beer kegs as brewing vessels, and his fifteen-gallon batches made the Brass Monkey the smallest licensed brewery in Indiana at the time.

Because of the small brew run, Brass Monkey quickly became known for nontraditional beers that changed frequently. All sales went through the bar in the Marketplace. Brass Monkey closed overnight when the Sycamore Marketplace food court closed.

LAFAYETTE

LAFAYETTE BREWING CO.
622 MAIN STREET
WWW.LAFAYETTEBREWINGCO.COM
765-742-2591

Founded by Greg Emig, former brewer at Broad Ripple Brewing, Lafayette Brewing quickly became a mainstay of the Purdue University crowd with an upstairs music hall. Emig was the active brewer but handed over the mash paddle to Chris Johnson, who held it for nine years before he started

his own People's Brewery in 2010. Matt Williams became the brewer at that time.

Greg Emig's father, Joe Emig, later founded the Aberdeen Brewing Co. in Valparaiso.

PEOPLE'S BREWING CO.
2006 NORTH 9TH STREET ROAD
WWW.PEOPLESBREW.COM
765-714-2777

Chris and Jessica Johnson and Brett Vander Plaats started People's with a twenty bbl system from Butte Creek Brewery in Chico, California. They opened a taproom in 2010 and started bottling in 2011.

LA PORTE

BRICK ROAD BREWERY
BACK ROAD BREWERY
308 PERRY STREET
WWW.BACKROADBREWERY.COM
219-362-7623

Chuck Krcilek started Brick Road Brewery in August 1996 in an older brick warehouse building. The first beers were sold in April 1997. By August 1997, he had to rename the company to Back Road under pressure from the Brick Brewing Co. of Waterloo, Ontario.

Back Road was largely a one-person shop for the first ten years. Chuck makes a lot of beer and distributes it all himself to pubs and liquor stores in northwest Indiana and southwest Michigan. He got a full-time assistant brewer in 2008.

Krcilek's credo is "Back Road Brewery will produce nothing less than mind numbing award winning beer styles and put them in plain packaging. We will put them in crazy places so it is really hard for you to find. We probably won't advertise or even try to market effectively. So don't expect it. Are you buying beer or packaging or what?"

MICHIGAN CITY

DUNELAND BREWHOUSE
5718 FRANKLIN STREET

A brewpub in an ex-Sambo's Restaurant building became a Rock Lobster and then the Duneland Brewhouse. Production problems, lack of investment and disinterest by the owners and staff led to its downfall. The owners retired and sold the building to Texas Corral, and the brewing ended on October 3, 2004.

Barb Kehe, a local home-brewer, was the only brewer. When it closed, Duneland's brewing equipment was purchased by the Mishawaka Brewing Co.

SHORELINE BREWERY AND RESTAURANT
208 WABASH STREET
WWW.SHORELINEBREWERY.COM
219-879-4677

Sam Strupeck, previously the brewer at Aberdeen Brewery in Valparaiso, is the founder of Shoreline. The name is homage to the Chicago, South Shore and South Bend intercity railroad.

The building was constructed for a lumberyard in 1857 and has been a golf ball factory, a camera factory, a training facility and a printing company. It had been abandoned for ten years before becoming the brewery.[407] With a large interior, weekly live music, a basic food menu and a wide variety of beers, Shoreline was immediately popular with the local, younger working man.

Brewers are Strupeck and Layton Cutler. They enlarged the brewery and started corked bottling of barrel-aged beer in May 2009.

MISHAWAKA (ELKHART)

In 2008, Granite City Food and Brewery opened a location in Mishawaka. See the Fort Wayne section for details.

MISHAWAKA BREWING CO.
BREWERY: 2414 LOWELL STREET, ELKHART
THE PUB: 408 WEST CLEVELAND ROAD, MISHAWAKA

The second brewpub in Indiana was started by Tom Schmidt—a food scientist at Miles Laboratories—and John Foster in a closed fitness center at 3703 North Main Street. They had to fill in the swimming pool and do other extensive work to make it happen. They, like the Broad Ripple Brewpub, had to form two companies, but they avoided having to move beer outside prior to serving by having four tanks in the brewery owned by the restaurant.

The Schmidt family bought out Foster's interests in 2000. Tom, his son Rick and his wife, Tami, are now the principals of this company.

They opened "The Pub" a couple of miles north as a satellite operation. In 2004, they bought Duneland's equipment and installed it in what is basically a large garage in Elkhart to produce more bottled beer.

Tom Schmidt ran for mayor of South Bend in 2003 but lost.

In 2008, the original location closed, and The Pub became the featured outlet. In early 2011, Mishawaka Brewing closed its doors and sold the equipment to a brewery start-up in South Bend.

JUST BREW IT
2828 LINCOLN WAY EAST

Jeff Nicholas started this business where people could come in and brew their own beer on Just Brew It's equipment. They could make fifteen gallons for home use or bottle their beer to serve at special occasions, such as wedding receptions. He added some food so he could sell his own beer in 1998. The enterprise died, basically due to lack of interest on the part of the public.

MUNSTER (HAMMOND)

THREE FLOYDS BREWING CO.
9750 INDIANA PARKWAY
WWW.THREEFLOYDS.COM
219-922-4425

The three Floyds are the founding family—retired surgeon Michael Floyd and his sons, Nick and Simon. They started in Hammond with a five bbl

system. A move to an industrial park in Munster in 2000 was needed to keep up with production, and they added an on-site restaurant in 2005 by selling shares to more than one hundred patrons.

Three Floyds' motto, "It's Not Normal," is reflected in a line of extreme beers that has attracted much attention among the industry, the press and beer aficionados, who voted its Dark Lord the second best beer in the world in 2006 and Three Floyds the best brewery in the world in 2009, 2010 and 2011.

Brew size is now thirty-five bbls with fifteen thousand bbls produced in 2010, making it the largest brewery in Indiana. Brewers have included Nick Floyd, Barnaby Struve, Chris Boggess, Andrew Mason, Travis Fasano and Adam Conway.

A bit of trivia: Michael Floyd once performed a kidney transplant on Ferdinand Marcos.[408]

NASHVILLE

BIG WOODS BREWING CO.
60 MOLLY LANE
WWW.BIGWOODSBEER.COM
812-988-6000

Three friends—Jeff McCabe, Ed Ryan and Tim O'Bryan—started the Big Woods brewpub in this small tourist town in an alley corner building that formerly housed an even smaller restaurant. Jeff McCabe owns a construction company specializing in timber-frame buildings, which came in handy when the founders immediately added a frontal extension to expand seating room.

Tim O'Bryan, Jeff's son-in-law, is the brewer, and for the first year, he shared space with the kitchen. In 2010, they added a back room to hold a bigger two bbl brewery.

New Albany

New Albanian Brewing Co.
Grant Line Road Public House
3312 Plaza Drive
812-949-2804

Bank Street Brewhouse
415 Bank Street
812-725-9585
WWW.NEWALBANIAN.COM

In 1987, Rich and Sharon O'Connell and their daughters, Amy and Kate, had a Noble Roman's franchise in a mall on the north side of New Albany. Three years later, Amy and her soon-to-be husband, Roger Baylor, added a barbecue restaurant adjacent, which quickly became Rich O's Public House (since renamed the Grant Line Road Public House). It specializes in interesting craft and imported beers and is a "lite free zone." The décor is an anarchical theme based on Eastern European communism, and no televisions are in view. They rapidly grew to become a popular place not only among local residents but also among beer lovers across the Midwest. A consumer website consistently votes the Public House among the top ten beer bars in the world.

After the Silver Creek Brewing Co. in Sellersburg closed in 2001, they bought the four bbl equipment. Silver Creek's brewer, Michael Borchers, moved to what is now known as New Albanian.

During the next eight years, the Public House continued to attract a loyal patronage with a series of annual beer festivals and trips to European beer meccas. Jesse Williams and Jared Williamson became the brewers in 2005. A game room became the location of an enlarged brewery in 2006.

A second restaurant location in downtown New Albany was started in 2009, complete with a second (and even larger) brewery capable of accommodating sales to other restaurants. New Albanian started bottling in 2011 to provide sales through liquor stores.

NOBLESVILLE

BARLEY ISLAND BREWING CO.
639 CONNER STREET
WWW.BARLEYISLAND.COM
317-770-5280

Jeff Eaton, a global marketing executive at a local medical diagnostics company, started Barley Island as a brewpub. He kept his full-time job for the next ten years until retiring to open a tied house in the Broad Ripple area of Indianapolis and spend more time in the Noblesville brewery.

Vlad Ponomerov and D.J. McCallister were the brewers for the first two years, and then Jon Lang became the head brewer in the twenty bbl brewhouse until he left in 2010 to join a startup brewery, Triton, in Indianapolis. Mike Hess moved from assistant to replace Lang at that time. Distribution covers Indiana and Illinois. In 2009, they opened a tied restaurant on the main corner of the Broad Ripple area of Indianapolis.

RICHMOND

NEW BOSWELL BREWING CO.
WWW.NEWBOSWELL.COM
765-546-7856

Rodrick & Kiera Landess started this small production brewery in Richmond, where Roderick works in the information technology area for the Richmond schools. With a $20,000 grant, Landess acquired a boiler that was a coffee maker at a Masonic temple in a previous life. Two Groen kettles are used as mash tuns, and fermenting happens in four wine tanks. The New Boswell name is homage to what may have been Indiana's first brewery, started in 1816 by Ezra Bozwell just a few blocks away.

Salem / Sellersburg

TUCKER BREWING CO.
1477 SOUTH STATE ROAD 60
SILVER CREEK BREWING CO.
435 EAST UTICA STREET
SELLERSBURG

Todd Tucker started a brewery in Salem with Donald Russell as the brewer. Jeff Compton, who owned an Internet service provider in Sellersburg, bought the Tucker Brewing Company in 1999. He moved Tucker's equipment, and an employee of his, Michael Borchers, became the brewer. The Tucker brand name continued to be used for beer made by the Silver Creek Brewing Co.

Silver Creek bought the Oldenberg Brewery in Fort Mitchell, Kentucky, in September 1999 after it declared bankruptcy, and it continued the operations there until April 2000. At that time, it sold the Tucker equipment to New Albanian Brewing Company, where Borchers became the brewer.

South Bend

SOUTH BEND BREWING CO.
300 EAST COLFAX AVENUE

Located on the east bank of the St. Joseph River, this brewpub was open for only about six months, but it did put out a full line of beers. James Masters and Shawn Sullivan were the principals.

The pub overlooked a scenic part of the river, the East Race Waterway—North America's first artificial whitewater recreation course. For this reason, South Bend called the pub a "viewpub."

NINE G BREWING CO.
1115 WEST SAMPLE STREET

This microbrewery was opened by the families of two National Guard aviators and named for the maximum force an F-16 fighter pilot can endure. Patrick and Beth Voors and Tim Rusch were the principals. Bryan Wiggs of Michigan was brought in as the brewer. The actual company name was Warrior Brewing Company. They stopped brewing in early 2007.

Terre Haute

Terre Haute Brewing Co.
Poplar Street
Brewpub: 402–03 South Ninth Street

The modern incarnation of the Terre Haute Brewing Co. (THBC) was founded by Mike Rowe and Gary Richards in a building originally constructed in 1837 as the Bleemel Brewery. The brewpub was filled with Rowe's collection of Terre Haute beer memorabilia, and the second floor was used as a museum and small function room.

THBC's Champagne Velvet trademark had passed through the hands of Atlantic Brewing, Associated Brewing, G. Heilman, Joseph Pickett & Sons and Pabst, from whom Rowe bought it to use on their new brand.

The first brewmaster was Ted Herrera. The flagship Champagne Velvet was re-created to approximate a pre-Prohibition beer, and the Bock was made from a Terre Haute Brewing Co. 1901 recipe that Mike Rowe found in a pile of old documents.[409]

In 2004, Rowe moved the brewery from the basement of the brewpub to a former THBC warehouse facility across the street, and he expanded the equipment to a forty bbl system. The restaurant business ended in 2005, and they stopped brewing in 2006.

There are still rumors of tunnels under the streets connecting the original building, under a drugstore across the street and then west to the present Vigo Brewing production building.

Vigo Brewing Co.
402–03 South Ninth Street

The Brugge Brasserie in Indianapolis bought the Terre Haute Brewing Company facilities in 2007 to expand its production of Belgian-style beers. Micah Weichert was the first head brewer, followed by John Kopta. Kopta left in 2009, and Ted Miller, president of Brugge, became the head brewer.

VALPARAISO

ABERDEEN BREWING CO.
210 ABERDEEN DRIVE

Started by the Emig family of Lafayette Brewing Company, Aberdeen was located at the entrance to a residential subdivision and golf course south of the city. Skip Bosak purchased the operation in 2002.

Aberdeen quit brewing in the summer of 2004. The brewing equipment went to the Mishawaka Brewery for a second plant in Elkhart. The brewer, Sam Strupeck, went on to open Shoreline Restaurant and Brewery in Michigan City in 2005.

FIGURE EIGHT BREWING CO.
1555 WEST LINCOLNWAY
WWW.FIGURE8BREWING.COM
219-477-2000

Tom and Lynne Uban are avid rock climbers and named their new brewery after a knot. They spent almost six months getting the brewery in operation, with most of that time spent on perfecting the details before first using their seven bbl system.

Distribution is done in kegs and twenty-two-ounce bombers to restaurants and liquor stores. Growlers are sold at the tasting room in the front of the brewery.

WHITEHALL

GOODFELLOWS BREWING CO.

Todd Reeves and Dale Drummond built their seven bbl brewery on Reeve's rural property on State Road 43, south of Whitehall (just west of Bloomington). From February 2000 to September 2001, their bottle-conditioned beer was sold in Bloomington liquor stores and groceries in one-liter swing-top bottles.

WILBUR

WILBUR BREWING CO. LLC
MEMBERS.BPL.COOP/BOHICA

Dan Hause expanded his home-brewing hobby by brewing five gallons at a time in an ex–Girl Scout camp dormitory situated in his backyard on an idyllic lake. He owned possibly the smallest brewery ever to be licensed and absolutely the smallest to be certified 100 percent organic. After only six months, Hause upgraded to a four bbl system (still wood-fired) and was producing two hundred cases of beer every month.

A dozen more start-up breweries in Indiana have plans to open in 2011:

Black Swan Brewpub—Plainfield—D.J. Macallister—Brewpub
Three Pints Brewing—Plainfield—Tom Hynes—Brewpub
Blue Republic Brewing Co.—Shelbyville—Bill Ballinger—Production brewery
Fountain Square Brewing Co.—Indianapolis—Skip DuVall—Production brewery
Triton Brewing Co.—Indianapolis—Jon Lang—Production brewery
Four Horsemen Brewing Co.—South Bend—Stephen Foster—Production brewery
Bare Hands Brewing Co.—Granger—Chris Gerard—Production brewery
Black Acre Brewing Co.—Indianapolis—Justin Miller—Production brewery
Bulldog Brewing Co.—Whiting—Kevin Clark—Brewpub
Heorot Pub and Draught House—Muncie—Bob Cox—Brewpub (currently a pub)
Cutters Brewing Company—Bloomington—Monte Speicher, Chris Inman—Production Brewery
Twisted Crew Brewery Company —Seymour —Tyler Kimbrell, Terry and Suzannah Miller —Production Brewery

Addenda
Breweries We Have Uncovered Since This Book Went to the Publisher

NORTHWEST INDIANA–NEW CHICAGO
The *Lake County Interim Report of the Indiana Historic Sites and Structures Inventory* of 1996 says there was a brewery in New Chicago in the first decade of the twentieth century.

NORTHEAST INDIANA—DECATUR—HENRY MEYER
The city directory for Fort Wayne (1883) lists the Henry Meyer Brewery in Decatur.

NORTHEAST INDIANA—DECATUR—HERMAN KURTENBRER
The city directory for Fort Wayne (1887) lists the Decatur Brewery with Herman Kurtenbrer as proprietor.

FORT WAYNE—GEORGE FALLO
According to the *History of Allen County, Indiana* (Kingman Brothers, 1880):

> On the north side of the canal, where the gas-works are, stood a brewery, owned and carried on by George Fallo, a French German whose beer got a reputation from the peculiar manner in which old George set the fermentation to work; this, however, was hearsay, but it was often told and never denied; let those who drank his beer tell the rest.

The *Pictorial History of Fort Wayne Indiana* (1917) confirms, "Among the business and professional men were J.B. Bourie and John B. Peltier, traders;…George Fallo, the first brewer."

FORT WAYNE—JACOB HOCK
The city directory for Indiana (1859) lists Jacob Hock as a brewer. (This brewery was located in the Bloomingdale section of the city but was not the Bloomingdale Brewery.)

WEST CENTRAL INDIANA—SULLIVAN—JOHN OTTO
According to the *Sullivan Democrat* of March 12, 1870, and June 11, 1942, John Otto's Sullivan Brewery brewed beer and ale starting in 1870. It was at the northeast corner of Court and Beech Streets. This facility also included a cooperage.

EAST CENTRAL INDIANA—FRANKLIN—PETER NOLL
A Franklin Brewery, with Peter Noll as proprietor, is listed in the *History of Johnson County, Indiana* by Elba L. Branigin, published by Bowne & Co in 1913. It is not known whether this is the same Peter Noll who owned a brewery in Louisville in the 1850s.

SOUTHEAST INDIANA—EUCHRETOWN—JACOB KUEHN
According to the *History of Jackson County, Indiana* (Brant & Fuller, 1886):

> *This little village, which is now extinct, was located on the line dividing Grassy Fork and Brownstown Townships, the business all being in the former. Few goods were ever sold and but little business transacted at this place. The most important Industry was the manufacture of beer and whisky by Jacob Kuehn. The brewery was rather extensively operated at one time, and a sufficient amount of beer was manufactured to supply the local trade.*

SOUTHEAST INDIANA—METAMORA
The Old Metamora Tourism Bureau says:

> *This two-story house is constructed of rubble limestone, it was built in the 1850s by John and Daniel Walker. They operated several businesses in Metamora, a general store, a distillery and a mill. This building served as a warehouse for the whiskey produced in their distillery. The barrels were loaded onto canal boats at a dock immediately below the Metamora Lock south of this building. By 1867, it was used as a brewery by A.I. Senior. In the late 1800's, it was converted into a residence.*

Index of Breweries and Brands

H ere is a list of all the pre–Modern Era breweries in Indiana that branded their lines of beer. Brand names came about when bottled beer became a viable product after the Civil War. Before that, almost all beer was sold over the counter by taverns either by the glass, by the pail or, for parties or large households, by the cask. Even though differing styles were often brewed by individual breweries, signage was minimal, and patrons asked for their favorites by brewery name and style.

Labels immediately became fancy, as you've seen throughout this book. Many times, brand names evoked then, as today, the spirit of the brewery or the community. Competition for the customer's interest began at this time, as beer could "travel" and stay fresh in sealed containers, and retailers could stock more than one brand.

German dominance brought many names to this list. Dortmunder, Münchner, Kulmbacher, Vienna, Wurzburger, Düsseldorfer, Budweiser, Pilsener and Bock all refer to cities or regions in Germany, Austria and Czechoslovakia. British ales were not ignored, with plenty of Pale Ales, India Pale Ales, Stouts, Porters and the now extinct Half and Half.

Export usually implied a slightly stronger lager, and a Pale Export normally had a lighter color. Extra, Select or Special could have been a stronger beer also but was not always.

Appendix A

Berghoff Brewing, Fort Wayne
 Dortmunder, Dortmunder Doppel, Extra Pale, Holiday Beer,
 Double X, Bock, Salvator Munich Lager, Pale, Dortmunder Dark,
 Bock, International Club, Berghoff Beer, Berghoff Ale, Berghoff
 1887, Berghoff Bock, Berghoff Malt Liquor, Hoff Brau Beer, Hoff
 Brau Ale, Berghoff Dark Beer

George A. Bohrer Brewing Co., Lafayette
 Indiana Pride, Amber Beer, Special Brew

Capital Brewery, Indianapolis
 Pale Stock, Amber, Champagne Ale

Centlivre Brewing Co., Fort Wayne (Old Crown)
 Special Export, Kaiser Bohemian, XX, Lager, Kulmbacher,
 Münchner, Münchner Export, Nickel Plate, Special Pale, Old
 Reliable, Classic, Bock, Old German, Extra Pale, Holiday Special,
 Old Crown Beer, Old Crown Ale, Old Crown Bock, Hoff-Bräu,
 Alps Brau Van Merritt, Renner, Old Oxford, Old German, Golden
 Amber, Kings Brew

Citizens Brewing Co., Indianapolis (R. Lieber, Phoenix, Ajax)
 Capital City Brew, T.T., Frauenlob, Camel's Milk, Ajax, Ajax Dark,
 Ajax Bock, Imperial, Düselager

City Brewing Co., Jeffersonville
 Pima Export

James O. Cole, Peru
 Golden Export, White Seal Export, Wiedershen Special Brew, Bock

F. W. Cook Co., Evansville
 Pilsener, Pale Lager, Augustiner, Capuchiner, Goldblume, Budweiser,
 Tonteum, Extra Export Lager, Standard, Dry, Pilsener, Bock, Ale,
 Goldblume Special, Goldblume Bock, Tropical Extra Fine Ale,
 Cook's 500 Ale

Columbia Brewing Co., Logansport
 Export, Logan Brew

Index of Breweries and Brands

CROWN BREWING CO., CROWN POINT
 KronenBräu

CRYSTAL SPRING BREWERY, LAPORTE (GUENTHER & ZWERECK)
 Excelsior, Home Brew, Indiana Gold

DREWRYS BREWERY, SOUTH BEND
 Drewrys Old Stock Ale, Drewrys Extra Dry, Drewrys Draft, Drewrys Bock, Drewrys Lager, All American, Atlas Prager, Bull Dog, Champagne Velvet, Cold Brau, Cooks, E&B, Eastern, Edelweiss, F&G Supreme, Friars Club, G.E.S, Gold Coast, Golden Stein, Great Lakes, Heritage, Home, K&J, Leisy's, Nine Star, Old Dutch, Pfeiffer, Prager, Prost, Redtop, Regal, Salzburg, Schmidt's, SGA, Silver Edge, Skol, Trophy, Twenty Grand, Volks Brau, Old Style Home Ale, Dry Lager Home Beer

EAGLE BREWERY, COLUMBIA CITY
 Select, Extra Export
VINCENNES
 Bock, Extra, Export, Elite

EVANSVILLE BREWING CO., EVANSVILLE
 Minnehaha

EVANSVILLE BREWING ASSOC., EVANSVILLE
 Rheingold, Sterling, Minnehaha, Pale, Pale Export, Erlanger, EBA Pale, Bohemian Creamdale, Drewrys Ale, Drewrys Half and Half, Drewrys October Ale Target, Lug o' Ale, Sterling Ale, Sterling Autumn Ale, Sterling Real Bock, Super Bru, Super Bru Pilsner, Sterling Premium Draft Beer, Sterling Draught Ale

EVANSVILLE BREWING CO., EVANSVILLE
 Sterling, Bavarian, Blatz, Champagne Velvet, Cook's, Drewrys, Drummond Brothers, Falls City, Gerst, Knickerbocker, Lemp, Penn, Tropical, Weidemann, Birell, Bad Frog, Cave Creek, Coldsburg Gray, Evansville, Gringo, Jackaroo, Joe's Freakin', Mo's Maxim, Red White and Brew, Rainbow Ridge, River City, Riverfront, Scorpion Malt Liquor, State Street, The Eagle, Zebra, New Frontier, Birds Brew, Brigade, Dirt Cheap, Dog Pound, Hey Mon, Havana Gold, Mardi

Gras, John Gilbert's Riverboat, Prime Time, Santa Claus, Squirrel, Steel Curtain, Whoomp, Treasure Bay, Bicycle, ASDA, Sainsbury's, Tesco's, Waitrose, Red Eagle, Star of America, El Rey, Lager Black, Lager Red, Rocky Mountain, Steamer, Wyoming, Alex, All Beer, American Lager, ISA, NS2, Sundown, Upstate, Vai-Vai, St. Johnsbury Porter, Bison Wheat, Highland Stout, Otto Bruckman Bavarian Bock, Jacob Rosenberger & Son Munich Dark, Angus MacDougall Scottish Red, Gustav Werner Alt Amber, India Pale Ale, Wurch & Warnke Pilsner, Hoosier Red, Allegheny Cream Ale, American Brown Ale, Dunham Castle London Nutty Brown Ale

EXCELSIOR BREWERY, JASPER
Jasper Common Draft Beer

FALSTAFF BREWING CO., FORT WAYNE
Falstaff, Haffenreffer, Narragansett, M*A*S*H 4077, Polska Piwo, Beer, Light Beer (generics), Haffenreffer Malt Liquor, Feigenspan, Old Heidel Brau

GREAT CRESCENT BREWING CO., AURORA
Aurora Lager Beer, Pilsener, Felsenbier

HAMMOND BREWING CO., HAMMOND
Muhlhauser Export, Bohemian Lager

HANNAGAN & FITZGERALD, LAFAYETTE
Pride of the State

HOFF-BRAU BREWING CO., FORT WAYNE
Hoff-Brau Beer, Pilsener, Golden Ale, Stout, Bock, Muenchener, Gold Star, Gold Star Bock, King Kole Pilsner, Hoff-Brau Dry Pilsener

HOME BREWING CO., INDIANAPOLIS
Columbia, Indiana, Stock Ale, Porter, Home Brew Pale Select

HUNTINGTON BREWERY, HUNTINGTON
Golden Drops, High Card, Silver Cream

Index of Breweries and Brands

INDIANA BREWING ASSOC., MARION
Indiana Beer, Special Brew, Pride of the State

INDIANAPOLIS BREWING CO., INDIANAPOLIS
Gold Medal Beer, Special Brew, Hoosier Beer, Champagne, Wiener, Wurzburger, Derby, Olden English Ale, Stock Ale, Pale Ale, Half and Half, Dublin Porter, Cream Ale, Stock Ale, Budweiser, Progress, Tafel, Duesseldorfer, Atrium, Hop Ale, Mausner, Mausner Hy-Test, Capital, Cream Velvet, Circle City, Crown Select, Deluxe Bock, Burgomaster, Burgomaster Bock, Efsie Lager, Pilsner Club, Indiana Club Pilsner and Bock, Jung's All Malt, 20th Century Pale Beer, Gold Medal Lager, Bock and October Ale, Lieber Lager, Krausened Beer, Export and Bock

HENRY INGERMAN, CAMBRIDGE CITY
XXX Ale, XXXX Ale

KAMM & SCHELLINGER, MISHAWAKA
Red Band, Premona, Private Stock Export, Standard, Black Label, Black Label Special, Kamm's Ale, Kamm's Lager, Kamm's Pilsener, Kamm's Pilsener Light Prize, Skilbru, Gay 90, Copper Kamm's Export, Kamm's Export Dark

KILEY BREWING CO., MARION (PETER FOX)
Patrick Henry, Old Dublin Style Stout, Original Old Time Half & Half, Limerick Ale, Bock, October Ale, Special Light, Patrick Henry Malt Liquor, Fox Deluxe Ale, Fox Deluxe Beer, Silver Fox Deluxe Ale, Silver Fox Deluxe Beer

LAFAYETTE BREWERY, INC., LAFAYETTE
Ye Tavern, Ye Tavern Bock, Tippecanoe, Kopper Kettle

P. LIEBER & CO., INDIANAPOLIS (CITY BREWERY)
Hoosier Beer, Lieber's Special Beer, Olden Time Ale, Porter, Tafel Beer, Lieber's Gold Medal Beer, Progress, Lieber's Special Brew

MADISON BREWING CO., MADISON
Madison XXX Ale, Lager, Pilsener, Behemian, Extra Brew, Export, Bon Ton, XXX Porter, Lager Beer

CASPER MAUS & CO., INDIANAPOLIS
 Bock

MINCK BREWING CO., RICHMOND
 Select, Export

MUESSEL BREWING CO., SOUTH BEND
 Arzberg Export, Bavarian, Silver Edge, Nine Star Lager, Burberry Ale

MUNCIE BREWING CO., MUNCIE
 Peerless Pure Family Beer, Home Brew, Birkenstock Special

NORTH JUDSON BREWING CO., NORTH JUDSON
 Pink Label

T. M. NORTON BREWING CO., ANDERSON
 Bock Beer, Gold Band Beer, Old Stock Lager, Pilsener Beer, Old Pal

PEOPLE'S BREWING CO., TERRE HAUTE
 Celtic, Spalter, Special Brew, Bock

PAUL REISING BREWING, NEW ALBANY
 Reising's Kaiser Beer, Ye Old Beer, Lager, Common, Rathskeller, Imperial, Culmbacher, Bohemian Lager, Pale Export, Sparkling Common

C.F. SCHMIDT BREWING CO., INDIANAPOLIS
 Export, Wiener, Tonica, Budweiser, Stock Ale, Bock, Cream Ale, Dublin Porter

K.G. SCHMIDT BREWING CO., LOGANSPORT
 First Premium Lager, Bock

SOUTH BEND BREWING ASSOC., SOUTH BEND
 Hoosier, Golden Glow, Tiger Export, Hoosier Cream

SOUTHERN INDIANA ICE CO., NEW ALBANY
 Ackerman's India Pale Ale, Ackerman's Royal Munich Beer, Ackerman's Vienna Select Beer, Ackerman's Special Vienna Select

Beer, Ackerman's Old Rip Beer, Amsterdamer Bock, Great Eagle, Gold Crest, Imperial Double Stout, Daniel Boone

STATE STREET BREWERY, NEW ALBANY
Niemaier's Common

STERLING BREWERS ASSOCIATION, EVANSVILLE
20 Grand, Pfeiffer, 9-0-5, Cook's Goldblume, Tropical Ale, Bavarian Select, Champagne Velvet, Mickey's Malt Liquor, Barbarossa, Drewrys, E&B, Edelweiss, Frankenmuth, Great Lakes, Hampden-Harvard, Home, Katz, Kling, North Star, Old Dutch, Piels, Regal, Schmidt, Hampden, Redtop, Wisconsin Club, Drummond Brothers, Falls City, Lederbrau, Prager

TELL CITY BREWING CO., TELL CITY
AC, Primo Lager, Bock

TERRE HAUTE BREWING CO., TERRE HAUTE
Velvet, Export, Tafel, Bohemian, Champagne Velvet, (CV) Gold Label, (CV) Bock, (CV) Strong Ale, (CV) Half and Half, Velvet Ale, Velvet Stout, '76 Ale, America's Pride, Blackhawk, Radium, Red Top, Select 20 Grand Cream Ale, Barbarossa

THIEME & WAGNER BREWING CO., LAFAYETTE
T.&W. Special, Ye Tavern Brew, Bohemian, Extra Brew, Bock Export, Lockweiler Special Brew, Star City

WABASH BREWING CO., WABASH
Wabash Beer, Wabash Extra Lager Beer

WILLIAM J. WITTEKINDT, EVANSVILLE
Hi-Hop, Münch'ner, Michigan City, Grain State, Golden Grain, Michigan City Cream, Pilsenzorn

Appendix B
Timeline of Indiana Brewing

1800–1816

The Indiana Territory was established in 1800 and had some rules about liquor before statehood. Sales of distilled spirits (not wine, cider or beer) were forbidden to Indians under specific circumstances. Tavern licensing came about in 1805, and courts sold those licenses for twelve dollars.[410] Gambling in taverns was prohibited starting in 1807.

1816

Statehood. Ezra Boswell in Richmond and the New Harmony Colony near Evansville started the first commercial breweries in the state. Initial state laws included a prohibition of sales on Sundays and sales to minors (under sixteen years old) or drunks (each a three-dollar fine).

1817–1836

New Harmony closed in 1825 and Boswell in 1831. Taverns had to have rooms to let. Townships could block licenses with a 50 percent vote of freeholders. Sales were prohibited within one mile of any religious meeting. Minors were redefined as being less than eighteen years of age. The Knickerbocker Saloon opened in Lafayette in 1835 (although closed during Prohibition, it is the oldest still-operating establishment in the state).

1837–1847

In 1837, Warren and Deming started what would become the Terre Haute Brewing Co., and Rice and Kroener started what would become the Evansville

Brewery. The Supreme Court of Indiana ruled that wine was not a spirit. "Spirit is the name of an inflammable liquor produced by distillation. Wine is the fermented juice of the grape or a preparation of other vegetables by fermentation. We cannot so far confound the signification of these general terms as to call wine a spirituous liquor."[411] The first Indiana drunk-driving law came into effect in 1843; it applied only to stagecoach drivers.

1848–1851

Wagner and Herbert opened what would become the Lafayette Brewery. Some counties started requiring a petition with 50 percent of the residents signing to obtain a liquor license. The Tremont House opened in Indianapolis in 1850; now the Slippery Noodle, it is the oldest still-operating bar in Indiana. Unlike the Knickerbocker Saloon in Lafayette, it was still a bar (speakeasy) during Prohibition and reportedly even brewed its own beer in the basement.

1852–1854

In 1852, statewide prohibition was introduced in the senate but failed to pass. The Muessel family started the brewery in South Bend that was to become Drewrys. In 1853, the future Kamm's (Mishawaka) and Cook (Evansville) breweries were started.

1855

Statewide prohibition based on the Maine law was enacted. It passed the senate by twenty-nine to eighteen and the House by fifty-one to forty-one and went into effect on June 12.[412] This law did not prohibit the making of homemade cider or wine. It also declared habitual drinkers incompetent to serve on juries. On December 20, this prohibition was found to be unconstitutional by the Indiana Supreme Court in the case of *Herman v. the State*. During the 1850s, prohibition laws were also in effect in Vermont, Massachusetts, Connecticut, New York, New Hampshire, Delaware, Iowa, Michigan, Nebraska and Minnesota.

1856–1860

When the 1855 prohibition went into effect, there were thirty-four breweries in Indiana. By 1860, this number had grown to fifty-six. New startups included Crystal Spring in La Porte and C.F. Schmidt and Peter Lieber in Indianapolis. In 1858, the Evansville City Brewery of Jacob Rice and F.W. Cook made the first lager beer in Indiana.[413]

Timeline of Indiana Brewing

1861–1865

The Civil War created much industry and wealth in Indiana. By the close of the war, there were sixty-seven breweries. New companies included the Centlivre's French Brewery in Fort Wayne and Casper Maus in Indianapolis.

1866–1872

Continued growth saw three more major breweries: T.M. Norton in Anderson, Great Crescent in Aurora and P.H. Zorn in Michigan City.

1873–1874

With Republicans in control, the Baxter Law was put into effect. Majority petitions were required to license taverns, and a bond of $3,000 was needed. Closing hours were set at 9:00 p.m. Sales were prohibited on Sundays, election days and all holidays. In the 1874 elections, the Republicans lost majority control of both the House and the Senate. The author of the Baxter Bill, Senator William Baxter, was reelected by only five votes.

1875

The liquor laws were rewritten in the backlash to the Baxter Law. One-way (beer), two-way (beer and wine) and three-way (beer, wine and liquor) permits were separated. One-way and two-way licenses were priced at $50. Three-way licenses were $100. License fees were earmarked to go to the county school fund. Closing hours were changed to 11:00 p.m. For the first time, public intoxication was made a crime with a fine of $2 to $5. An all-time high of eighty-six Indiana breweries was reached.

1876–1889

During this time, many breweries fell out, leaving just forty-nine in 1890. Temperance organizations were proliferating. The Prohibition Party of Indiana was formed in 1884, and 3,868 votes were cast in Indiana for Prohibition Party candidate John P. St. John, ex-governor of Kansas (born in Brookville, Indiana). He got 147,520 votes nationally for president. In 1888, those numbers nearly doubled for candidate Clinton B. Fisk.

1889–1894

Round one of mergers and acquisitions began. In 1889 the Indianapolis Brewing Co. was formed as a merger of C. F Schmidt, P. Lieber, and C. Maus. In 1890, Federal regulations were changed to allow breweries to

bottle in-house. In 1894, the Fulton Avenue Brewery, John Hartmetz, and the Evansville Brewing Co. merged into the Evansville Brewing Association.

1895–1899
Indiana got the Nicholson Law in 1895. It returned the remonstrance rules, where if more than half of a county's population voiced an objection, a liquor license would be denied. People could give a proxy, objecting to all liquor licenses. Minors were forbidden in taverns. The dangers of alcohol and narcotics were mandated to be taught in schools. The Indiana Brewers' Association was organized in 1899 with thirty-five member breweries.

1900–1904
The South Bend Brewing Association was formed in 1900. It would grow to be a substantial operation until Prohibition. In 1904, Frank Hanly was elected governor on an anti-alcohol, anti-gambling platform. In 1916, he became the Prohibition Party candidate for president. Also in 1904, the Association of Indiana Brewers (A of IB) was formed with twenty-four member breweries as an alternative to the Indiana Brewers' Association. Some breweries were in both trade associations. The A of IB formed a Vigilance Bureau with the purpose of "cleaning up and closing all objectionable places in which beer and other liquors are sold." They cooperated with "local authorities and civic bodies and through their earnest and sincere efforts, are bringing about a better condition of the saloons of this State and thereby causing a revulsion of public sentiment."[414]

1905–1910
The newly elected Congress immediately amended the Nicholson Law to allow township-wide voting on "dry." This was expanded in 1908 to county option voting. By 1909, forty-two of Indiana's ninety-two counties were dry, and seventy were dry a year later.

1911–1916
In 1910, the Democrats took control of both houses of Indiana's Congress, and with Democratic governor Thomas Marshall, they set about undoing the previous six years' mischief. County options were changed to township options, necessitating revoting in all dry counties. Still, local options took their toll, and Richmond, Madison, Marion, Wabash, Columbia City, Lawrenceburg and Jasper all lost their local breweries.

1917–1918

Statewide prohibition passed the House seventy to twenty-eight and the senate by thirty-eight to eleven. Signed by Governor James Goodrich, it became effective on April 2, 1918. Note that beverages were still allowed to contain half of 1 percent alcohol. Twenty breweries closed at the start of Indiana Prohibition.

Breweries that continued through Prohibition:

> Berghoff as Berghoff Products Mfg. Co.—Fort Wayne
> Bohrer Bros. as Bohrer Products Co. (until 1923)—Lafayette
> Centlivre as Centlivre Ice and Cold Production Storage Co.—Fort Wayne
> Eagle Brewery (until 1930)—Vincennes
> Evansville Brewing Association as Sterling Products Co.
> Home Brewing (until 1920)—Indianapolis
> Kamm & Schellinger as Arrow Beverage Mfg.—Mishawaka
> Indianapolis Brewing Co.—Indianapolis
> Muessel (until 1922)—South Bend
> People's Brewing as Peoples' Ice and Storage Co. (until 1920)—Terre Haute
> South Bend Brewing Association as South Bend Beverage & Ice—South Bend
> Southern Indiana Ice & Beverage Co.—New Albany
> Terre Haute Brewing Co.—Terre Haute
> Thieme & Wagner as National Fruit Juice Co. sold to Val Blatz in 1927—Lafayette
> P.H. Zorn—Michigan City

Breweries that closed during Prohibition but reopened afterward:

> Citizens Brewing Co. (Capital City—Richard Lieber—Ajax)—Indianapolis
> F.W. Cook—Evansville
> T.M. Norton—Anderson

1919–1924

In 1919, Indiana ratified the National Prohibition Amendment. National Prohibition came into effect on January 16, 1920.

1925–1931

In 1925, the Wright "Bone-Dry" law was enacted. It mandated a prison sentence for possession of liquor. Even the smell of alcohol was evidence of guilt. Approximately 250 people were arrested in the first week of enforcement. "Regarded as the most drastic liquor law in the United States,"[415] local prosecutors were awarded twenty-five dollars for each Prohibition conviction. By 1929, police officers were awarded twenty-five dollars for seizing automobiles carrying alcoholic beverages.

1932–1933

By this time, Prohibition had already lost much popular support nationwide. The Indiana Democratic Party Platform included a plank calling for approval of beer up to 2.75 percent by weight (ABW). Newly elected Democratic governor Paul McNutt signed a repeal of the "Bone Dry" law in 1933 and released all people in Indiana prisons convicted by that law. This freed 982 men and 47 women. The national Volstead Act was amended by the Cullen-Harrison Act, effective April 7, 1933. Beer was again available at 3.2 percent by weight (4 percent ABV) in Indiana and nineteen other states. In Indiana, beer had to be bottled and could be sold in restaurants, hotels, dining cars and private clubs for consumption with food or be bought for off-premises drinking.[416] Wine and spirits remained illegal, as did drinking in a tavern.

1934–1938

In Indiana, beer wholesalers that imported beer from another state had to pay an additional license fee of $1,500 and post a bond of $10,000. These licenses were limited in number to fifty, but only thirteen were taken. Brewers from out of state were forbidden to deliver to Indiana directly. These laws were common in many states and were designed to protect local manufacturers and local agriculture during the Depression. This came to a head in 1938, when the Indianapolis Brewing Co. sued the State of Michigan. Michigan had previously banned beer importation from Indiana and other states that discriminated against Michigan-made beer. In 1939, the U.S. Supreme Court upheld the Michigan law as the Twenty-first Amendment gave states the right to prohibit or regulate alcohol and supercede the Equal Protection clause of the Constitution. In March 1938, an agreement was reached in which Michigan would stop the embargo and Indiana would remove the "port of entry" fee. The Indiana law was changed in early 1939.

1939–1945

In 1939, Indiana became the first state to have a blood alcohol content test for drunk driving (.15 percent). There were just fifteen breweries open in Indiana after T.M. Norton closed in 1940. Canned beer disappeared in April 1942 as metals were diverted to war production.

1946–1960

The Indiana State Fair went dry in 1947.[417] Consolidation of breweries occurred, and thirteen breweries in 1948 become just four by 1960. Closures included Kamms, Hoff-Brau, K.G. Schmidt, Lafayette, F.W. Cook, Indianapolis Brewing, the South Bend Brewing Assoc. and the Terre Haute Brewing Co. The four left were Centlivre (Old Crown), Drewrys, Sterling and Falstaff.

1961–1971

Many minor changes during the 1960s affected people's lives in subtle ways. Cold beer could be sold in liquor stores starting in 1963 (previously only sold in taverns). Women could be hired as bartenders starting in 1967; they were allowed to sit, but not stand, at bars in 1969. In that year, canned beer outsold bottled beer nationwide for the first time.

1972–1978

Consolidation of national beer companies was still going strong in the 1970s. In 1972, Drewrys and Sterling were sold to G. Heileman, who immediately closed Drewys. Old Crown closed in 1973, having lost its core base of customers. Falstaff had bought Berghoff in 1954, and Falstaff itself was sold to Paul Kalmanovitz's S&P Corportation in 1975.

1979–1989

The Indiana Alcoholic Beverage Commission ruled, in 1979, that distributors could not have exclusive territories for brands of beer. This led to large distributors expanding at the expense of smaller nearby distributors. In 1989, the "Beer Baron" bill that would have reversed that 1979 rule was passed by the legislature but was vetoed by Governor Evan Bayh. In 1979, there were more than two hundred distributors in Indiana; by 1989, there were only eighty.[418] The original rule was finally rescinded in 2002.

1989–1997

The Indianapolis Brewing Co., the first modern-era brewery, opened in 1989. The Broad Ripple Brewpub opened the next year, followed by Lafayette, Bloomington, Oaken Barrel, Turoni's, Ram, Rock Bottom, Back Road and Three Floyds in the next five years. Meanwhile, Falstaff closed its doors in 1990, and Evansville Brewing followed in 1997. As the old-line breweries died, new smaller, leaner, more imaginative breweries started putting out a wide variety of ales and lagers.

1998–2000

In 1999, home-brewers were allowed for the first time to take their beer out of their houses. This allowed the first Indiana State Fair Brewers Competition to be held, with eight categories for home-brewers and six categories for professional breweries. In 2000, the Prohibition Party candidate, Earl Dodge, got 208 votes for president.

A detailed, year-by-year timeline can be found at our companion website, **www.HoosierBeerStory.com**.

Notes

Common Beer, Ale and Lager

1. White and Owen, *Evansville*.

Influences

2. Much of this section relies on Kathleen A. Hinkle, "The Tide of Immigration Into Indiana: 1800–1920" (Honors thesis, Ball State University, May 1980). We want to thank her for her comprehensive work.
3. Zach, *Indianapolis of To-day*.
4. Van Wieran, *American Breweries II*.
5. United States Brewers Association.

Northwest Indiana

6. *Griesel v. Schmal, Receiver*. Indiana Supreme Court, November 1876.
7. Salem, *Beer, Its History*; Reports of the historical secretary of the Old Settlers' Association of Lake County, Indiana, 1898.
8. Northwest Indiana Photo Gallery, Crown Brewing Company.
9. *Lake County Times*, December 6, 1907.
10. Salem, *Beer, Its History*.
11. *La Porte Argus-Bulletin*, May 30, 1896.

12. Ibid., August 23, 1911.
13. Backus and Martin, *Laporte, Indiana.*
14. Ibid.
15. Packard, *History of La Porte County.*
16. Fern Eddy Schultz, "Silly Shenanigans Ended Early Attempts to Make Hops a Crop in La Porte County," *Whats New La Porte*, November 22, 2009.
17. Packard, *History of La Porte County.*
18. Ibid.
19. Daniels, *20th Century History.*
20. Salem, *Beer, Its History.*
21. Howard, *History of St. Joseph County.*
22. Salem, *Beer, Its History.*
23. Howard, *History of St. Joseph County*; Anderson & Cooley, *South Bend.*
24. Cutter, *American Biography.*
25. *Reports of Cases Decided in the Appellate Court of the State of Indiana*, 1910.
26. Goodspeed and Blanchard, *Counties of Porter and Lake.*
27. Ibid.
28. Ibid.
29. Salem, *Beer, Its History.*
30. Friedrich and Bull, *Register of Breweries.*

SOUTH BEND

31. Salem, *Beer, Its History.*
32. Howard, *History of St. Joseph County.*
33. Robinson, *German Settlers of South Bend*; Howard, *History of St. Joseph County.*
34. Anderson & Cooley, *South Bend.*
35. *Ice and Refrigeration* 39 (1910); *Annual Report of the Indiana Department of Inspection*, 1910; Friedrich and Bull, *Register of Breweries.*

NORTHEAST INDIANA

36. Salem, *Beer, Its History.*
37. Zach, *Whitley County.*
38. *Ice and Refrigeration Illustrated* 45 (1913).
39. Zach, *Whitley County.*

40. Ibid.
41. Bash, *History of Huntington County.*
42. Annual Report of the Indiana State Board of Health, 1914.
43. Salem, *Beer, Its History.*
44. *Trust Companies of the United States.*
45. *Fort Wayne City Directory,* 1877, 1907.
46. Taylore, *War Work.*
47. Friedrich and Bull, *Register of Breweries.*
48. Bull, *American Breweries.*
49. 1901 biographical memoirs of Wabash County, Indiana; Weesner, *History of Wabash County.*
50. Robertson, *Wabash County History.*
51. Salem, *Beer, Its History.*

Fort Wayne

52. Howard, *History of St. Joseph County.*
53. Griswold and Taylor, *Pictorial History.*
54. Fort Wayne, Indiana City Directory, 1875, 1876.
55. Ibid.
56. *Pictorial History.*
57. Williams' Fort Wayne Directory, 1864.
58. Salem, *Beer, Its History.*
59. 1875 Fort Wayne City Directory.
60. Salem, *Beer, Its History.*
61. *Fort Wayne Gazette,* June 9, 1897.
62. *Fort Wayne Journal-Gazette,* May 30, 1905.
63. Berhoff, Berghoff and Ryan, *Berghoff Family Cookbook.*
64. *Fort Wayne News,* October 26, 1894; Griswold and Taylor, *Pictorial History.*
65. *U.S. v. Falstaff Brewing Corp.* (1973).
66. "The History of the Falstaff Brewing Company and Falstaff Beer." http://www.falstaffbrewing.com.

North Central Indiana

67. Salem, *Beer, Its History.*
68. 1868 Business Directory for Indiana.

69. Helm, *History of Cass County*.

70. Ibid.

71. Salem, *Beer, Its History*.

72. *Logansport Weekly Pharos*, March 20, 1894.

73. Ibid., September 28, 1894.

74. Helm, *History of Cass County*.

75. *Buck et al. v. K.G. Schmidt Brewing Co., Inc., et al.*

76. *Marion Daily Chronicle*, May 1, 1894.

77. *Ice and Refrigeration* 45 (1914).

78. Van Wieran, *One Hundred Years of Brewing*; Fox Deluxe Brewing Co. files, Marion Public Library, Dr. Harry Counceller, 1985.

79. Joseph Patrick Murphy, "Kiley Family History," 1971.

80. *Fort Wayne News*, June 26, 1913.

81. Kiley Brewing Co. files, Marion Public Library, Dr. Harry Counceller, 1985.

82. *Marion Leader-Tribune*, April 27, 1934.

83. *Marion Observer*, May 4, 1934.

84. Zach, *Cass, Miami, Howard and Tipton Counties*.

85. Settle, *"Here We Live"*; Zach, *Cass, Miami, Howard and Tipton Counties*; Goss, *Cincinnati, the Queen City*.

86. Salem, *Beer, Its History*.

87. *Rochester Sentinel*, Wednesday, July 29, 1885.

88. Submitted by Charles Bauer, St. Petersburg, Florida, Andrew Baldner's great-great-grandson.

89. McDonald, *Twentieth Century History*.

90. *The History of Union Township, Marshall County, Indiana*. Corwin, IN: Published in the Culver Citizen, n.d.

91. *History of Indiana*. Special Edition for Marshall County, 1890.

92. *Plymouth Democrat*, January 4, 1900.

93. Salem, *Beer, Its History*.

94. Ida Chipman, "Old Mansion Along Indiana 17 Has Ties to Slavery, Mob," *South Bend Tribune*, October 25, 2005.

95. *Rochester Standard*, January 6, 1870.

96. *Rochester Sentinel*, November 4, 1876.

97. *Rochester Sentinel*, January 11, 1879.

98. George A. Nye "Warsaw in 1879," YesterYear in Print.

99. *Northern Indianian*, May 31, 1860.

100. Nye, "Warsaw in 1880–81."

Lafayette

101. DeHart, *Past and Present*.
102. Salem, *Beer, Its History*.
103. *Polk's Lafayette City Guide*, 1891.
104. Ben Ross, "The Breweries of Lafayette, Indiana," http://b-levi.com/lafayette/breweries.
105. Salem, *Beer, Its History*.
106. *Printers' Ink* 108 (1919).
107. *Lafayette Journal and Courier*, October 12, 1933.
108. Ross, "Breweries of Lafayette."
109. Tippecanoe County Historical Association.

West Central Indiana

110. Bull, *American Breweries*.
111. *Polk's Indiana State Gazetteer and Business Directory*, 1885.
112. Clay County Genealogical Society, http://www.ccgsilib.org/articles/bellaire.htm.
113. Salem, *Beer, Its History*.
114. Travis, *History of Clay County*.
115. *Cold Storage and Ice Trade Journal*, January–June 1908.
116. Beckwitch, *History of Fountain County*.
117. Zach, *Crawfordsville*.
118. Salem, *Beer, Its History*.
119. *Daily Argus News*, April 5, 1892.
120. Weik, *Weik's History of Putnam County*.
121. Friedrich and Bull, *Register of Breweries*.
122. Young and Shawver, People's Guide.

Terre Haute

123. Timeline of History, Vigo County Library.
124. Mike McCormick, "Historical Perspective: Contralto Edith Castle and Other Vigo Notables," *Terre Haute Tribune-Star*, June 2, 2007.
125. Salem, *Beer, Its History*.
126. Oakey, *Greater Terre Haute*.

127. McCormick, *Terre Haute*.

128. Mike McCormick, "Wabash Valley Visions & Voices: A Digital Memory Project," *Terre Haute Tribune-Star*, 2006.

129. *Ice and Refrigeration Illustrated*, July–December 1903.

130. Paris, Illinois City Directory, 1909.

131. *Muncie Morning News*, November 6, 1898.

132. McCormick, *Terre Haute*.

133. "Wabash Valley Profiles," Terre Haute National Bank, 2001.

134. "The Wabash Valley Remembers, 1787–1938," Terre Haute Northwest Territory Celebration Committee, 1938.

135. Kious and Roussin, *ABC*.

136. Mike McCormick column, *Terre Haute Tribune-Star*, June 9, 2002.

137. *Sullivan Democrat*, August 16, 1860.

138. Beckwith, *Vigo and Parke Counties*.

139. Salem, *Beer, Its History*.

140. Oakey, *Greater Terre Haute*.

141. McCormick, "Historical Perspective."

142. McCormick, *Terre Haute*.

143. Bull, *American Breweries*.

144. Oakey, *Greater Terre Haute*.

145. Blum, *Brewed in Detroit*.

EAST CENTRAL INDIANA

146. Forkner and Dyson, *Historical Sketches*.

147. Ibid.

148. Ibid.

149. Dunn, *Indiana and Indianans*.

150. *Stone: an illustrated magazine* 14 (1897).

151. *Indianapolis Star*, June 18, 1923.

152. Zach, *Wayne, Fayette, Union and Franklin Counties*.

153. Salem, *Beer, Its History*.

154. Undated *Cambridge City Tribune*.

155. Salem, *Beer, Its History*.

156. *Cambridge City Tribune*, February 11, 1915.

157. Zach, *Wayne, Fayette, Union and Franklin Counties*.

158. Zach, *Warrick, Spencer, and Perry Counties*.

159. Friedrich and Bull, *Register of Breweries*; Salem, *Beer, Its History*.

160. 1876/1877 Emerson Directory of Muncie.
161. McDonald, *Twentieth Century History*.
162. *Muncie Star Press*.
163. Friedrich and Bull, *Register of Breweries*.
164. Zach, *History of Wayne County*; Wasson, *Annals of Pioneer Settlers*.
165. Plummer, "Reminiscences."
166. Ibid.
167. E.M. Haas, *Richmond Palladium-Item*, August 25, 1934.
168. Zach, *History of Wayne County*.
169. *Ice and Refrigeration* 41 (1911).
170. Salem, *Beer, Its History*; Friedrich and Bull, *Register of Breweries*.
171. The Joseph Lay Company Records, 1843–1925, Ridgeville Museum, Ridgeville, IN.
172. *Shelby County*, 409.
173. Friedrich and Bull, *Register of Breweries*.
174 Dunn, *Indiana and Indianans*.

INDIANAPOLIS

175. *Indianapolis Police Manual*, 1895.
176. Bodenhamer and Barrows, *Encyclopedia of Indianapolis*.
177. *Commemorative Biographical Record*.
178. Sulgrove, *History of Indianapolis*.
179. 1860 *Polk City Directory of Indianapolis*.
180. 1860 *Indianapolis City Directory*.
181. Stoll, *Pictorial and Biographical Memoirs*.
182. Sulgrove, *History of Indianapolis*.
183. Salem, *Beer, Its History*.
184. Sulgrove, *History of Indianapolis*.
185. Bodenhamer and Barrows, *Encyclopedia of Indianapolis*.
186. *Indianapolis Star*, September 22, 1915.
187. Salem, *Beer, Its History*.
188. 1870 *Indianapolis City Directory*.
189. *Pictorial and Biographical Memoirs*.
190. *Who's Who in Finance and Banking* (New York, 1922).
191. *Conversations with Kurt Vonnegut* (N.p.: University Press of Mississippi, 1988).
192. 1865 *Polk City Directory of Indianapolis*.

193. 1865 and 1870 *Indianapolis City Directories*. See also Edward's *Annual Directory of Inhabitants, Institutions, Incorporated Companies, Manufacturing Establishments, Etc. Etc. In the City of Indianapolis*, 1867.
194. Cahill, *Thunderbolt*.
195. 1865 *Indianapolis City Directory*.
196. Salem, *Beer, Its History*.
197. *Hutchinson's Indianapolis City Directory*, 1870.
198. Friedrich and Bull, *Register of Breweries*.
199. Polk's Indianapolis City Directory for 1887; "The City of Indianapolis, The Advantages Offered for Business Location and the Investment of Capital," Indianapolis Board of Trade, 1889.
200. Robert Taylor Swaine, The Cravath Firm and Its Predecessors, 1819–1947, Vol 1. (N.p., 1948).
201. Van Wieran, *One Hundred Years of Brewing*.
202. *Indianapolis Star*, November 7, 1971.
203. *Journal Handbook of Indianapolis*, 1902.
204. Ad in *Indianapolis Star*, September 7, 1914.
205. *Indianapolis Times*, July 8, 1933.
206. *Indianapolis Star*, June 21, 1938.
207. *Indianapolis Times*, November 28 and 29, 1945.
208. *Time*, February 25, 1952; *Milwaukee Journal*, February 16, 1952.
209. Bodenhamer and Barrows, *Encyclopedia of Indianapolis*.
210. Monthly Bulletin of the Indiana State Board of Health, April 1906.
211. *Indianapolis Star*, February 1, 2001.
212. Hyman, *Hyman's Handbook*.
213. *New York Times*, June 22, 1901.
214. Van Wieran, *One Hundred Years of Brewing*.
215. Hyman, *Hyman's Handbook*.
216. Crompton, *Twentieth Century Champions*.
217. Lieber Brewing Corp. Annual Report, 1936, used in Cause #M-4569 Superior Court, September 6, 1948.

SOUTHEAST INDIANA

218. *History of Dearborn and Ohio Counties*.
219. Boomhower and Jones, *Destination Indiana*.
220. *Wiggins and Weaver's Ohio River Directory*, 1871–77.
221. Salem, *Beer, Its History*.

NOTES TO PAGES 126–134

222. *Chronicle* 29 (1886).

223. *Chicago Tribune*, February 20, 1890.

224. *Sandusky Star*, April 12, 1899.

225. Bull, *American Breweries*.

226. Ibid.

227. *Business Directory for Indiana*, 1868; Bull, *American Breweries*.

228. Jacoby, History of Marion County.

229. *History of Dearborn and Ohio Counties*.

230. Ibid.

231. Ibid.

232. *Chandler Co.'s Business Directory for Indiana*, 1868; *History of Dearborn and Ohio Counties*.

233. Salem, *Beer, Its History*.

234. *Legislative and State Manual of Indiana*, 1905.

235. Smith, *History of Kentucky*.

236. Salem, *Beer, Its History*.

237. *Indianapolis of To-Day*.

238. Grimes and Ammeson, *Madison*.

239. *Indianapolis of To-Day*.

240. *Madison Courier*, March 12, 1937.

241. Zach, *Clark, Crawford, Harrison, Floyd, Jefferson, Jennings, Scott, and Washington*.

242. *Madison Courier*, September 23, 1938.

243. *Madison Mirror*, date unknown.

244. Grimes and Ammeson, *Madison*.

245. *New York Times*, May 1, 1891.

246. *Madison Courier*, April 22, 1937.

247. *Williams' Madison City Directory*, 1859–1960.

248. Salem, *Beer, Its History*.

249. *Indiana State Gazetteer and Business Directory*, 1880–1881; Ripley County History 1818-1988, Ripley County History Book Committee, Osgood, IN, Taylor Publishing, Dallas, 1989.

250. Ripley County History Book Committee, *Ripley County History*.

251. *History of Dearborn and Ohio Counties*.

252. Salem, *Beer, Its History*.

253. Some information about the Zix family comes from Rootsweb genealogy database.

254. Souvenir and Official Program, 19th Annual Encampment, Grand Army of the Republic, 1898.

255. Salem, *Beer, Its History*.
256. Blanchard, *Catholic Church in Indiana*.
257. Salem, *Beer, Its History*.
258. Bull, *American Breweries*.
259. Friedrich and Bull, *Register of Breweries*.
260. Salem, *Beer, Its History*.
261. Friedrich and Bull, *Register of Breweries*.
262. Friedrich and Bull, *Register of Breweries*.
263. Salem, *Beer, Its History*.
264. David S Dreyer, "A Sesquicentennial History of Penntown, 1837–1987," 1987.
265 Salem, *Beer, Its History*.

New Albany–Jeffersonville

266. Reverend Charles Rogers, *The Scottish Minstrel; the Songs of Scotland Subsequent to Burns, with Memoirs of the Poets* (Edinburgh, UK: Nimmo, 1876).
267. James Grant Wilson, *The Poets and Poetry of Scotland* (Cambridge, UK: Chadwyck-Healey, 1999).
268. Western Biographical Publishing Company, *American Biographical History*.
269. Zach, *Clark, Crawford, Harrison, Floyd, Jefferson, Jennings, Scott, and Washington*.
270. Salem, *Beer, Its History*.
271. *Floyd County Gazetteer*, 1868.
272. James Schremp, "Breweries of New Albany," essay, 2003.
273. *Louisville Courier Journal*, February 1, 1959.
274. Zach, *Clark and Floyd Counties*.
275. Robbins, *Advantages and Surroundings*.
276. *New Albany Daily Ledger*, February 8, 1897.
277. Ibid., June 26, 1902.
278. Kleber, *Encyclopedia of Louisville*.
279. Souvenir History, New Albany Centennial Celebration, 1913.
280. *New Albany Weekly Ledger*, February 10, 1915; July 7, 1915; November 17, 1915.
281. Ibid., June 16, 1915.
282. *New Albany Daily Ledger*, September 20, 1921.
283. *New Albany Weekly Ledger*, September 1, 1933.
284. Kleber, *Encyclopedia of Louisville*.

285. Ibid.

286. *Floyd County Gazetteer*, 1868.

287. Schremp, "Breweries of New Albany."

288. *New Albany Ledger*, April 4, 1889.

289. *Illustrated Louisville*, "The City of New Albany," 1891.

290. *New Albany Tribune*, Marxh 28, 1962.

291. Robbins, *Advantages and Surroundings*.

292. *New Albany Daily Ledger*, May 3, 1899.

293. *Floyd County Gazetteer*, 1868.

294. Salem, *Beer, Its History*.

295. *New Albany Ledger Standard*, February 21, 1877.

296. Ibid., January 26, 1884.

297. Ibid., June 24, 1886.

298. Ted Fulmore, "Our History in New Albany," 2006.

299. Salem, *Beer, Its History*.

300. Ibid.

301. Guetig and Selle, *Louisville Breweries*.

302. Kleber, *Encyclopedia of Louisville*.

303. Annual Report, Indiana Department of Inspection, 1911.

304. Notes in the New Albany Library collection from "Brewers and Breweries of New Albany, Indiana," Walter H. Kiser, filed 1973.

305. *New Albany Weekly Ledger*, January 22, 1919; *New Albany Tribune*, June 27, 1936.

306. *New Albany Daily Ledger*, March 17, 1894.

307. Great New Albany Centennial Celebration program, 1913.

SOUTHWEST INDIANA

308. Zach, *Warrick, Spencer, and Perry Counties*.

309. Cannelton Historic District Walking Tour, Perry County Convention and Visitors Bureau.

310. Salem, *Beer, Its History*.

311. Bull, *American Breweries*.

312. Ibid.

313. Bull, *American Breweries*.

314. Annual Report of the Indiana Department of Inspection, 1910.

315. Bull, *American Breweries*.

316. Zach, *Pike and DuBois Counties*.

317. Ibid.
318. Bull, *American Breweries*.
319. Flick and Ammeson, *Jasper and Huntingburg*.
320. Annual report of the State Bureau of Inspection Relating to Manufacturing, 1913.
321. Zach, *Pike and DuBois Counties*.
322. Annual report of the State Bureau of Inspection Relating to Manufacturing, 1908.
323. Zach, *Pike and DuBois Counties*.
324. The Kuhlenschmidt Family in Indiana, www.kuhlenschmidt.com/indiana.html.
325. Zach, *Warrick, Spencer, and Perry Counties*.
326. Salem, *Beer, Its History*.
327. William Hofmann papers, Indiana Historical Society.
328. Zach, *Warrick, Spencer, and Perry Counties*.
329. Brother Gabriel Hodges, *BYO Magazine*, March–April 2004.
330. Thrasher, *History of Tell City*.
331. Zach, *Warrick, Spencer, and Perry Counties*.
332. Hunt, *Perry County*.
333. Salem, Beer, Its History.
334. *Boonville Enquirer*, August 31, 1894.
335. Hunt, *Perry County*.
336. Van Wieran, *One Hundred Years of Brewing*.
337. Andrea's Genealogical Attic, 2009.
338. Salem, *Beer, Its History*.
339. Zach, *Warrick, Spencer, and Perry Counties*.
340. Ibid.
341. Salem, *Beer, Its History*.
342. Report of the Secretary of State of Indiana, 1906.
343. Annual report of the Department of Inspection of Manufacturing and Mercantile Establishments, Laundries, Bakeries, Quarries, Printing Offices and Public Buildings, 1909.
344. *National Provisioner* 48 (1913).
345. *Indiana Gazette*, 1866.
346. Salem, *Beer, Its History*.
347. Hodge, *Vincennes in Picture and Story*.

EVANSVILLE

348. *Chandler Co.'s Directory of Indiana*, 1868; *Williams City Directory of Evansville*, 1869.

349. *Bennet's Evansville City Directory*, 1875.

350. Salem, *Beer, Its History*.

351. *Williams City Directory of Evansville*, 1881.

352. Zach, *History of Vanderburgh County*.

353. *Chicago Tribune*, March 29, 1890.

354. Zach, *History of Vanderburgh County*.

355. Leffel, *History of Posey County*.

356. White and Owen, *Evansville*.

357. Evansville City Directories, 1861 through 1878.

358. Salem, *Beer, Its History*.

359. Zach, *History of Vanderburgh County*.

360. *Chicago Tribune*, December 4, 1891.

361. Van Wieran, *One Hundred Years of Brewing*.

362. *Louisville & Nashville R. Co. v. Cook Brewing Co.*, 223 U.S. 70 (1912).

363. *New York Times*, May 13, 1949.

364. U.S. Federal Circuit Court of Appeals Reports, May 13, 1971.

365. *Williams City Directory of Evansville*, 1869.

366. Ibid., 1858 through 1876.

367. Friedrich and Bull, *Register of Breweries*.

368. *Williams City Directories of Evansville*, 1858 through 1870.

369. *G.W. Hawes' Indiana State Gazetteer and Business Directory*, 1858.

370. *Williams City Directories of Evansville*, 1861 through 1869.

371. Ibid., 1861 through 1878.

372. Ibid., 1863.

373. *Evansville Courier and Press*, July 3, 1976.

374. Salem, *Beer, Its History*.

375. Friedrich and Bull, *Register of Breweries*.

376. *Evansville Courier and Press*, April 22, 1958.

377. Connelley and Coulter, *History of Kentucky*.

378. *Evansville Courier and Press*, April 22, 1958.

379. Baron and Young, *Brewed in America*.

380. Gilbert, *History of Evansville*.

381. *New Albany Ledger Standard*, Februray 21, 1898; *Evansville Courier and Press*, February 25, 1946.

382. *Evansville Courier and Press*, March 17, 1987.

383. Ibid., October 18, 1970.

384. Papers related to 313 F2d 803 *Sterling Distributors Inc. v. United States.*

385. Mittelman, *Brewing Battles.*

386. Blum, *Brewed in Detroit.*

387. *Coopers International Journal* 15 (1906) and 12 (1912).

388. *Evansville Courier-Journal,* July 3, 1976.

389. Baier, *Brewing Industry in La Crosse.*

390. Apps, *Breweries of Wisconsin.*

391. *Evansville Courier and Press,* July 3, 1976.

392. Ibid., April 22, 1988.

393. Ibid., September 15, 1988.

394. *Chicago Tribune,* December 12, 1993.

395. *Indiana Business Magazine,* June 1, 1993.

396. *Toledo Blade,* August 23, 1994.

397. Collection of Mike Murphy, Glenwood, Iowa.

398. *Indianapolis Monthly,* June 1995.

399. *Chicago Tribune,* August 26, 1997.

400. *Bowling Green Daily News,* September 13, 1995.

401. *Marketing Week,* April 21, 1995.

402. *Lexington Herald Leader,* September 1, 1997.

403. *Indianapolis Star,* February 16, 1995.

404. *Modern Brewery Age,* November 10, 1997.

Modern-Era Breweries

405. *Indianapolis Star,* November 26, 1996.

406. *Tippecanoe Home-brew Circle Newsletter,* December 2000.

407. Interview with Sam Stupeck, Rita Kohn, Indiana University Press, 2010.

408. *Indianapolis Monthly,* May 2008.

409. *Terre Haute Tribune Star,* 2004.

Appendix B

410. Spooner, *Cyclopædia of Temperance.*

411. Woollen, *Intoxicating Liquors.*

412. Clubb, *Maine Liquor Law.*

413. White and Owen, *Evansville and its Men of Mark.*

414. United States Brewers' Association, Proceedings of the Forty-ninth Convention, 1909.
415. *New York Times*, May 3, 1925.
416. *United Press*, March 14, 1933.
417. *Billboard*, March 22, 1947, 71.
418. AP report, March 1, 1989.

Bibliography

CITY DIRECTORIES

Chamberlain, E., ed. *The Indiana Gazetteer: or Topographical Dictionary of the State of Indiana*. Indianapolis: E. Chamberlain, 1849.

City Directories for Anderson, Angola, Bedford, Bloomington, Bluffton, Columbus, Connersville, Crawfordsville, Evansville, Decatur, Elkhart, Fort Wayne, Frankfort, Franklin, Gary, Goshen, Hammond, Hobart, Huntington, Indianapolis, Jasper, Jeffersonville, Kokomo, Lafayette, La Porte, Logansport, Madison, Marion, Michigan City, Mishawaka, Mount Vernon, Muncie, New Albany, Newburgh, New Castle, Peru, Princeton, Richmond, Rushville, Seymour, Shelbyville, South Bend, Terre Haute, Tipton, Union City, Vincennes, and Washington, Warsaw and Winchester. Published by R.L. Polk.

City Directories of Fort Wayne and Evansville. Published by C.S. Williams of Cincinnati biannually from 1859 through 1870.

Edward's Annual Directory of Inhabitants, Institutions, Incorporated Companies, Manufacturing Establishments, Business Firms, Etc. Indianapolis: Edwards & Boyd, 1867

Hawes, George W., and James Sutherland. *Indiana State Gazetteer and Business Directory*. Indianapolis: Geo. W. Hawes, 1859.

Hutchinson's Indianapolis City Directory, Embracing an Alphabetical List of Citizens' Names. Indianapolis: Sentinel Steam Printing Establishment, 1870.

Indiana State Gazetteer and Business Directory. Indianapolis: R.L. Polk & Co. 1882, 1916 and 1928.

Young, Curtis R., and Phil Shawver. *The People's Guide: A Business, Political and Religious Directory of Boone County, Indiana*. Plainfield, IN: Plainfield-Guilford Township Public Library, 2001.

INDIANA AND OTHER HISTORIES

Anderson & Cooly, eds. *South Bend and the Men Who Have Made It*. South Bend, IN: Tribune Printing Co., 1901.

Backus, Edith J. and H.H. Martin. *Laporte, Indiana: History of the First Hundred Years*. N.p., 1932.

Ball, T.H. *Northwestern Indiana from 1800 to 1900*. Chicago: Donohue & Henneberry, 1900.

Bash, Frank S., ed. *History of Huntington County, Indiana*. Chicago: Lewis Publishing, 1914.

Beckwith, Hiram Williams. *History of Fountain County: Together with Historic Notes on the Wabash Valley, Gleaned from Early Authors, Old Maps and Manuscripts*. Chicago: H.H. Hill and N. Iddings, 1881.

———. *History of Vigo and Parke County: Together with Historic Notes on the Wabash Valley, Gleaned from Early Authors, Old Maps and Manuscripts*. Chicago: H.H. Hill and N. Iddings, 1880.

Berhoff, Carlyn A., Jan Berghoff and Nancy Ross Ryan. *The Berghoff Family Cookbook: From Our Table to Yours, Celebrating a Century of Entertaining*. Kansas City, MO: Andrews McMeel Publishing, 2007.

Blanchard, Charles, ed. *History of the Catholic Church in Indiana*. Logansport, IN: A.W. Bowen & Co., 1898.

Bodenhamer, David J., and Robert Graham Barrows. *The Encyclopedia of Indianapolis*. Bloomington: Indiana University Press, 1994.

Bodurtha, Arthur L., ed. *History of Miami County Indiana*. Chicago: Lewis Publishing Co., 1914.

Boomhower, Ray E. *Destination Indiana: Travels through Hoosier History*. Indianapolis: Indiana Historical Society, 2000.

Cline & McHaffie. *The People's Guide: A Business, Political and Religious Directory of Boone Co., Ind*. Indianapolis: Indianapolis Printing and Publishing House, 1874.

Commemorative Biographical Record of Prominent and Representative Men of Indianapolis and Vicinity, Containing Biographical Sketches of Business and Professional Men and of Many of the Early Settled Families. Chicago: J.H. Beers & Co., 1908.

Connelly, William Elsey, and E. Merton Coulter. *History of Kentucky*. Chicago: American Historical Society, 1922.

Crompton, John L. *Twentieth Century Champions of Parks and Conservation*. Champaign, IL: Sagamore Publishing, LLC, 2007–2008.

Cutter, William Richard. *American Biography: A New Cyclopedia*. Vol. 10. New York: American Historical Society, 1922.

Daniels, E.D. *A 20th Century History and Biographical Record of La Porte County, Indiana*. Chicago: Lewis Pub. Co., 1904.

DeHart, Richard P. *Past and Present of Tippecanoe County, Indiana*. Indianapolis: B.F. Bowen, 1909.

Dunn, Pacob Piatt. *Indiana and Indianans: A History of Aboriginal and Territorial Indiana and the Century of Statehood*. Chicago: American Historical Society, 1919.

Flick, Ron, and Jane Ammeson. *Images of America. Jasper and Huntingburg*. Charleston, SC: Arcadia Publishing, 2005.

Forkner, John L., and Byron H. Dyson. *Historical Sketches and Reminiscences of Madison County, Indiana*. N.p.: John L. Forkner, 1897.

Fox, Henry Clay, ed. *Memoirs of Wayne County and the City of Richmond Indiana*. Madison, WI: Western Historical Association, 1912.

Gilbert, Frank M. *History of the City of Evansville and Vanderburg County Indiana*. Chicago: Pioneer Publishing Co., 1910.

Goodspeed, Weston A., and Charles Blanchard. *Counties of Porter and Lake, Indiana*. Chicago: F.A. Battey & Co., 1884.

———. *History of Whitley and Noble Counties, Indiana*. Chicago: F.A. Battey & Co., 1882.

Goss, Charles Frederick. *Cincinnati, the Queen City, 1788–1912*. Chicago: S.J. Clarke Pub. Co, 1912.

Greene, George E. *History of Old Vincennes and Knox County Indiana*. Chicago: S.J. Clarke Publishing Co., 1911.

Grimes, Ron, and Jane Ammeson. *Images of America—Madison*. Charleston, SC: Arcadia Publishing, 2006.

Griswold, Bert Joseph, and Samuel R. Taylor. *The Pictorial History of Fort Wayne, Indiana*. Chicago: Robert O. Law Co., 1917.

Helm, Thomas B., ed. *History of Cass County, Indiana*. Chicago: Brant & Fuller, 1886.

History of Dearborn and Ohio Counties. Evansville, IN: Unigraphic, 1977.

The History of Union Township, Marshall County, Indiana. Corwin, IN: Published in the Culver Citizen, n.d.

Hodge, J. *Vincennes in Picture and Story*. N.p.: Applewood Books, 2009.

Howard, Timothy Edward. *A History of St. Joseph County Indiana.* Chicago: Lewis Publishing Co., 1907.

Hunt, Thomas James, de la. *Perry County. A History.* Indianapolis: W.K. Stewart Co., 1916.

Hyman, Max R. *Handbook of Indianapolis—An Outline History.* Indianapolis: Indianapolis Journal Newspaper Co., 1902.

Indianapolis of To-Day. N.p.: Consolidated Illustrating Co., 1896.

Jacoby, John Wilbur. *History of Marion County, Ohio, and Representative Citizens.* Chicago: Biographical Pub. Co., 1907.

Kaler, Samuel P., and R.H. Maring. *History of Whitley County, Indiana.* N.p.: B.F. Bowen & Co., 1907.

Kemper, General William Harrison. *A Twentieth Century History of Delaware County, Indiana.* Chicago: Lewis Publishing, 1908.

Kleber, John E. *The Encylopedia of Louisville.* Lexington: University Press of Kentucky, 2001.

Leffel, John C. *History of Posey County, Indiana.* Chicago: Standard Publishing Co., 1913.

Lockwood, George Browning. *The New Harmony Communities.* Marion, IN: The Chronicle Co., 1902.

McCormick, Chester A. *McCormick's Guide to Starke County.* N.p.: Chester A. McCormick, 1902.

McCormick, Mike. *The Making of America—Terre Haute: Queen City of the Wabash.* Charleston, SC: Arcadia Publishing, 2005.

McDonald, Daniel. *A Twentieth-Century History of Marshall County Indiana.* Indianapolis: Indiana State Library, [1969?].

Norris, Minnie Harris. *The Story of Marshall County.* Tucson, AZ: Roadrunner Publications, 1965.

Oakey, C.C. *Greater Terre Haute and Vigo County. Closing the First Century's History of City and County.* Chicago: Lewis Publishing Co., 1908.

Packard, Jasper. *History of La Porte County, Indiana, and Its Townships, Towns and Cities.* La Porte, IN: S.E. Taylor & Co., 1876.

The Pictorial History of Fort Wayne, Indiana: A Review of Two Centuries of Occupation of the Region about the Head of the Maumee River. Vol. 1. N.p.: Robert O. Law Co., 1917.

Plummer, John T. "Reminiscences of the History of Richmond." In *City Directory of Richmond, Indiana.* Richmond, IN: R.O. Dormer & W.R. Holloway, 1857.

Powell, Jehu Z., ed. *History of Cass County Indiana.* Chicago: Lewis Publishing Co., 1913.

Ripley County History Book Committee. *Ripley County History, 1818–1988, Ripley County, Indiana*. Osgood, IN: Ripley County History Book Committee, 1989.

Robbins, David Peter. *The Advantages and Surroundings of New Albany, Ind*. New Albany, IN: Ledger Co. printers, 1892.

Robertson, Linda. *Wabash County History—Bicentennial Edition*. Kansas City, MO: Walsworth Publishing, 1976.

Robinson, Gabrielle. *Voices of America: German Settlers of South Bend*. Chicago: Arcadia Publishing, 2003.

Settle, Patricia Jones. *"Here We Live Over the Last Fifty Years": Peru and Miami County, 1885–1935*. Evansville, IN: Unigraphic, 1929.

Shelby County, IN. Turner Publishing Co., 1992.

Smith, Zachariah Frederick. *This History of Kentucky: From Its Earliest Discovery and Settlement to the Present Date*. Louisville, KY: Prentice Press, 1895.

Stoll, John B. *Pictorial and Biographical Memoirs of Indianapolis and Marion County, Indiana*. Chicago: Goodspeed Brothers, 1893.

Sulgrove, Berry Robinson. *History of Indianapolis and Marion County*. Philadelphia: L.H. Everts & Co., 1884.

Sweet, William Warren. *Circuit-Rider Days in Indiana*. Indianapolis: W.K. Stewart Co., 1916.

Taylor, Isabelle H. *War Work of the Fort Wayne Chapter of the American Red Cross*. Fort Wayne chapter of the American Red Cross, 1919.

Taylor, William Charles. *A History of Clay County*. Austin, TX: Jenkins Pub. Co., 1972.

Thrasher, Mary Ahlf. *A History of Tell City*. Tell City Historical Society, 1989.

Trust Companies of the United States and Statements of Condition. New York: United States Mortgage & Trust Company, 1914.

Wasson, John Macamy. *Annals of Pioneer Settler on the Whitewater and Its Tributaries in the Vicinity of Richmond, Ind., from 1804 to 1830*. Indianapolis: John Woolman Press, 1962.

Weesner, Clarkson W., ed. *History of Wabash County, Indiana*. Chicago: Lewis Publishing Co., 1976.

Weik, Jesse William. *Weik's History of Putnam County, Indiana*. Indianapolis: B.F. Bowen & Co., 1910.

Western Biographical Publishing Company. *A Biographical History of Eminent and Self-Made Men of the State of Indiana*. Cincinnati, OH: Western Biographical Pub. Co., 1880.

White, Edward, and Robert Dale Owen. *Evansville and Its Men of Mark*. Evansville, IN: Historical Publishing Co., 1873.

Wissing, Douglas A. *One Pint at a Time*. Indianapolis: Indiana Historical Society Press, 2010.

Zach, Karen Bazzani. *Biographical and Genealogical History of Cass, Miami, Howard and Tipton Counties, Indiana*. Chicago: Lewis Publishing Co., 1898.

———. *Biographical and Genealogical History of Wayne, Fayette, Union and Franklin Counties, Indiana*. Chicago: Lewis Publishing Co., 1899.

———. *Biographical and Historical Souvenir for the Counties of Clark, Crawford, Harrison, Floyd, Jefferson, Jennings, Scott, and Washington, Indiana*. Chicago: John M. Gresham & Company, 1889.

———. *Commemorative Biographical Record of Prominent and Representative Men of Indianapolis and Vicinity*. Chicago: J.H. Beers & Co., 1908.

———. *Crawfordsville, Athens of Indiana*. Charleston, SC: Arcadia Publishing, 2003.

———. *History of Dearborn and Ohio Counties, Indiana. From their Earliest Settlement*. Chicago: F.W. Weakley & Co., 1895.

———. *History of La Porte County, Indiana*. Chicago: Chas. C. Chapman & Co., 1880.

———. *History of Knox and Daviess Counties, Indiana*. Chicago: Goodspeed Bros. & Co., 1886.

———. *History of Pike and Dubois Counties, Indiana*. Chicago: Goodspeed Bros. & Co., 1885.

———. *History of Vanderburgh County Indiana*. Madison, WI: Brant & Fuller, 1889.

———. *History of Warrick, Spencer, and Perry Counties, Indiana*. Chicago: Goodspeed Bros. & Co., 1885.

———. *History of Wayne County, Indiana*. Chicago: Inter-State Publishing Co., 1884.

———. *Indianapolis of To-Day*. Indianapolis: Consolidated Illustrating Co., 1896.

———. *Valley of the Upper Maumee River*. Madison, WI: Brant & Fuller, 1889.

———. *Whitley County and its Families, 1835–1995*. Paducah, KY: Turner Publishing, 1995.

Beer and Other Histories

Apps, Jerold W. *Breweries of Wisconsin*. Madison: University of Wisconsin Press, 1992.

Baier, Steven Michael. *History of the Brewing Industry in La Crosse*. N.p., 1976.

Baron, Stanley, and James Harvey Young. *Brewed in America: A History of Beer and Ale in the United States*. Boston: Little, Brown & Co., 1962.

Blum, Peter H. *Brewed in Detroit: Breweries and Beers since 1830*. Detroit: Wayne State University Press, 1999.

Bull, Donald. *American Breweries*. Vol. 2. Trumbull, CT: Bullworks, 1984. [This book and the Freidrich and Bull *Register of United States Breweries* below are early attempts by the authors, and many transcriptions of names and dates are not verified.]

Clubb, Henry S. *The Maine Liquor Law: Its Origin, History and Results*. New York: Fowler and Wells for the Maine Law Statistical Society, 1856.

Friedrich, Manfred, and Donald Bull. *The Register of United States Breweries, 1876–1976*. Stamford, CT: Manfred Freidrich, 1976.

Guetig, Peter, and Conrad Selle. *Louisville Breweries: A History of the Brewing Industry in Louisville, Kentucky, New Albany and Jeffersonville, Indiana*. Louisville, KY: Mark Skaggs Press, 1995.

Holl, John, and Nate Schweber. *Indiana Breweries*. N.p.: Stackpole Books, 2011.

Kious, Kevin, and Donald Roussin. *ABC: The Original King of Bottled Beer*. Collector Café, n.d.

Kohn, Rita T., and Kris Arnold. *True Brew: A Guide to Craft Beer in Indiana*. N.p.: Indiana University Press, 2010.

Mittelman, Amy. *Brewing Battles: A History of American Beer*. New York: Algora Pub., 2008.

Morrison, Samuel E. *Oxford History of the United States, 1778–1917*. New York: Oxford University Press, 1927.

Okrent, Daniel. *Last Call: The Rise and Fall of Prohibition*. New York: Scribner, 2010.

Salem, Frederick William. *Beer, Its History and Its Economic Value as a National Beverage*. Springfield, MA: Clark W. Bryan Co., 1880. Reprint, New York: Arno Press, 1972.

Schlüter, Hermann. *The Brewing Industry and the Brewery Workers' Movement in America*. Cincinnati, OH: International Union of United Brewery Workmen of America, 1910.

Spooner, Walter W. *Cyclopaedia of Temperance and Prohibition*. New York: Funk & Wagnalls, 1891.

Swaine, Robert Taylor. *The Cravath Firm and Its Predecessors*. New York: Ad Press, 1946.

Van Wieran, Dale P. *American Breweries II*. West Point, PA: East Coast Breweriana Association. 1995. [This is an updating of *American Breweries* by Donald Bull.]

————. *One Hundred Years of Brewing*. Chicago: H.S. Rich & Co., 1903.
Woollen, William Watson. *Intoxicating Liquors: The Law Relating to the Traffic in Intoxicating Liquors and Drunkenness.* Cincinnati, OH: W.H. Anderson, 1910.

PERIODICALS

American Issue, An Advocate of Christian Patriotism, ca. 1901.
American Prohibition Year Book, ca. 1910.
Breweriana Collector, 1972 to present.
Coopers International Journal, ca. 1890.
Ice and Cold Storage, ca. 1908.
Ice and Refrigeration Illustrated, 1933 to present.
The Year Book of the United States Brewers' Association, ca. 1914.

INTERNET SOURCES

Breweries of Lafayette, Indiana, www.b-levi.com/lafayette/breweries.
Brewers of Indiana Guild, www.brewersofindianaguild.com.
Brewery Collectibles Club of America, www.BCCA.com.
Bruce Mobley's Beer Bottle Library, www.brucemobley.com/beer.
Crowncap Collectors Society International, www.bottlecapclub.org.
Falstaff Brewing Corporation fan site, www.falstaffbrewing.com.
Historic Evansville, www.historicevansville.com.
IndianaBeer, www.indianabeer.com.
Indiana Historical Society Digital Image Library, images.indianahistory.org.
Indiana Memory Collection, cdm1819-01.cdmhost.com.
Ingermann Brewing History, www.ingermann.com/history.html.
Northwest Indiana Photo Gallery, www.northwestindiana.com/photo.htm.
Old Metamora, www.emetamora.com.
Our History New Albany, ourhistorynewalbany.blogspot.com.
Sterling Beer at Rustycans, www.rustycans.com/COM/month0306.html.
Tippecanoe County Historical Association, www.tcha.mus.in.us.
Vigo County Public Library Index of Businesses, www.vigo.lib.in.us/subjects/genealogy/timeline/business.
YesterYear in Print—Kosciusko County Indiana, www.yesteryear.clunette.com.

Index

C

Cambridge City Brewery 100
Capital Brewery 116
Capital City Brewing Co. 122
Chris-Craft 60
City Brewery
 Evansville 163
 Indianapolis 115
 Jeffersonville 146
 Lafayette 82
Cole, Omer 74
Columbia Brewing Co. 69
Cook, Frederick Washington 163
Cooperages 35, 55, 56, 69, 81, 85,
 97, 101, 174
Coquillard, Alexis 55
Corbett, James S. 70
County Option 21, 50, 72, 74,
 85, 104
Crescent City Brewery 167
Crown Brewing Co. (1) 29
Crown Brewing Co. (2) 186
Crystal Spring Brewery 31

D

Deming, Demas 89
Dick, Clemens 31, 34
Dick, Frank 31, 32, 34
Distilleries 69, 90, 119, 125
Downer, W. S. 116
Drewrys Beer 172
Drewrys Brewery 44

E

Eagle Brewery
 Columbia City 47

 Evansville 167
 Fort Wayne 58
 Newburgh 154
 Vincennes 159
Easter, Moses 95
Ebner, John 159
Eckert, Ignatz 152
Eder, George 30
Emdee, Christian 82
Engle, Peter 145
English Syndicates 118, 125, 170,
 217
Evansville Brewery 167
Evansville Brewing Association 170
Evansville Brewing Co. (1) 170
Evansville Brewing Co. (2) 175
Excelsior Brewery 151

F

Fairbanks, Crawford 90
Falstaff Brewing Co. 65
Faux, Rene 111, 113
Ferdinand Brewing Co. 150
Fires 31, 36, 50, 59, 61, 74, 76, 86,
 87, 98, 116, 119, 125, 143,
 158, 164, 172
Franklin Brewery 168
Fredrick, Kosmos 128
Freshness Dating 93
Fulton Avenue Brewery 161
F. W. Cook Brewing Co. 163

G

Gaff, Thomas 125
Garnier, John B. 128
Garst, Albert J. 103
Generic Beer 66

G. Heileman 44, 66, 95, 174
Glueckert, George 43, 48
Great Crescent Brewery (1) 125
Great Crescent Brewery (2) 183
Greiner, Mathias 130
Guenther Brothers Brewing 31

H

Hack, Eugene 159
Haffenreffer Beer 65
Hammerle, Balthasar 128
Hammond Brewing Co. 30
Harrison Brewery 159
Harting & Bros. 116
Hartman, Herman C. 56
Hartmetz, John, Charles, Otto 168, 170
Hawks, Cephas, Howard 49
Heck, Willam, Frederick 149
Herberg Brothers 51
Herbert, Dietrich 79, 81
Higert, Robert L. 87
Hiller, George 39
Hillforest Mansion 125
Hill, John 23, 183
Hochgesang, Edward Andrew 151
Hoch, Henry W. 50
Hoedt, Ferdinand 161
Hoff-Brau 64
Hofmann, County William 154
Hoham, John 76
Home Brewing Co. 122
Hoosier Brewery 42
Hop growing 32
Horning, John George 55
Hornung, Jacob 142
Huber, Jacob 149
Hulman, Tony 165

Huntingburg Brewing Co. 151
Huntington Brewery 50

I

Indiana Brewing Assoc. 70
Indiana Brewing Co. 142
Indianapolis Brewery 111
Indianapolis Brewing Co. (1) 118
Indianapolis Brewing Co. (2) 191
Ingermann family 100

J

Jauch, Joseph 167, 169
Jungclas, William P. 122
Jung, William E. 72
Junker, John 39

K

Kalmanovitz, Paul 65
Kamm, Adolph 34, 57
Kamm's Brewery 34
K. G. Schmidt Brewing Co. 69
Kiley Brewing Co. 70
Kirchgessner, J. 146
Kline, Jacob 68
Klinghammer, John 76
Kocher, George 137
Korn, Julius 29
Krodel, John 150
Kroener, Fred 161
Kroener, John 161, 169
Kunkler, Jacob 158

T

Taverns 85, 111, 148
Tell City Brewery 157
Tell City Brewing Co. 156
Temperance Societies 19, 72, 75, 103
Terre Haute Brewing Co. (1) 96
Terre Haute Brewing Co. (2) 89
Terre Haute Brewing Co. (3) 204
Terstegge & Co. 146
Thieme & Wagner 81
Trade Associations
 Assoc. of Indiana Brewers 218
 Brewers of Indiana Guild 183
 Indiana Brewers' Assoc. 21, 92, 172, 218
Troy Model Brewery 158

U

Ullmer, Charles Wilhelm 161, 170
Underground Railroad 76
Union Brewery 132, 166

V

Voelke, Frederick 157
Vonnegut, Kurt 116

W

Wabash Brewing Co. 52
Wack, Herman 167, 168
Wagner, John 34, 81
Walter-Raupfer Brewing Co. 47
Warren, Chauncey 89
Washington St. Brewery 56
Weber, Adam, Peter, Charles 132

Weiss Beer Brewery 96
Wernweg, William 111
Wimberg, Henry C. 170
Wingert, Henry 167
Winterath, John S. 158
Wittekindt, William J. 174
Wright "Bone Dry Law" 220
Wright, Frank M. 116
WWII Labels 28, 36

Y

Young, John L. 111

Z

Zahm, August 31
Zix, Joseph, Michael 133
Zwerweck, Herman 31

About the Authors

B ob Ostrander is retired but has owned pieces of an Indianapolis bar and a Terre Haute brewery. He founded the IndianaBeer.com news website and has been the webmaster for the Brewers of Indiana Guild trade association. He contributed to the IU Press book *True Brew* by Rita Kohn.

D errick Morris is a surgical technician, trained by the U.S. Navy more than twenty-five years ago. He has a strong passion for collecting breweriana (beer memorabilia) from his home state. He owns the world's largest collection of Indiana beer history. He contributed to *U.S. Beer Labels* by Bob Kay. He is a member of the Brewery Collectibles Club of America (BCCA), serving as a board member in 1993–94. Derrick's wife, Karen, attended the CANvention held in Indianapolis in 1996, and they got married in April 1997.

Visit us at
www.historypress.net

More about this book and Indiana brewing history can be found at
www.HoosierBeerStory.com